THE GAUGUIN ATLAS

NIENKE DENEKAMP

TRANSLATED BY LAURA WATKINSON

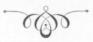

YALE UNIVERSITY PRESS
NEW HAVEN AND LONDON

CONTENTS

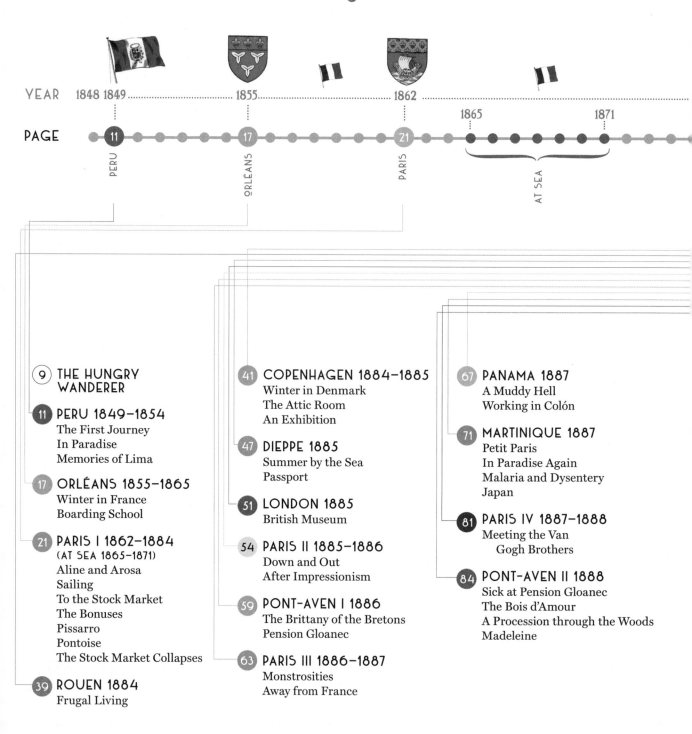

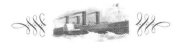

THE GAUGUIN ATLAS

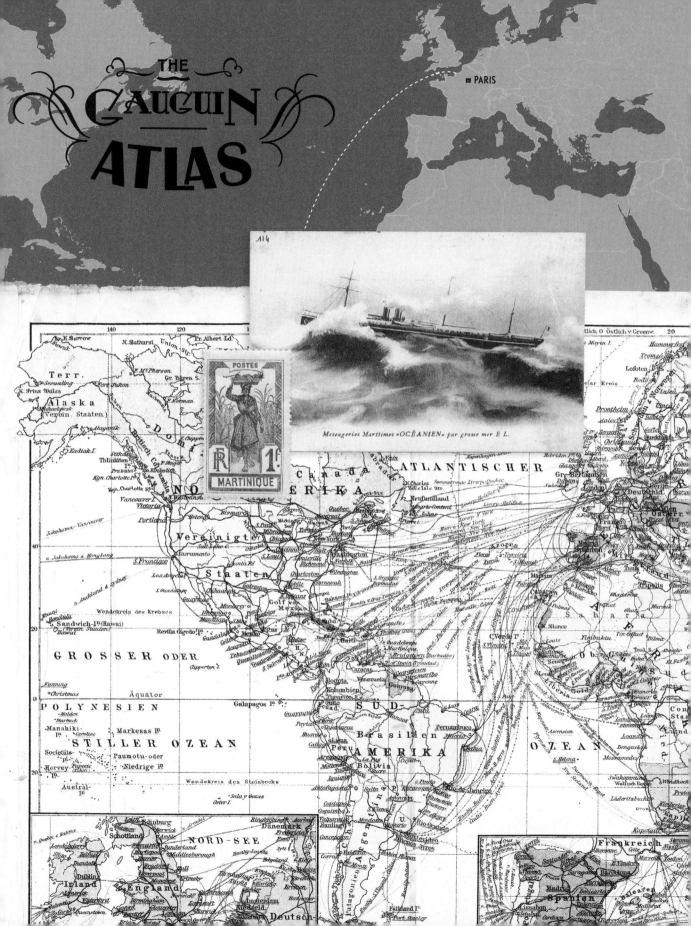

THE
GAUGUIN
ATLAS

□ PARIS

114

Messageries Maritimes «OCÉANIEN» par grosse mer E L.

The Hungry Wanderer

The French painter Edgar Degas sometimes compared his peer Paul Gauguin to the wolf in one of La Fontaine's fables. This hungry wanderer struck up a conversation with a well-fed dog who was lying in the farmyard, allowing his last meal to digest. The dog explained to the thin and starving wolf that his owner gave him food and affection every day. Such an easy life! The wolf thought it sounded very fine, so he decided to stay and live in the farmyard—until he saw the chain to which the dog was tied. So the wolf would have to give up his freedom, too? Never! Paul Gauguin was the same. He abandoned his women and children, broke up his friendships, and ended promising careers. All for art. His journey took him over the entire world, from England, Denmark, and Spain to Martinique, Tahiti, and Hiva Oa, an island in the Pacific Ocean, where he created works that would eventually, after his death, make him world-famous. This atlas follows Gauguin on his travels.

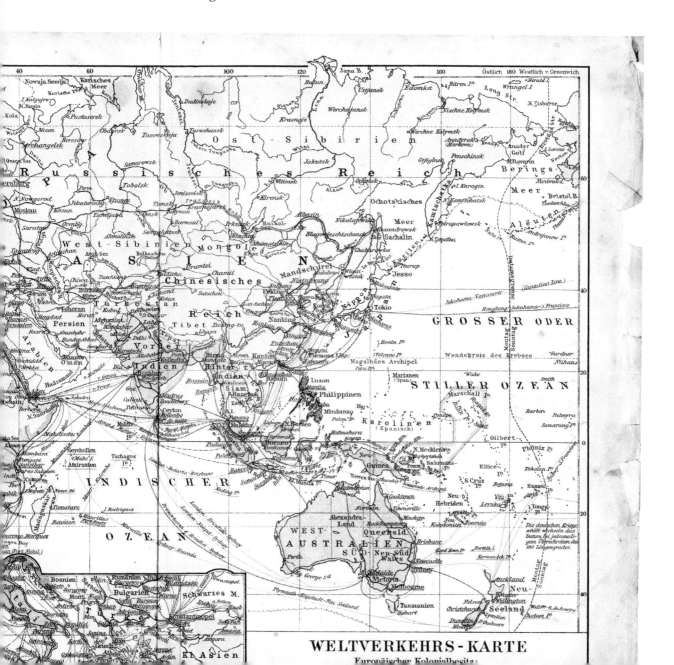

WELTVERKEHRS-KARTE

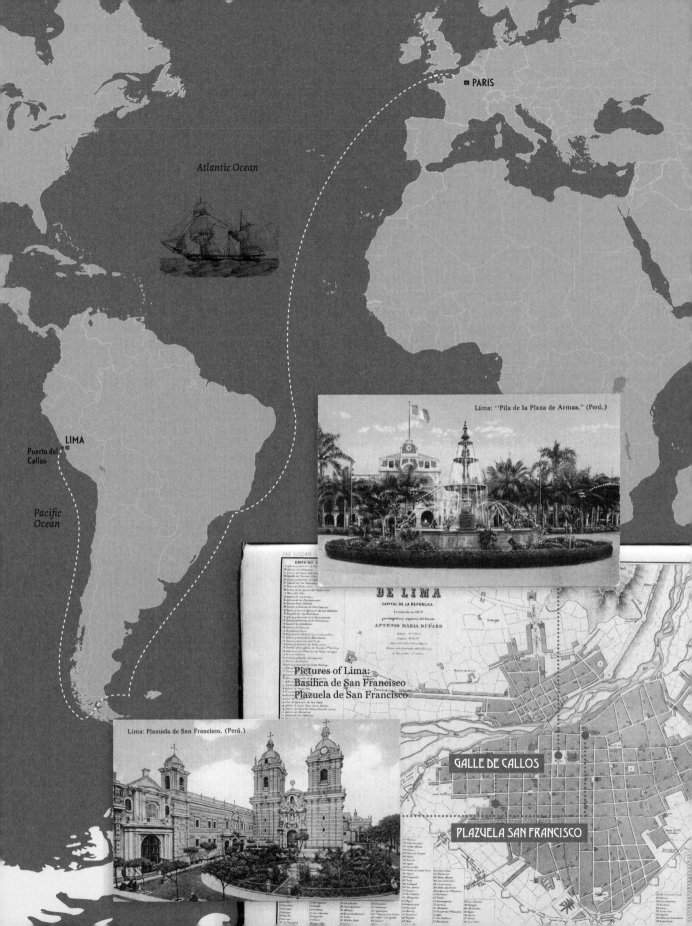

PARIS

Atlantic Ocean

LIMA

Puerto del Callao

Pacific Ocean

Lima: "Pila de la Plaza de Armas," (Perú.)

DE LIMA

CAPITAL DE LA REPÚBLICA

Levantado en 1859
por disposición y mandato del Estado

ANTONIO MARIA DUPARD

Pictures of Lima:
Basílica de San Francisco
Plazuela de San Francisco

Lima: Plazuela de San Francisco, (Perú.)

GALLE DE CALLOS

PLAZUELA SAN FRANCISCO

Peru

Paris

Notre Dame de Lorette

Below: Before emigrating, Paul Gauguin's parents lived at 52 (now number 56) Rue Notre-Dame-de-Lorette in Paris.
Left: the church on the same street, where Gauguin was baptized

THE FIRST JOURNEY

Gauguin made his first trip abroad just after his first birthday. In 1849, his parents traveled to Lima, Peru, with Paul and his two-year-old sister, Marie. They had left Paris because Clovis, Gauguin's father, was in trouble. As a journalist, he had spoken out strongly against the Bonapartes, and when it looked likely that Charles-Louis Napoléon, who later became Emperor Napoléon III, had won the elections, Clovis and his wife and children took the train to Le Havre, where they left the country on a ship called the *Albert*. After a journey of two and a half months, the *Albert* arrived in Punta Arenas, the southernmost city in Chile, where the passengers were allowed to disembark for a while to stretch their legs. As the Gauguins were being rowed ashore in a smaller boat, Clovis unexpectedly died of a heart attack.

The captain refused to delay the departure, so the widow had to bury her husband that same day. The *Albert* continued its journey to Lima the following day. At some point in November 1849, Aline Gauguin disembarked at Puerto del Callao as a single mother of two children. She would be dependent on the kindness of family and friends for most of her remaining life.

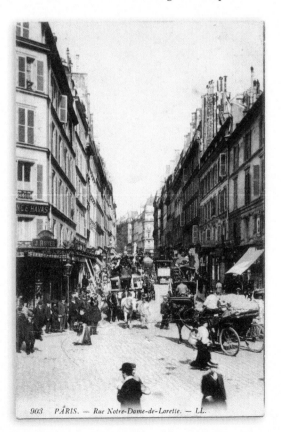

903 PARIS. — Rue Notre-Dame-de-Lorette. — LL.

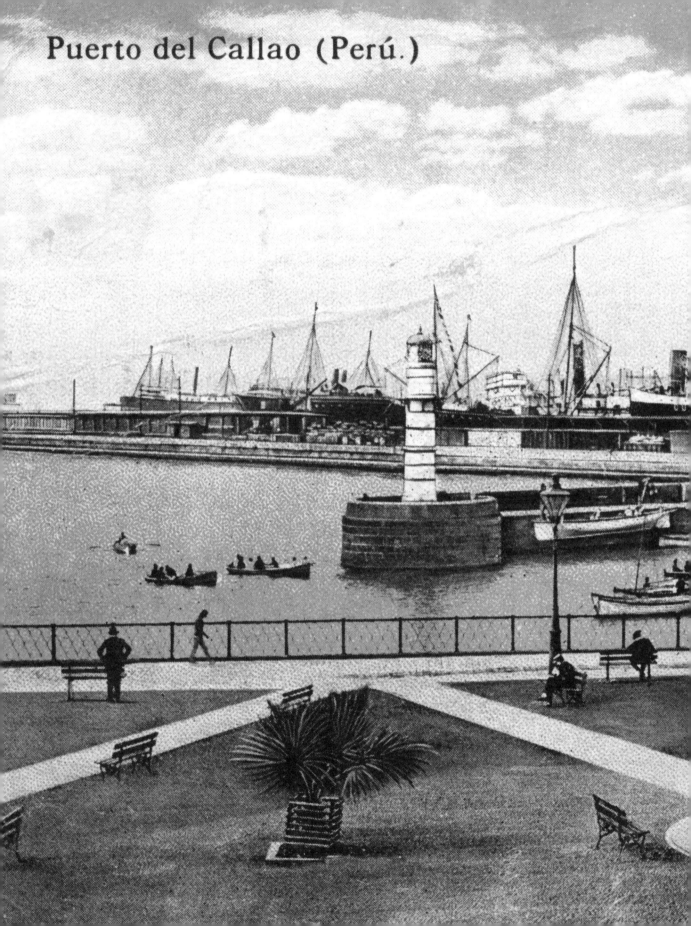

Puerto del Callao (Perú.)

IN PARADISE

Fortunately, Aline Gauguin's family in Lima welcomed her with open arms. Her wealthy great-uncle, Don Pío de Tristán y Moscoso, took both her and the children under his wing. He lived, surrounded by family members and plenty of staff, in a stately colonial house that extended over an entire block and had various courtyards.

Don Pío was descended from a Spanish family of colonists who had settled in South America five generations before. By the time Aline arrived in Lima, he had already held a number of important political and military positions in the service of the Spanish crown. He would go down in history as the last viceroy of Peru. His brother Mariano, Paul Gauguin's great-grandfather, was less of a royalist. After his studies in Europe, he did not return to Peru but instead settled in Paris, where he married a French-woman, Thérèse Laisnay. Unfortunately, due to an administrative error, their marriage turned out to be invalid. When Don Mariano suddenly died, Thérèse waited

patiently for her inheritance to arrive from Peru. It never came.

Her daughter, Flora Tristán, the mother of Aline and the grandmother of Paul, was cut from entirely different cloth. In an age when divorce was not an option, she left her violent husband, who beat her and their daughter, Aline, and traveled to Lima to claim the inheritance to which she and her mother were entitled.

She was one of the first French feminists, a socialist-anarchist activist, and the first to argue for an international workers' movement, even before Karl Marx. Years later, a square in Paris was named after her, she was given a statue, and her portrait appeared on postage stamps. Her proud grandson later wrote that all her money went to the workers' cause.

However, she did not succeed in all of her endeavors. The journey to Lima did not bring her a single cent. Don Pío was not too fond of his feminist niece. Their relationship did not improve when, back in France, she wrote a book about the desperate situation of women in the Spanish colony of Peru. Paul Gauguin never met his famous grandmother, Flora Tristán, as she died before he was born. He did, however, read her books, and mentioned in his memoirs that she was a very pretty and noble woman, but also a bluestocking who probably could not cook.

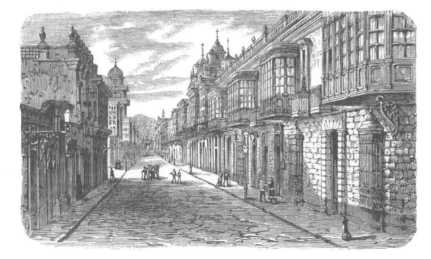

Don Pío lived in Galle de Callos, Lima (now 253 Avenida de la Emancipación).

MEMORIES OF LIMA

In his memoirs, *Avant et après*, which Gauguin wrote in the years just before his death, at a time when his view, as he glanced up, included coconut palms, banana trees, and in the distance the Tahitian island of Moorea, he described his sheltered life in Lima in detail. The house where he lived, for example, and the painting of his uncle, which seemed to come to life during an earthquake one night. He saw the woodcarvings of the dome of the Basílica de San Francisco and his mother's eye when she was dressed as a *tapada limeña*, in a costume that covered the entire body except for one eye. At the end of his life, Gauguin even recalled the servants who had taken such good care of the Gauguins back then. There was a black maid who had carried a mat to the basilica for the young Paul to kneel on during prayers. There was a Chinese manservant who ironed the clothes and who found him when he had hidden among the barrels of molasses in a grocery store for so long that his mother had burst into tears. Running away and hiding was something that the young Paul Gauguin liked to do.

Although Gauguin lived in Peru for no longer than six years and came from a family of Spanish colonists, for the rest of his life he would tell people that he was descended from Incas and that he was actually "un sauvage" from Peru.

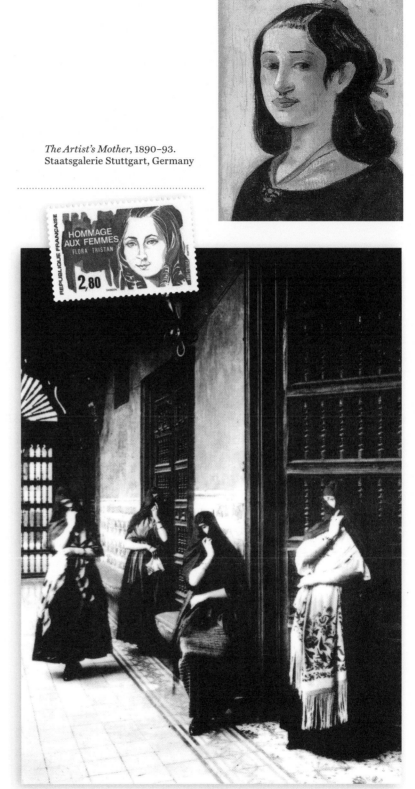

The Artist's Mother, 1890–93. Staatsgalerie Stuttgart, Germany

Tapadas limeñas

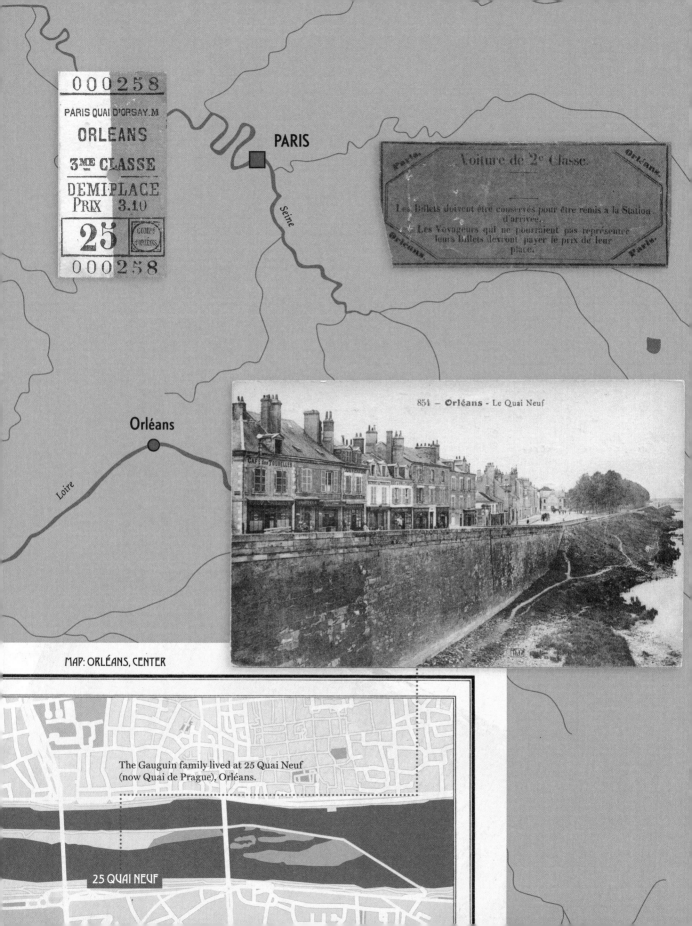

000258
PARIS QUAI D'ORSAY. M
ORLEANS
3ME CLASSE
DEMI-PLACE
PRIX 3.10
25 COMPE D'ORLÉANS
000258

PARIS

Seine

Voiture de 2e Classe.

Les Billets doivent être conservés pour être remis à la Station d'arrivée.
Les Voyageurs qui ne pourraient pas représenter leurs Billets devront payer le prix de leur place.

854 – Orléans – Le Quai Neuf

Orléans

Loire

MAP: ORLÉANS, CENTER

The Gauguin family lived at 25 Quai Neuf (now Quai de Prague), Orléans.

25 QUAI NEUF

Orléans

WINTER IN FRANCE

Meanwhile, back in France, in Orléans, the health of Clovis's father was deteriorating. The seventy-year-old Guillaume Gauguin wrote to his daughter-in-law in Lima that he would like to see his grandchildren, who were also his heirs, again. So, in early 1855, Aline returned to France and settled in Orléans.

The eight-year-old Marie and seven-year-old Paul suddenly had to wear winter coats to walk to school. Gauguin later remembered that he and his sister, who spoke Spanish, could not understand anyone at first. One of his memories from this time is of a woman who saw him carving the handle of a dagger and exclaimed, "He's going to be a famous sculptor!" The family was far from the land where, in Gauguin's memories, it never rained. When he was nine, he ran away from home with a handkerchief filled with sand on a stick over his shoulder, as if he were a vagabond. The local butcher saw Gauguin out walking and, holding his hand, took him back home.

Guillaume Gauguin lived, surrounded by a large number of Gauguin cousins, in the well-to-do neighborhood of Saint Marceau in Orléans. His house at 25 Quai Neuf had a beautiful view of the Loire and of the old town across the river. The house behind it and the garden between the two houses also belonged to Guillaume. Boats used to moor in front of the house

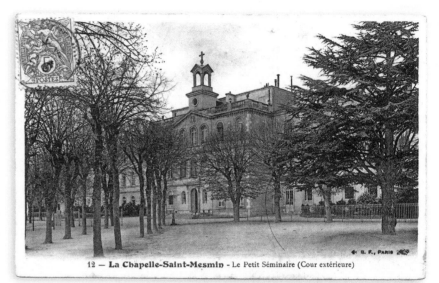

12 — La Chapelle-Saint-Mesmin - Le Petit Séminaire (Cour extérieure)

The boarding school
La Chapelle-Saint-Mesmin

to collect the vegetables and flowers that Guillaume grew in his garden and transport them to the market. Guillaume's unmarried son, Isidore, lived in the other house. He was a jeweler who specialized in gold, and the children of his deceased brother called him "Uncle Zizi."

Guillaume Gauguin had once run a grocery store with his wife, Elizabeth Juranville, who had passed away. He was also the owner of various houses and pieces of land in the area and even had a small vineyard, and he was able to live off the proceeds. A few months after his daughter-in-law and the little Peruvians came to live on the Quai Neuf, he also passed away. Uncle Zizi became the children's guardian and inherited half of his father's possessions, while the children received the other half. Aline had the right of usufruct. This did

not do her much good though, as the capital was tied up in assets.

Don Pío also died shortly after the Gauguins left Lima. Aline seemed to have succeeded where her grandmother and mother had not: Don Pío had left her a considerable sum of money. According to Gauguin, it was 25,000 francs. But the Tristán y Moscoso children put a stop to it, refusing to share their inheritance with Aline.

32 ORLÉANS — Panoram

e la Ville pris du Quai Neuf C. M.

The school courtyard

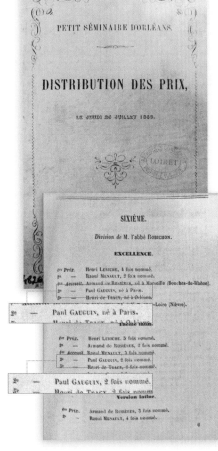

BOARDING SCHOOL

From the age of eleven, Paul Gauguin attended one of the best schools in France, Le Petit Séminaire de la Chapelle-Saint-Mesmin, in a small village a few miles away along the Loire. The school, a boarding school, was founded by the Bishop of Orléans, Félix Dupanloup, the author of the six-volume book *De l'Education* and a leading advocate for the liberalization of French religious education. Dupanloup argued for the education of women and approved of students not just receiving purely religious instruction but also, for example, reading Greek tragedies, much to the horror of his stricter colleagues. He also believed that his students should be as critical as possible when it came to their faith. He was a large, ruddy-faced man with dramatic eyebrows, who refused to travel by carriage, preferring to walk along the Loire, talking to some of his students. But never without an umbrella.

Gauguin received a very thorough Catholic education at the school. He later acknowledged that it had been of great benefit to him. He was among the best students in his year, but it also gave him a thorough dislike of hypocrisy and sanctimoniousness. The boy was very much a loner. Life at the boarding school must have been hard for him. Forty boys shared a dormitory, and a bell woke them at five in the morning. This was followed by a long day full of study, prayer, and services, interrupted by meals. It was not the ideal situation for a boy who preferred to run away, out into the big wide world.

List of school prizewinners, including "Paul Gauguin, born in Paris"

Right: Ladies' fashions, 1880

Paris I

ALINE AND AROSA

As the inheritances had yielded little to nothing, Aline had to earn money herself now. She moved to Paris, where she set up shop as a seamstress in a busy street with a lot of clothing stores and sewing workshops. She was far from the only woman working in the textile industry in Paris. After household maid, *couturière* was the city's most common job for women, not counting prostitution. Some specialized in the repair and alteration of clothing or in embroidery, while others made gloves, hats, corsets, and so on. None of them earned much, particularly when compared to male tailors, but even so it was a little more than the workers in textile factories, who were fined if a thread snapped and sometimes had to supplement their meager pay with prostitution.

Aline was lucky. Through Spanish friends and contacts in Paris, she met the Arosa family. The businessman Gustave Arosa had become rich on the stock exchange and, like many wealthy men at the time, he invested in art. He was an enthusiast, collecting pottery from all over the world, and he had a large collection of paintings.

When he sold some of his paintings at auction in the late 1870s, dozens of works by artists including Jean-Baptiste Corot, Gustave Courbet, Honoré Daumier, Camille Pissarro, Eugène Delacroix, and Johan Barthold Jongkind went under the hammer.

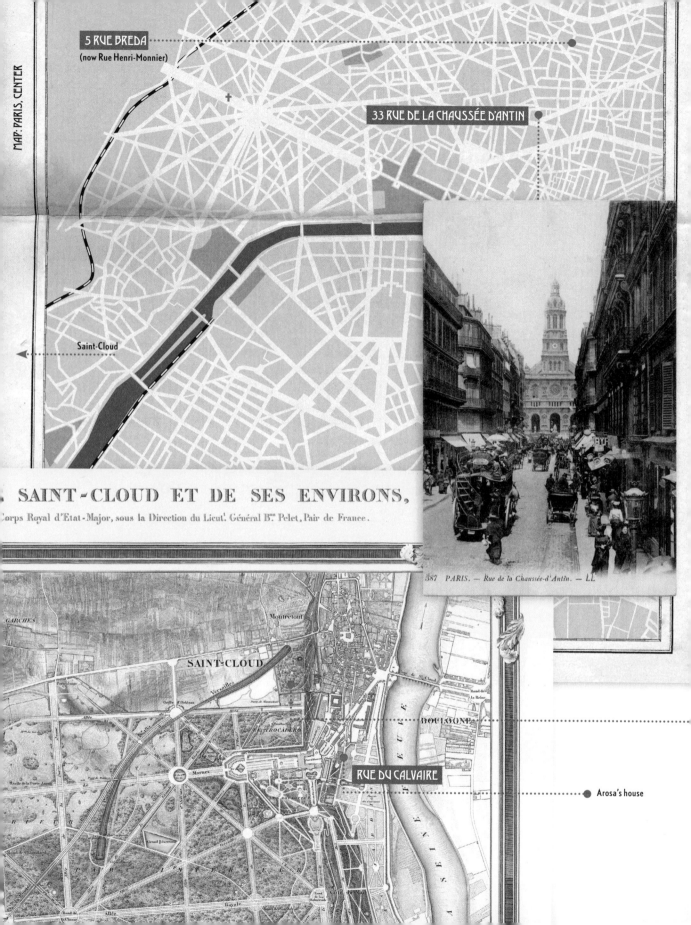

5 RUE BREDA
(now Rue Henri-Monnier)

33 RUE DE LA CHAUSSÉE D'ANTIN

Saint-Cloud

SAINT-CLOUD ET DE SES ENVIRONS,

Corps Royal d'Etat-Major, sous la Direction du Lieut!. Général B.ᵉⁿ Pelet, Pair de France.

387 PARIS. — Rue de la Chaussée-d'Antin. — LL.

GARCHES

Montretout

SAINT-CLOUD

TROCADERO

BOULOGNE

RUE DU CALVAIRE

Arosa's house

Gustave Arosa, photographed
by his friend Félix Nadar

Arosa liked to spend his time in artistic circles. He was a friend of and worked with the photographer Félix Nadar. When he was in Paris, he lived in the middle of the artists' quarter, Pigalle. He spent the weekends at his country house in Saint-Cloud, around seven miles from Paris, where Napoléon III also had a palace. Aline and her children were frequent guests at his house, which was located on the railway line. This gave the young Gauguin the opportunity to study the work of all those famous painters close-up. Together with Marguerite, Arosa's daughter, he went out on the weekends to paint the local landscapes.

Eventually, Aline moved into her own house in Saint-Cloud, near the church. Gauguin biographers believe she may have had an affair with Arosa. Perhaps that was why Gauguin behaved so badly when he was taken from the boarding school near Orléans and brought to Paris. He made himself so unpopular with her friends, his mother complained, that she was afraid he would ultimately have no one left. She sent him back to boarding school. In 1865, Aline, who was struggling with poor health, adjusted her will, officially giving guardianship of her children to Arosa.

Sunday painters in the park at Saint-Cloud

85. - Saint-Cloud. - Le Parc - La Mare aux Biches - Vue artistique

« L'Abeille »

SAILING

After finishing high school, Gauguin wanted to go to sea. In 1865, he signed up as a trainee officer in the merchant navy. His first trip was three months, with Rio de Janeiro as the destination. He related in his memoirs that he had good memories of this journey on the *Luzitano*, a 1,200-ton ship that could reach twelve knots in a good wind.

Gauguin later described the amorous adventures he experienced on his travels. Before embarking upon this first journey, he had been instructed by a superior to deliver a parcel and a letter to a Madame Aimée in Rua do Ouvidor in Rio. When he arrived, it turned out that he himself was the gift. "You're so handsome!" she exclaimed when she saw the seventeen-year-old—who by his own admission looked more like a fifteen-year-old—standing at her door. Madame Aimée was an actress in her thirties, who "was still very attractive in spite of her age," Gauguin later reminisced. Beautifully dressed, she rode around in a cart pulled by a mule, and her admirers included not only Gauguin but also the son of the Russian tsar. The stop in Rio lasted a month. On the way back to Le Havre, Gauguin began a relationship with a German lady. They had to keep it a secret, as the captain also had his eye on her. In their love nest in the sail room, Gauguin told her one lie after another. When the lady, head over heels in love, finally asked for his address in Paris, he gave her the address of a brothel. Gauguin contentedly decided that he intended to be a complete scoundrel.

Gauguin did not write much more about his early sea voyages. He did not want to bore the readers of his memoirs with dull sea stories. This is a pity, as those journeys took him all over the world, including back to Peru and Tahiti. During a stop in India, he heard that his mother, Aline, had passed away. It was another six months before his ship moored in Le Havre and he could return home.

In January 1868, a time when the threat of war between France and Prussia was increasing, Gauguin joined the French navy. He was admitted as a seaman third class on the *Jérôme-Napoléon*, a warship that also served as a yacht for a cousin of Emperor Napoléon III. For more than two years, before the Franco-Prussian War broke out, the *Jérôme-Napoléon*, with Prince Napoléon on board, mainly undertook amateur scientific journeys, from the Mediterranean to far into the freezing north. When France declared war on Prussia in the summer of 1870, the prince went ashore and spent the war in Italy. His ship became part of the Northern Squadron, which was supposed to teach the Prussians a lesson. The

Paul Gauguin in the 1870s

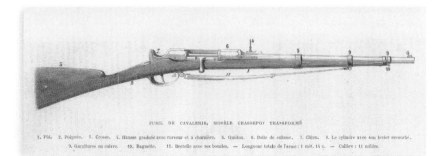

FUSIL DE CAVALERIE, MODÈLE CHASSEPOT TRANSFORMÉ

1. Fût. 2. Poignée. 3. Crosse. 4. Hausse graduée avec curseur et à charnière. 5. Guidon. 6. Boîte de culasse. 7. Chien. 8. Le cylindre avec son levier recourbé.
9. Garnitures en cuivre. 10. Baguette. 11. Bretelle avec ses boucles. — Longueur totale de l'arme : 1 mèt. 14 c. — Calibre : 11 millim.

Engraving of a modern French gun,
as used in the Franco-Prussian War

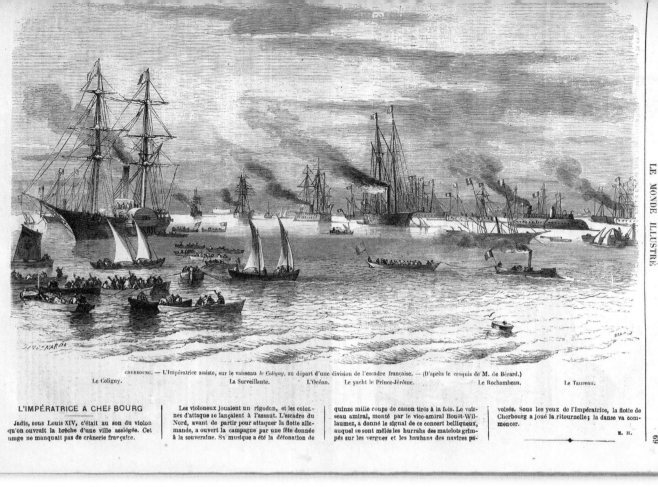

CHERBOURG. — L'Impératrice assiste, sur le vaisseau *le Coligny*, au départ d'une division de l'escadre française. — (D'après le croquis de M. de Bérard.)

Le Coligny. La Surveillante. L'Océan. Le yacht le Prince-Jérôme. Le Rochambeau. Le Taureau.

L'IMPÉRATRICE A CHERBOURG

Jadis, sous Louis XIV, c'était au son du violon qu'on ouvrait la brèche d'une ville assiégée. Cet usage ne manquait pas de crânerie française.

Les violoneux jouaient un rigodon, et les colonnes d'attaque se lançaient à l'assaut. L'escadre du Nord, avant de partir pour attaquer la flotte allemande, a ouvert la campagne par une fête donnée à la souveraine. Sa musique a été la détonation de quinze mille coups de canon tirés à la fois. Le vaisseau amiral, monté par le vice-amiral Bouët-Willaumez, a donné le signal de ce concert belliqueux, auquel se sont mêlés les hurrahs des matelots grimpés sur les vergues et les haubans des navires pavoisés. Sous les yeux de l'Impératrice, la flotte de Cherbourg a joué la ritournelle; la danse va commencer.

E. H.

69

Departure of the fleet, including the *Jérôme-Napoléon*, from Cherbourg

weekly *Le Monde illustré* featured, in addition to the words and music of the French national anthem, *La Marseillaise*, a full-page engraving of the departure of the fleet. As the Empress Eugénie looked on, sailors and flags waved, and cannons fired. This sense of superiority was, however, mercilessly crushed, as their plan to trap the much stronger and smarter Prussian ships ended in catastrophe. The French were devastatingly defeated on land, too. The Empire fell, and Paris was besieged. After the surrender, in January 1871, Gauguin left the ship in Toulon. It was the end of his military career. He wandered around for some time, before returning to Saint-Cloud to find that both the palace of Napoléon III, where the German troops had holed up, and the village itself had been wrecked. Hardly anything remained of his deceased mother's house and belongings. The house that belonged to Arosa, who had sat out the war in England with his family and with Marie Gauguin, was, however, intact, as was his collection of paintings. Paul Gauguin's only option was to move in with his guardian.

Napoléon III's damaged palace in Saint-Cloud

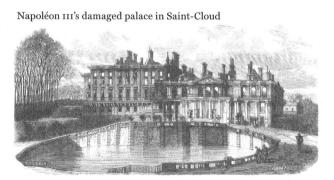

TO THE STOCK MARKET

Arosa arranged a position for Gauguin as a *liquiditeur* working for the stock trader Paul Bertin. His office was at one end of Rue Lafitte, where there were also many art galleries. This was a place where money met art. It was inevitable that the artistic aspirations of this stock-market boy would flourish rapidly in such a location.

At first, Gauguin had a dull office job. Shares were traded on the stock market in all kinds of ways, often with payment at a later point. This resulted in a mountain of paperwork, of which the *liquiditeur* was supposed to make sense. The former sailor quickly became skilled at his work and was promoted to the steps in front of the stock exchange, where the deals were prepared. It was a peak time for the stock market. After the Franco-Prussian War, the French state had to pay huge reparations to Prussia and borrowed this money on the market. Trading flourished and it rained bonuses, including for Gauguin. He moved into a bachelor apartment on Rue la Bruyère, close to the house of the Arosas in Pigalle.

Man in a Toque (Self-Portrait), ca. 1875–77. Harvard Art Museums/Fogg Museum, Cambridge, MA

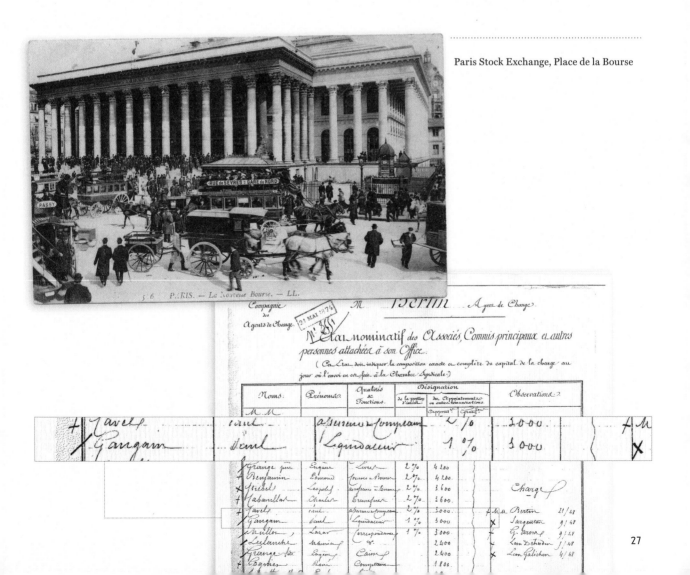

Paris Stock Exchange, Place de la Bourse

Émile Schuffenecker
and his wife, Louise

...

Mette Asleep on a Sofa, 1875.
Private collection

In 1872, Gauguin met two of the most important people in his life. At Bertin's, he met Émile Schuffenecker, known as "Schuff," who was to become one of his closest friends. Schuff devoted his every free moment to art. He took painting and drawing lessons in various places, and at lunchtime he dragged Gauguin along to the galleries on Rue Lafitte to see work by as yet unknown painters or to the Louvre to copy the old masters.

Then, at a party at the Arosas' house, Gauguin was introduced to the twenty-two-year-old Mette Gad, a sturdy, self-assured young woman from Copenhagen, who made a huge impression on him. Mette's father, a magistrate on an island in the Kattegat, the broad sea area east of Denmark, had also died young. After his death, Mette's mother moved to Copenhagen with her children. Mette became a governess, and moved in high political circles in Denmark as a result of her job. She had just arrived in Paris with a friend, and they were planning to enjoy themselves. She was charmed by the promising and prosperous young man. Within no time, Gauguin was engaged to his "precious pearl." He wrote to one of Mette's Danish acquaintances that he would do whatever possible—and even impossible—to prevent Mette from missing her Danish friends. A number of letters survive from this period that show that

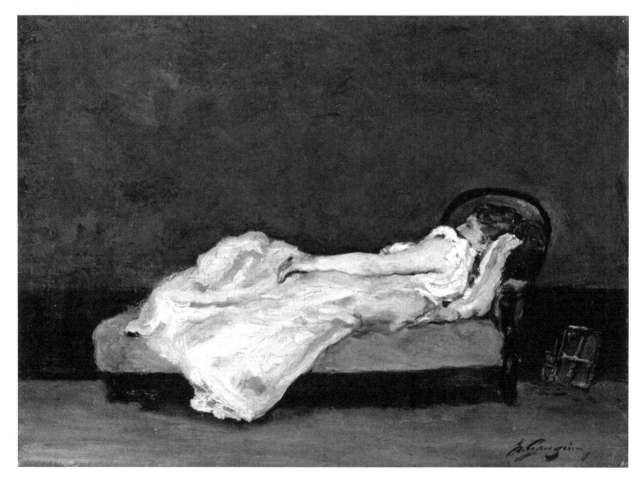

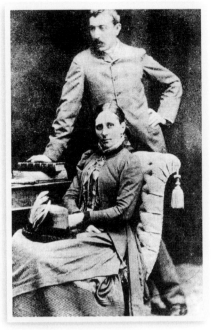

Top: Paul and Mette in 1885

Top right: the church where
they married, on Rue Chauchat

the Gauguins' early married life
was a succession of parties and
that Mette loved shopping. She
liked going to Le Printemps, one
of the first department stores in
Paris. Gauguin wrote that he did
not know much about fashion, "but
I believe the hats are extravagant
this year, and that costumes will
enrich the dressmakers and ruin
the husbands."

On November 22, 1873, a year
after they met, Paul and Mette got
married in Paris, and their first son,
Emil, was born nine months and
ten days later. Gauguin described
him in a letter to Denmark as "as
white as a swan and as strong as
Hercules." Emil was a particularly
handsome baby, and it was not
only his parents who thought so.
They named him Emil after Emile
Schuffenecker, but in the Danish
style, without an *e*, or, as it would
be said in French, "Emile sans *e*"
(Emile without the *e*). As a result,
the registry official wanted to note
the child's name as "Emile Sanzé"
at first, then he thought Gauguin
had been playing a prank on him.
Paul and Mette went on to have
four more children.

THE BONUSES

The chic apartment that the couple
moved into after their marriage
was just a few minutes' walk from
the place where Gauguin was born,
the church where he was bap-
tized, and the Arosas' house. Gau-
guin may have traveled all over
the world, but in Paris he always
returned to the same neighbor-
hood—until 1875, when the grow-

Les Eglises de Paris. — 48. Temple de la Rédemption

ing family needed more space.
After receiving an annual bonus
of 3,000 francs on top of his con-
siderable salary of 200 francs a
month, three or four times the pay
of a skilled worker, Gauguin and
Mette moved to a larger apartment
in a very elegant neighborhood,
between the Arc de Triomphe and
the Seine. A year and a half later,
when another child came along,
they moved to the other bank of
the Seine, where Gauguin rented

Place Saint-Georges, with Gauguin
and Mette's first home

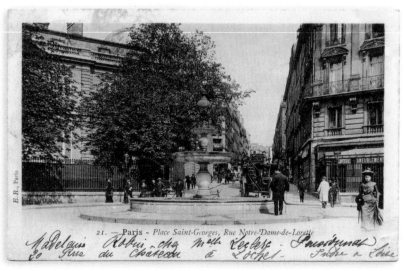

21. — Paris - *Place Saint-Georges, Rue Notre-Dame-de-Lorette*

Map of Paris, ca. 1870

a house from a sculptor, Jules-Ernest Bouillot, who had a studio at home. Gauguin thought this was interesting. He wanted to try his hand at sculpting, too. With some help from Bouillot, he made a classic marble bust of Mette and then one of little Emil. Hardly anyone could believe that these were his first attempts at sculpture, as the busts were so accomplished.

Bust of Emil Gauguin, 1877–78. The Metropolitan Museum of Art, New York

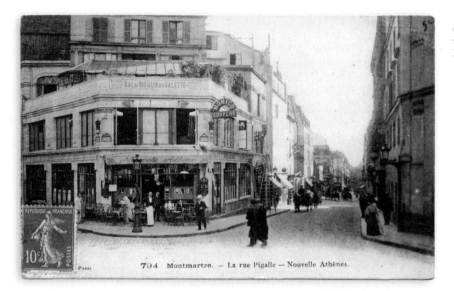

Café de la Nouvelle Athènes in Pigalle, where Gauguin met Degas, Monet, Manet, and Renoir

PISSARRO

In the late 1870s, Gauguin met the landscape painter Camille Pissarro, the man who would become his painting teacher. Pissarro was one of the founders of the Impressionist movement and one of the organizers of the Impressionist exhibitions that were held almost every year. These exhibitions were a reaction to the prestigious, state-funded Salon, where work by more conservative painters was displayed, including realistic, historical, and religious depictions and portraits of prominent individuals. The Impressionists rarely made it through the selection process. They did not strive for realism in their work, but aimed to capture the light with small brushstrokes, to give an impression of the world around them, with ordinary people. These painters, after having stood all day at an easel *en plein air*, in the open air, used to meet up at Café de la Nouvelle Athènes in Pigalle. That is where Pissarro introduced the Sunday painter Gauguin to other artists, including Edgar Degas, Claude Monet, and Pierre-Auguste Renoir. Gauguin introduced himself to Édouard Manet as an amateur.

The years after the Franco-Prussian War had been hard for the Impressionists. In the second half of the 1870s, in particular, it had become impossible to sell their paintings. Pissarro, trying to balance pursuing a career as a painter with supporting a family with, at that point, five children, could not afford to live in Paris. He lived and worked in Pontoise, a village to the northwest of Paris, except for when his wife sent him to Paris to knock on the doors of potential clients. Out of sheer necessity, Pissarro was once forced to sell a painting for seven francs.

Camille Pissarro, ca. 1900

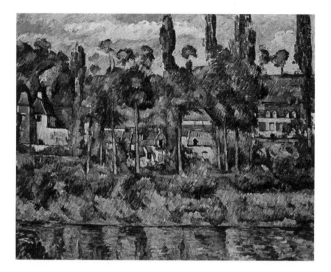

Paul Cézanne, *The Château of Médan*, 1880.
Kelvingrove Art Gallery and Museum, Glasgow

There were various places in Paris where the Impressionists liked to go. For example, the store owned by the paint and art dealer Julien Tanguy in Rue Clauzel. When his wife was not around, this friendly art dealer, also known as Père Tanguy, or Father Tanguy, would accept paintings in exchange for paint. His business became a meeting place for artists. Paul Cézanne and, later, Vincent van Gogh were frequent visitors. Pissarro had a debt with Tanguy that, by 1880, amounted to 2,413 francs. Eugène Murer, a pastry chef who painted and wrote novels, was also a patron for these painters. He had a bakery and restaurant on Rue Voltaire. For a long time, this was the headquarters of the Impressionists, but writers and musicians also joined them every Wednesday for the baker's excellent *paté en croûte*. There are no pictures of the restaurant, but if we are to believe Murer, it must have been a wonderful place. Renoir had decorated the ceiling ornaments with flowers and lavish garlands. Pissarro had painted magnificent Pontoise landscapes on the walls. Murer purchased works by the Impressionists, in exchange for food, but also offered them small amounts of cash for their work. The scent of fresh bread made the hungry painters inclined to agree to the rock-bottom prices. So, over the course of a decade, Murer succeeded in building up a collection that included twenty-eight works by Alfred Sisley, twenty-two by Armand Guillaumin, ten by Monet, sixteen by Renoir, eight by Cézanne, and twenty-five by Pissarro. Murer also took the initiative to hold a lottery to benefit Pissarro and his large family, selling the tickets in his store. Prizewinners could select one of the paintings by Pissarro, which were displayed among the trays of pastries. One of the winners was a local housemaid, who confessed that, if the baker did not mind, she would rather have a cream bun—and so Murer was able to add another Pissarro to his collection.

Camille Pissarro, *Woodland Scene, Spring*, 1878. Ny Carlsberg Glyptotek, Copenhagen

By 1879, things were starting to look up for Pissarro. The shrewd Gauguin frequently turned up with fellow businessmen who were also keen to invest in art and had heard from him that buying a Pissarro was a good bet. Gauguin himself bought several Pissarros in those years. He was also making rapid progress with his own paintings, although some were quite similar to the paintings that Arosa had on his walls at home. Even so, Pissarro and Degas invited him—a week before the opening—to exhibit one of his marble busts at a group exhibition of the Impressionists. Gauguin felt very honored. It was too late to include him as an artist in the catalogue, but a "Monsieur G." is named there as the owner of three of the thirty-eight Pissarros in the exhibition.

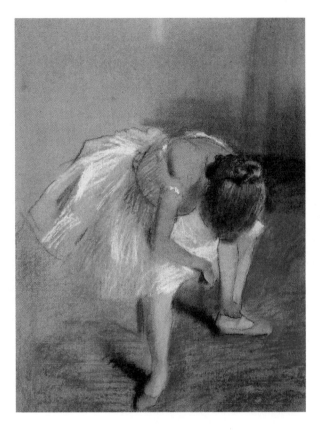

Edgar Degas, *Seated Dancer with Hand on Her Ankle*, 1879. Ordrupgaard, Copenhagen

Paul Gauguin's art collection included works by Cézanne, Degas, and Pissarro.

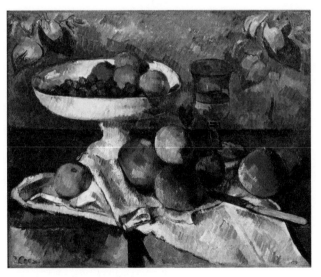

Paul Cézanne, *Fruit Bowl, Glass, and Apples*, 1879. Private collection

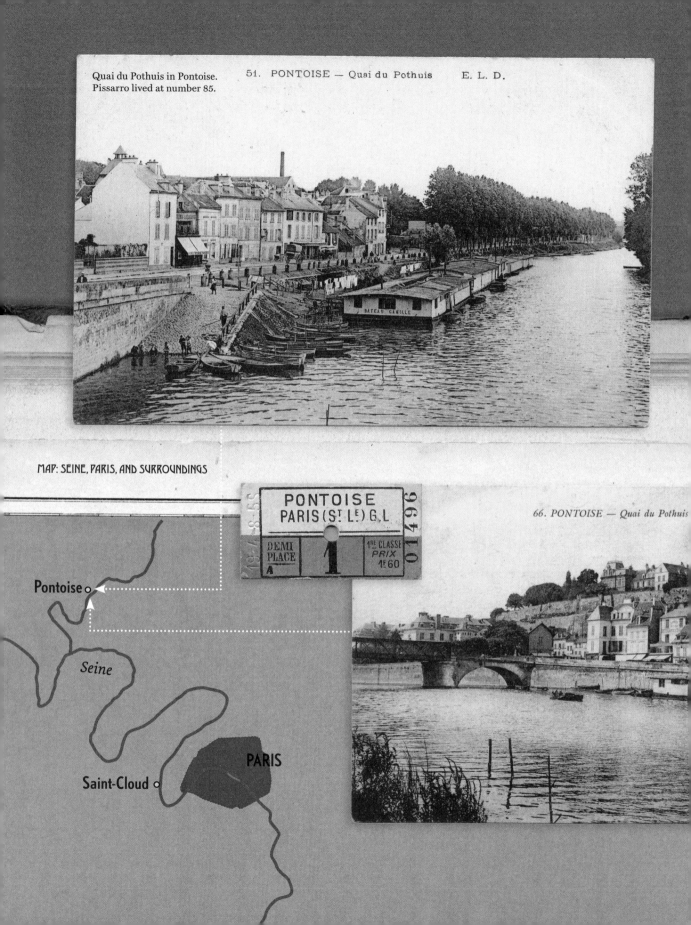

Quai du Pothuis in Pontoise.
Pissarro lived at number 85.

51. PONTOISE — Quai du Pothuis E. L. D.

MAP: SEINE, PARIS, AND SURROUNDINGS

Pontoise

Seine

Saint-Cloud

PARIS

PONTOISE
PARIS (St L) G.L
DEMI PLACE A 1RE CLASSE PRIX 1f60

66. PONTOISE — Quai du Pothuis

PONTOISE

Pissarro and Gauguin were not only the impoverished artist and the wealthy art collector, but also teacher and student. Pissarro first taught Gauguin how to stretch his own canvases and sent him to Père Tanguy's store, where Gauguin purchased eighty francs worth of paint in one go. From 1879, the student was regularly invited to come and work *en plein air* in Pontoise. The Gauguins spent various summer vacations there. Gauguin met artists, including Paul Cézanne, in Pontoise. *An Impressionist Picnic*, a beautiful drawing by Georges Manzana, one of Pissarro's sons, shows how the painters worked with their easels lined up together. In that case, they were painting a view of Val d'Oise. In the drawing, the painters are taking a break. Hortense is frying eggs, and Guillaumin and Pissarro are sitting on a rock, slicing bread or peeling apples, with Gauguin standing nearby. Cézanne is still working at his easel. Gauguin greatly admired Cézanne, but this feeling was not mutual. Cézanne felt as if he were being watched, and claimed that Gauguin, who owned a number of his works, was copying his method. Back in Paris, Gauguin wrote to Pissarro, perhaps not entirely in jest: "Has Cézanne already found a formula for art that everyone wants? I beg you, try to sound him out. Serve him one of your mysterious homeopathic remedies and listen to what he says in his sleep. Then come straight to Paris and tell us all about it."

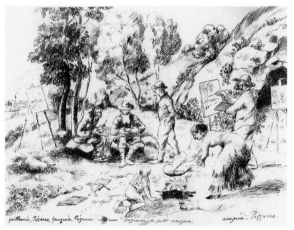

An Impressionist Picnic by Georges Manzana, Pissarro's son. From left to right: Guillaumin, Pissarro, Gauguin, and Cézanne. In the foreground, Georges Manzana and Madame Hortense Cézanne

Camille Pissarro, *Portrait of Paul Gauguin Chiseling on a Statuette*. Nationalmuseum Stockholm

THE STOCK MARKET COLLAPSES

Very slowly, it dawned on Mette that she was not married to a promising stock trader, but to an artist who had not yet sold anything. Gauguin spent all of his free time painting and was in Pontoise for entire weekends. In 1880, Mette decided that she had had more than enough of his constant absence. So she left and took the children to her mother's in Copenhagen, much to the fury of Gauguin, who threatened divorce in a letter. Mette came back. To make it up to her, Gauguin took a different position with even better prospects and bought her a piano. He also looked for a different house, where they could make a new start together. The advantage of this new house was that there was also room to set up a studio. Perhaps that is why he painted a lot of domestic scenes during this period: a man and a woman around a piano; his sleeping daughter, Aline; the children and the maid in the sun in the back yard; and the maid, Justine, stitching on a button before getting dressed. This nude received a lot of praise. The writer Joris-Karl Huysmans remarked: "Monsieur Gauguin is the first artist in years who has attempted to capture today's woman. He has succeeded and has made a bold and authentic painting." He was less enthusiastic about Gauguin's landscapes, which were very similar to those of his teacher, Pissarro. That did not, however, prevent Paul Durand-Ruel, the gallery owner who sold the work of the Impressionists, from buying three works by Gauguin.

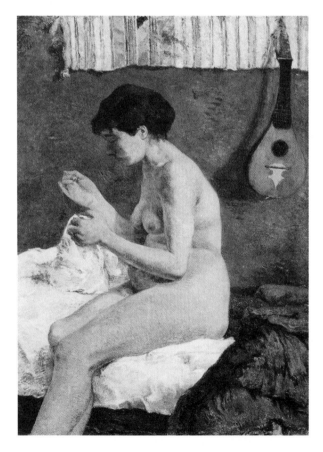

Study of a Nude (Suzanne Sewing), 1880.
Ny Carlsberg Glyptotek, Copenhagen

Interior of the Painter's House, Rue Carcel, 1881. Nasjonalmuseet, Oslo

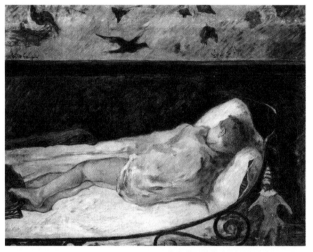

The Little One Is Dreaming, 1881. Ordrupgaard, Copenhagen

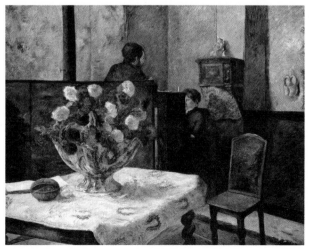

Gauguin became increasingly reluctant to go to work. Then, in 1882, the Paris stock market collapsed. This was triggered by the implosion of the Union générale bank in Lyon, which had made half of France invest in unreliable projects. The bubble burst, and the entire financial edifice toppled. Even though, since 1880, Gauguin had had a permanent position with a Paris insurance dealer, which miraculously stayed afloat, and so he was not immediately on the street, the consequences were still painful for him. There were no more bonuses, his personal shares became worthless, and, perhaps worst of all, the art trade came to a halt. No art was sold, and galleries closed their doors. Debts that Gauguin had recklessly taken on in better days now began to tear him apart. Mette was pregnant for the fifth time. It is not clear if Gauguin was made redundant or if he resigned. In any case, he stopped working for a boss. By the time his youngest son, Paul, also known as "Pola," came along in 1883, the father's profession was registered as "artist."

The Family in the Garden, Rue Carcel, 1881.
Ny Carlsberg Glyptotek, Copenhagen

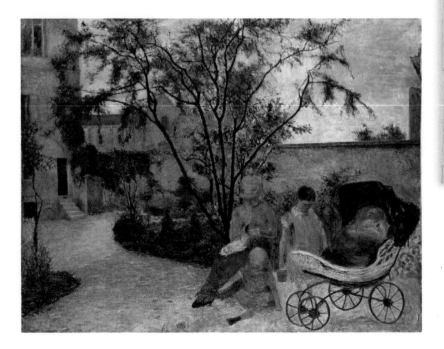

Catalogue of the fourth group
exhibition of the Impressionists

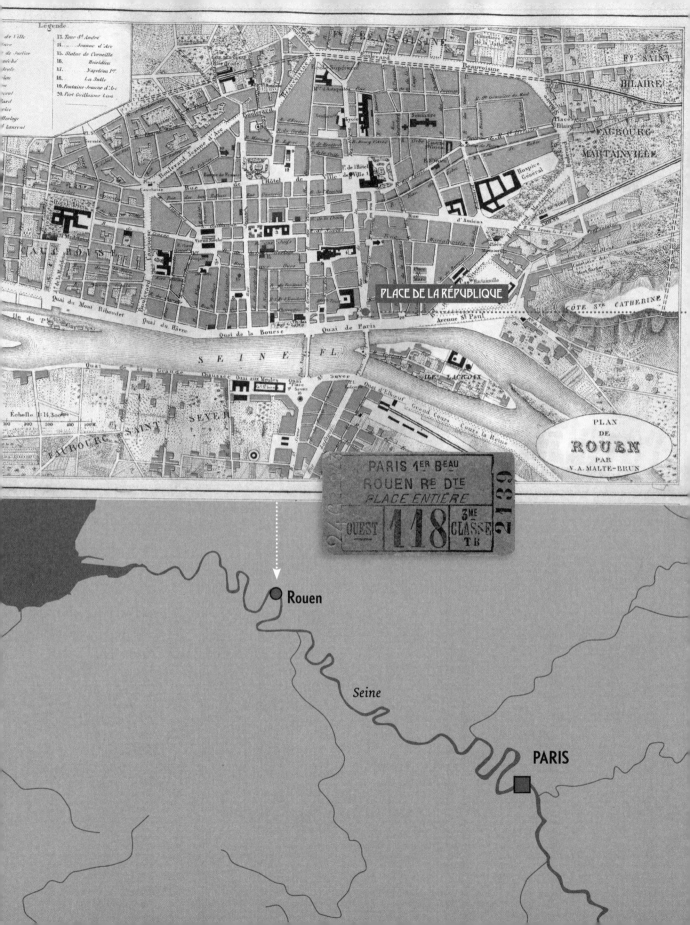

Rouen

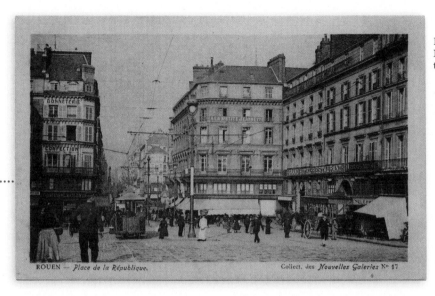

ROUEN — *Place de la République.* Collect. des *Nouvelles Galeries* N° 17

Place de la République in Rouen. Murer's hotel was in the corner on the right.

FRUGAL LIVING

The Gauguins had to live more frugally now. Paris had become too expensive, so the family moved to Rouen. They—along with their maid—moved into a house in the hills to the north of the old city center, on a dead-end street. Gauguin hoped that he would find success in the prosperous city in Normandy and that he and his family would be able to live on the proceeds of his art. Pissarro, who regularly went to paint in Rouen for a while, had told him that Murer, the Parisian pastry chef who collected the works of the Impressionists, had started a hotel on the Place de la République in Rouen. Gauguin began to paint, but Murer, perhaps cautious after the economic crisis, bought only one painting. "What a joke, that Murer," a cynical Gauguin wrote to Pissarro. To his son Lucien, who lived in England, Pissarro reported: "Gauguin is going to conquer Rouen! He is very com-mercially minded, or at least gives that impression. . . . He needs a lot, as his family is used to a life of luxury." Mette did indeed soon have enough of this frugality. In the summer of 1884, she left with Aline and little Pola on a trip to Denmark. From Denmark, she wrote that she would return only to fetch her belongings. Gauguin stayed in Rouen and continued working. His financial problems were getting worse. At the end of the year, he sold his life insurance at a loss of 50 percent, and traveled with the other children to join his wife. The luggage contained not only his own unsold paintings, but also his complete collection of Impressionists. Gauguin would rather have sold his last shirt than one of the Cézannes.

Madame Mette Gauguin in Evening Dress, 1884. Nasjonalmuseet, Oslo

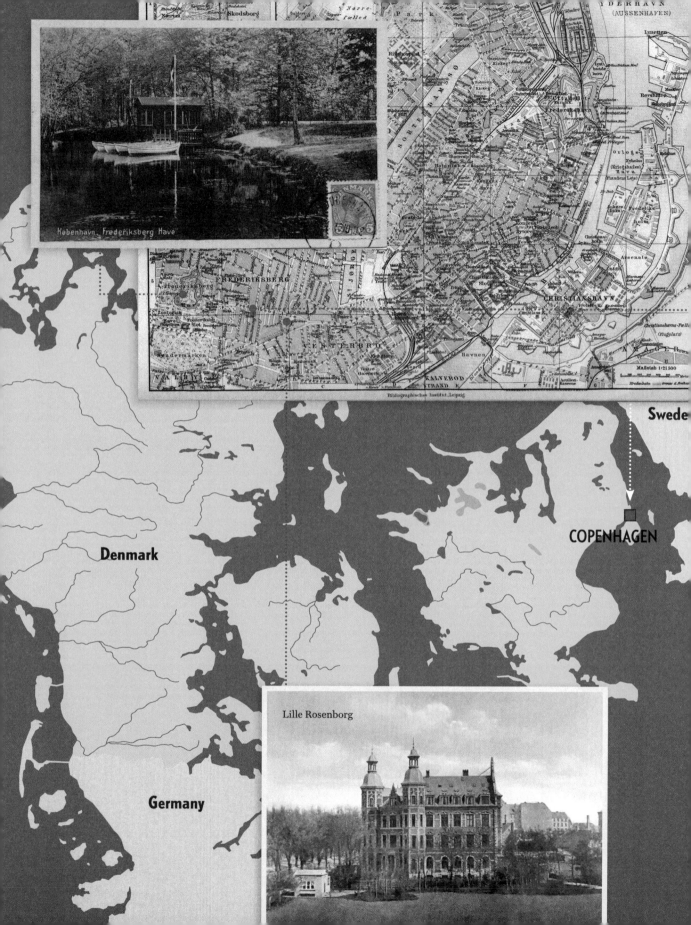

København. Frederiksberg Have

Swede

COPENHAGEN

Denmark

Germany

Lille Rosenborg

Copenhagen

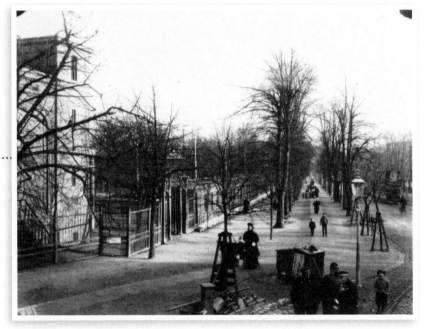

Frederiksberg Allé

WINTER IN DENMARK

In November 1884, Gauguin arrived in Copenhagen. He moved into his mother-in-law's apartment, where Mette and their five children were also staying. The respectable Madame Gad lived on the third floor of the castle-like Lille Rosenborg on Frederiksberg Allé, the Champs-Élysées of Copenhagen. This tree-lined avenue was originally the driveway to the royal summer palace through equally royal gardens, which had since been opened to the public as a park. One of the ponds in the park inspired Gauguin to make *Skaters in Frederiksberg Park*, one of his first works in Denmark. He probably painted much of it indoors, as it was around fifteen degrees when Gauguin arrived in Denmark. He noted that the people on the streets moved around on sleds, and he wrote to his teacher, Pissarro, that he had already seen a number of typical local subjects in Copenhagen that were worth painting. In mid-December, the Gauguins, their five children, and their painting collection moved to an apartment of their own. Gauguin set to work in good spirits. Before leaving France, he had already found a position as the Scandinavian representative for the company A. Dillies & Cie from Roubaix. On behalf of this textile company, he sold heavy waterproof fabrics that functioned as tarpaulins for trains and boats.

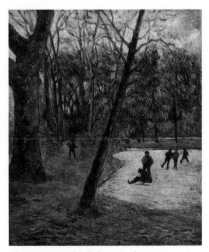

Skaters in Frederiksberg Park, 1885.
Ny Carlsberg Glyptotek, Copenhagen

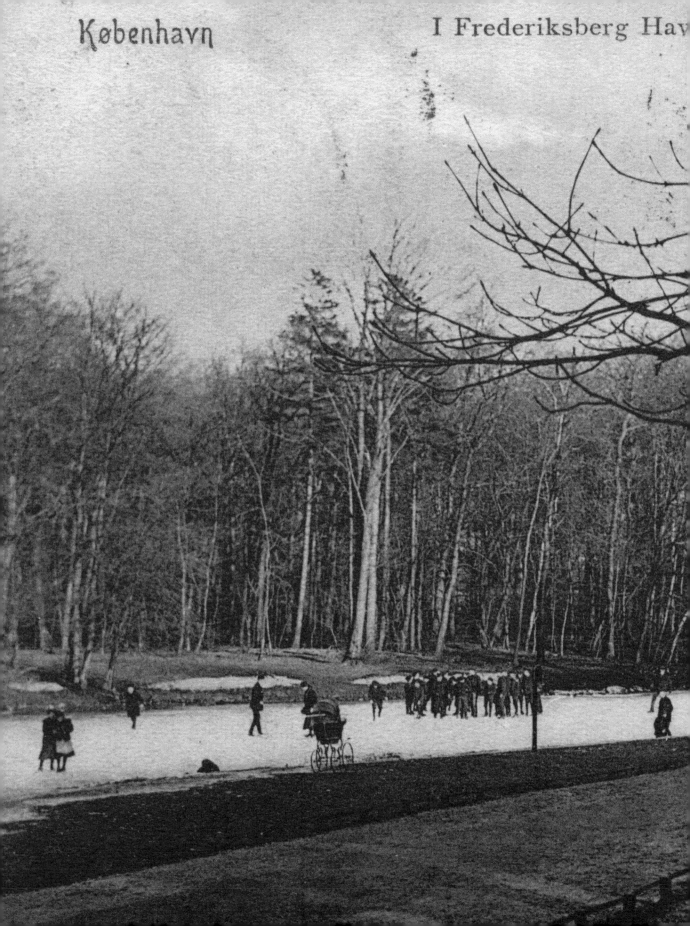

København I Frederiksberg Hav

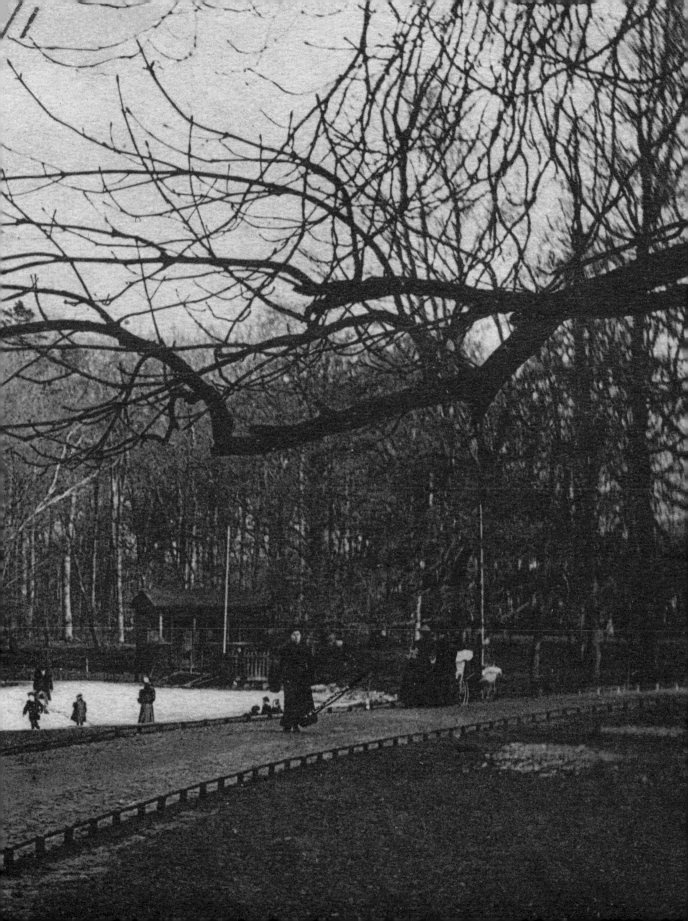

As Gauguin did not speak the language, his brother-in-law helped him to approach potential customers in Denmark and Norway. On several occasions, Gauguin asked Messieurs Dillies in Roubaix urgently to send some more samples of the tarpaulin and—far more importantly—an advance. After all, he had to be able to take the customers out for meals and pay the import duties when the goods arrived in Denmark from France.

In addition to his work as a representative, both Gauguin and Mette gave French lessons to keep their heads above water. "You'll surely laugh at me," Gauguin wrote to Schuffenecker. "Me, teaching French!" Mette had been very bad-tempered lately, he continued. This was because of the constant lack of money. She had suffered a blow to her pride, in her own country where "everyone knew everyone else." Gauguin always received the same reproach from her. If he had not insisted on painting, he would be an important stockbroker by now.

Letter to Schuffenecker and sketches on company stationery from A. Dillies & Cie

THE ATTIC ROOM

A lack of money forced the Gauguins to move again at the end of April, this time to a cheaper and smaller apartment. It was clear that the import trade in tarpaulin was not going to be a success, mainly because he did not speak Danish. He also fell out with his brother-in-law. Every now and then he was forced to send a painting from his collection to Durand-Ruel in Paris to be sold. When diplomats from the Ministry of Foreign Affairs arrived for their French lessons with Mette, Gauguin withdrew to a room in the attic to paint. Mette and her respectable relatives were ashamed of this bohemian who appeared unable to take care of his family.

Painting was no picnic for Gauguin in Copenhagen. He could not work outside because of the cold. The German paint that was available in Copenhagen was inferior to the French paint. While he

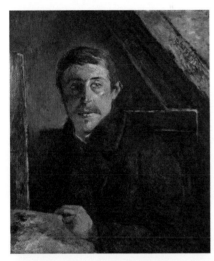

Self-Portrait, 1885. Kimbell Art Museum, Fort Worth

heard Mette downstairs, laughing with her sophisticated students, he sat in the attic with his winter coat on. That is where he painted a gloomy-looking self-portrait, gazed at the Pissarros and Cézannes in his shrinking collection, and created landscapes from memory. In Copenhagen, he also started writing. In a notebook that he had purchased in Rouen, he put into words his thoughts about painting, the most beautiful of all art forms, under the title of *Notes Synthétiques*. Gauguin argued it was important to paint outside, as the Impressionists and his teacher Pissarro always did, but that the painter's real work took place after that, in the studio. Art was not so much about realism or lifelike reproduction, but about what the artist subsequently added, in terms of ideas and symbols.

These almost prophetic words did not apply to the work he made in Copenhagen, but were all the more true of his later paintings.

AN EXHIBITION

When spring finally came, the tide seemed to turn. Gauguin was allowed to exhibit at the Kunstforeningen, an independent artistic society that had been founded by artists who were dissatisfied with the elitist Royal Danish Academy of Fine Arts. The aim was to make art accessible to a wide audience. But, like everything that Gauguin attempted in Copenhagen, this exhibition was a failure. There was no catalogue, and the exhibition lasted only five days, much to Gauguin's anger. "Canceled on the instructions of the scandalized Royal Academy," he wrote to Schuffenecker. He claimed that newspapers had been put under

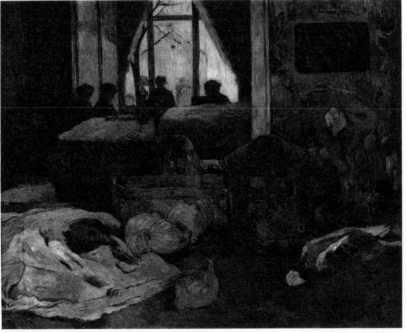

Still Life with Interior, 1885. Private collection

pressure from above not to review the exhibition and that he even had to have his frames made by a coffin manufacturer, as the official framers refused to accept work from him. They were afraid of losing their other customers. "And this is the nineteenth century!" fumed Gauguin. What he did not mention was that exhibitions of work by relatively unknown artists at the Kunstforeningen changed on a weekly basis. Perhaps he had misunderstood, or maybe he wanted to let "Paris" know that his work had had a huge impact in Copenhagen.

He wrote to Pissarro that he was at the end of his tether. All that was stopping him from putting a noose around his neck in his attic room was the painting. "I only want to paint. Everyone hates me because I paint, but it is the only thing I can do." The memoirs that Gauguin wrote at the end of his life—when he had had some time to cool off—contain an entire

essay that begins with the sentence "I hate Denmark, its climate, and its people." He goes on to list everything else that was wrong with Denmark. He criticized the stuffiness of middle-class Danish interiors, the small-mindedness of its Protestantism, the prudery and frumpishness of Danish women, and, of course, the Danish attitude to art. Although he was also honest enough to admit that Madame Gad could make excellent game and fish dishes, that he had noticed that Danish hospitals were very modernly equipped, and that the Danes were quite good at dancing. He had not had enough time to form an opinion about Danish literature during his time in Copenhagen.

Gauguin wanted to return to France. His youngest son, Pola, who was not yet two when his father left Copenhagen in early June 1885, wrote in his book *My Father, Paul Gauguin* that it was a calm good-bye, without tears or promises. Paul and Mette knew that a temporary separation was the best option for both of them. The plan was that he would settle in Paris for the time being, with their six-year-old son, Clovis, and that he would work there. He left much of his collection of his own paintings and works by other artists with Mette. These would eventually end up in Danish museums.

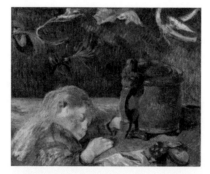

Clovis Gauguin Asleep, 1884.
Private collection

Aline Gauguin and One of Her Brothers, 1883. Private collection

Dieppe

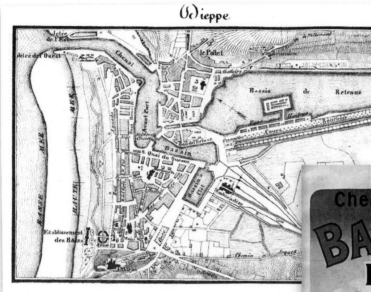

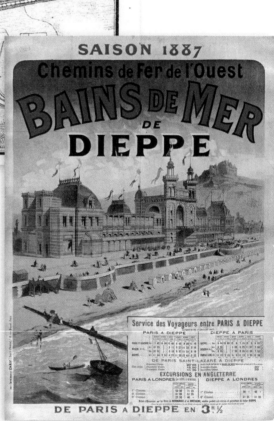

SUMMER BY THE SEA

After their arrival in Paris, Gauguin and Clovis moved in with Schuffenecker and his family on Rue Boulard, and Gauguin asked around and actually found some work. He would be able to assist a sculptor who was about to receive a large commission. It was just a question of waiting a while. Gauguin thought it would be better not to do so in the expensive city of Paris. So he took Clovis to stay with his sister, and he caught the train to the seaside town of Dieppe. He had heard in Paris that Degas and a bunch of his followers were spending the summer there, and he expected to be able to join them without any problems.

The town of Dieppe, Normandy, was at that time a busy stop between Paris and London. Travelers departed from Gare Saint-Lazare in Paris and were in Rouen less than three hours later. They changed trains, then it was another hour to Dieppe. A regular ferry service took the traveler, weather permitting, to Newhaven in England in five hours, after which the journey could be continued by train to Victoria Station in London. Traveling from one capital city to the other took eleven and a half hours. The route via Calais and Dover was somewhat faster, but also far more expensive, as miles by rail cost more than miles by sea.

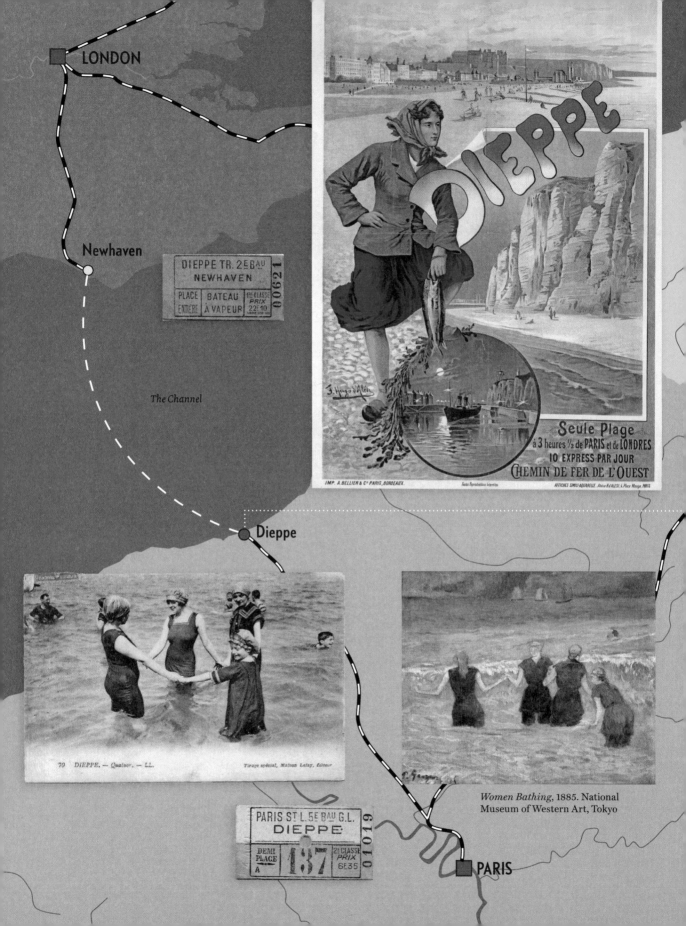

LONDON

Newhaven

The Channel

Dieppe

DIEPPE TR. 2E B AU
NEWHAVEN

PLACE | BATEAU | 1RE CLASSE
ENTIÈRE | À VAPEUR | PRIX
| | 22 10

00621

DIEPPE

Seule Plage
à 3 heures ½ de PARIS et de LONDRES
10 EXPRESS PAR JOUR
CHEMIN DE FER DE L'OUEST

IMP. A. BELLIER & Cⁱᵉ PARIS, BORDEAUX.

AFFICHES SIMILI-AQUARELLE. Atelier H. CALLE. 4, Place Monge, PARIS.

70 DIEPPE. — Quatuor. — LL.

Tirage spécial, Maison Lefay, Éditeur

Women Bathing, 1885. National
Museum of Western Art, Tokyo

PARIS St L. 5E BAU G.L.
DIEPPE

DEMI
PLACE
A | 137 | 2E CLASSE
PRIX
6 35

01019

PARIS

Waiting in Dieppe for the boat or to recover from seasickness was certainly no hardship. It was a chic seaside resort, with a casino, medieval castle, luxury hotels, and parks. The beaches were popular with both the English and the French. At the end of Rue Alexandre Dumas, the boulevard that ran along the beach, a huge chalet had been built up against the cliffs. This Chalet du Bas-Fort-Blanc belonged to the Parisian portrait painter Jacques-Émile Blanche, the son of a very wealthy psychiatrist. Just as Dieppe was a stopover point between London and Paris, Blanche was an important link between the artistic world of the two cities. Blanche was equally at home in artistic circles in London and Paris and regularly traveled between them. He was friends with both Marcel Proust and Oscar Wilde, with French painters like Degas and Manet, and also with artists who were based in England, such as John Singer Sargent and Walter Sickert. He painted portraits of many famous people. Writers and artists from both cities met in his chalet in Dieppe.

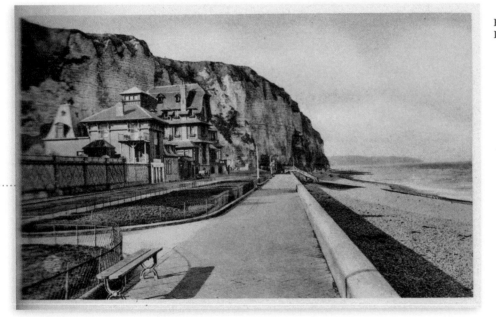

Rue Alexandre
Dumas, Dieppe

Gauguin went to paint on the beach right in front of that very house, perhaps hoping to be invited in. The bathers trying to stay upright in the waves, which Gauguin painted on the beach of Dieppe, were a theme that would later recur in his work. Blanche could see him at work from his chalet and must have watched him. In one of the books he wrote about his encounters with many famous artists, he remembered Gauguin's peculiar face, his strange appearance, and particularly his wild gaze, which, as Blanche had learned from his psychiatrist father, was a sign of megalomania. Blanche Junior's diagnosis was insanity or alcoholism. Gauguin was not invited into the chalet where Degas was a frequent guest.

PASSPORT

The American travel guide *Harper's Hand-Book for Travellers in Europe and the East* warned the traveler that there could be a lot of trouble with passports in Europe. Usually a casual comment such as "Je suis américain" was sufficient, but when there was the slightest political tension, travel documents were suddenly checked very strictly. Passports, whether they were American, British, or French, did not yet have photographs, but they did have a list of facial features. Shape of head, eyes, nose, mouth, chin, hairstyle, beard, mustache, skin color, and complexion: everything was described in detail. Americans were urged not to take this list lightly; everything had to be exactly right. The smallest blunder in your documents might necessitate a trip to the consulate, with all the associated costs and loss of

time. It was, however, possible for a whole family to travel on one passport, including staff, if necessary. You could take 110 pounds of luggage for free, barring local differences. There were few checks on contraband, although, according to *Harper's Hand-Book*, travelers had to be very careful with cigars. Apparently trade of tobacco was more strictly regulated than other goods in that period. The whereabouts of Gauguin's passport is unknown. However, in the navy, he was described in 1868 as follows: Height: 1 meter 630 millimeters (just over five foot four inches); hair color: chestnut brown; eyes: brown; nose: average; forehead: high; mouth: average; chin: rounded; face: oval. He may have had discussions about his nose at border crossings. His self-portraits show that it was not exactly average, but enormous.

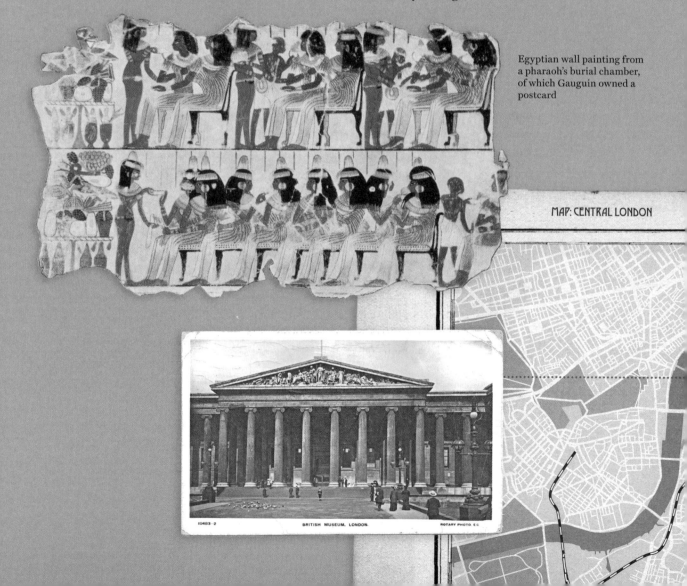

Egyptian wall painting from a pharaoh's burial chamber, of which Gauguin owned a postcard

MAP: CENTRAL LONDON

10483-2 BRITISH MUSEUM, LONDON. ROTARY PHOTO. E.C.

London

BRITISH MUSEUM

Little is known about Gauguin's stay in Dieppe, where he painted twenty-two landscapes and two still lifes. For example, it is not clear where he stayed. He also went on a two-week trip to London while he was there, to visit a friend, and he most likely paid a visit to the British Museum. This is suspected because he owned postcards with images of items that were on display at the museum, including Egyptian and Greek objects, elements of which later recurred in his work.

He had one postcard of a wall painting from 1350 BCE that was found in the burial chambers of a pharaoh. Henry Salt, an Egyptologist and the British consul in Cairo, had sold sections of these wall paintings to the British Museum in the 1820s. Salt employed people to dig up the treasures of ancient Egypt for him. He sold thousands of objects to the British Museum and to the Louvre, depending on which museum made the better offer.

When he returned to Dieppe, Gauguin ran into Degas, who was amazed to see Gauguin there and immediately invited him to visit. A few days later, Gauguin saw him at work in Blanche's chalet on Rue Alexandre Dumas. He plucked up courage and rang the doorbell. The maid who answered the door was sorry to inform him that Monsieur Blanche and Monsieur Degas were out. In October, Gauguin found time to return to Clovis in Paris. As he was about to set off, he received a letter in Dieppe: the job with the sculptor had been given to someone else.

The Egyptian Gallery at the
British Museum in London

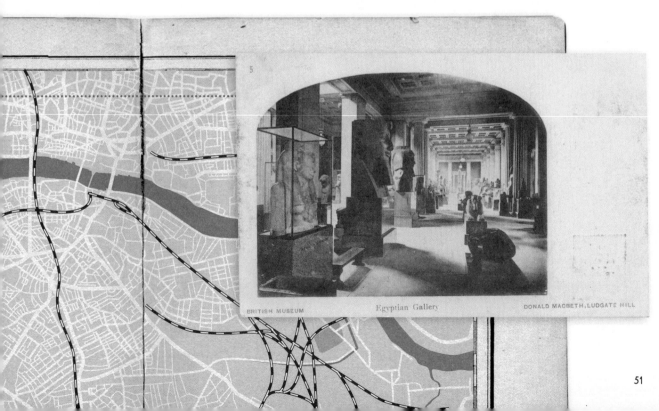

DIEPPE. — Rue Alexandre Dumas.

Jacques-Émile Blanche's
Chalet du Bas-Fort-Blanc

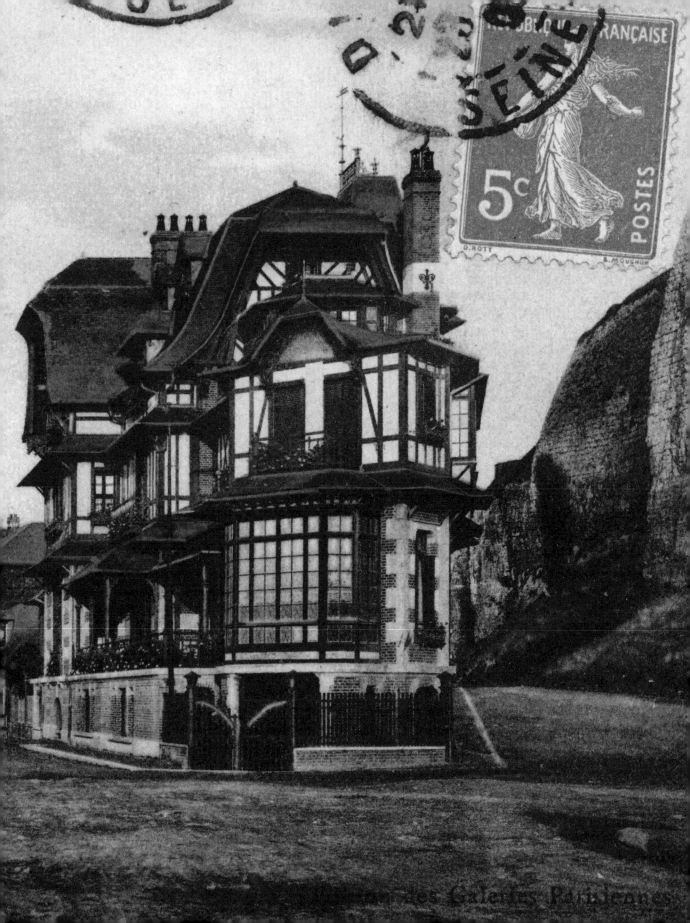

Paris II

DOWN AND OUT

When Gauguin returned to Paris in October 1885, he had serious financial problems. He sold a Pissarro and a Renoir and found a shabby room on Rue Cail, a street sandwiched between the rails of Gare du Nord and Gare de l'Est. He rented a bed for Clovis and slept under a travel blanket on a mattress on the floor himself.

"Four walls, a bed, a table, no fire, no company," Gauguin complained to Mette, who reported in a letter about her own situation as a single mother who had to feed four children. "Clovis bears it well when all we have to eat in the evening is a slice of bread and ham. He never talks about the treats he always used to get. He says nothing, asks nothing, not even if he can get down from the table to play, then he goes to bed. . . . He's growing fast, but he's not very healthy." Clovis was indeed not well; he was suffering from smallpox. When he eventually recovered, Gauguin enrolled him at a boarding school on the outskirts of Paris. That way at least he knew for certain that Clovis would be well fed.

Gauguin finally found a job, this time putting up posters at Paris stations for the Societé de publicité diurne et nocturne, where, to the boss's amusement, he turned up in a suit to apply for the job. A ban on posters had recently been lifted in France. Combined with rapid developments in the printing sector, this meant that Paris was plastered with posters with a wide range of messages. No wall or fence was safe from the posters.

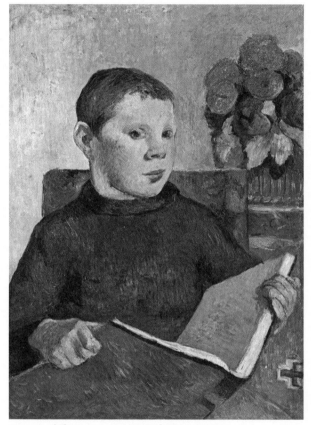

Portrait of Clovis, ca. 1886. Newark Museum, NJ

Gauguin earned five francs a day, but his boss soon realized that he was capable of more. He offered him a job as an inspector, which meant Gauguin would earn considerably more. This offer came at around the same time as news from Pissarro that the Impressionists were organizing an eighth Impressionist exhibition. Gauguin immediately resigned. He was thirty-seven and ready for his breakthrough.

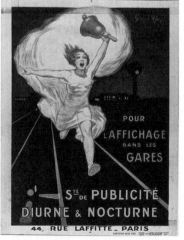

Poster for the company that employed Gauguin

Rue Lafitte. The eighth Impressionist exhibition took place at number 1, which was also where Gauguin worked for Bertin, the stock trader.

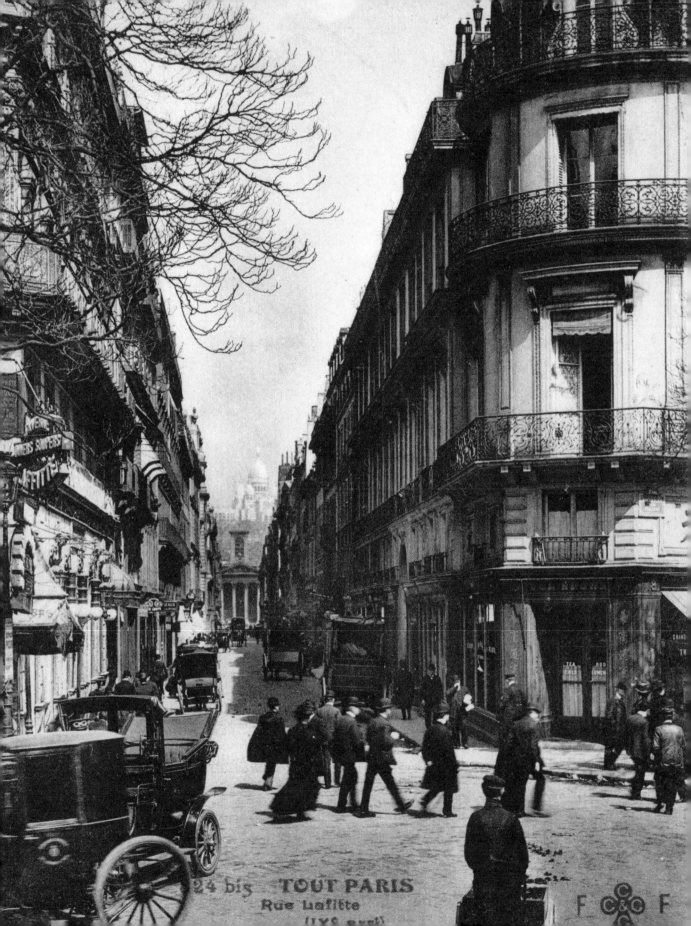

24 bis TOUT PARIS
Rue Lafitte
(IXᵉ arrᵗ)

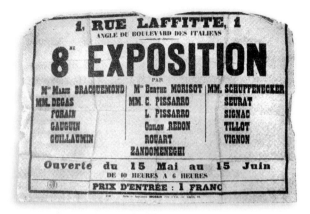

AFTER IMPRESSIONISM

The eighth Impressionist exhibition was held in 1886 at Maison Dorée on the corner of Rue Lafitte, which happened to be the same building where Gauguin had worked on the second floor for the stock trader Paul Bertin. It was to be the last Impressionist group exhibition. Degas and Pissarro had invited a number of young artists, so some of the painters who had originally participated, such as Renoir and Monet, chose not to partake. Cézanne had not taken part in the exhibition for some time. For Vincent van Gogh, who had just come to live in Paris and had never stood in front of an Impressionist painting before, this was initially a bitter disappointment. When he first saw it, he thought the Impressionist art he had heard so much about was "slapdash, ugly, badly painted, badly drawn, bad in color, everything that is miserable." Van Gogh would soon revise that opinion.

There were no fewer than nineteen Impressionist landscapes by Gauguin in the exhibition, which he had painted in and around Rouen, Dieppe, Pontoise, and Copenhagen. However, it was not entirely the breakthrough for which he had been waiting. Georges Seurat, a talented twenty-six-year-old artist who had been introduced by Pissarro, stole the show. He had worked for two years on a painting of more than two by three yards, which was called *A Sunday Afternoon on the Island of La Grande Jatte*. It depicted forty-eight people, three dogs, and a monkey, all enjoying a warm Sunday afternoon on a small island in the Seine. The work was built up entirely of dots. Seurat did not mix the colors on the palette, but applied them next to one another on the canvas, in such a way that they combined in the viewer's eye. This Divisionist method was developed by Seurat and his friend and fellow artist Paul Signac. Pissarro was very enthusiastic about what critics would later call Pointillism. In Pissarro's opinion, it was the only possible movement that could develop from Impressionism. He, his son Lucien, and Schuffenecker also began to experiment with Seurat and Signac's technique. Even Gauguin made an attempt, although he soon gave up.

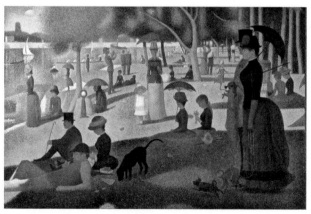

Georges Seurat, *A Sunday Afternoon on the Island of La Grande Jatte*, 1884–86. Art Institute of Chicago

Center: the building with Seurat's and Signac's studios, where the argument between Seurat and Gauguin took place

Not long after that, Gauguin became embroiled in an argument with Seurat. The reason for this was Paul Signac's studio at 130 Boulevard de Clichy, where Gauguin was allowed to work in Signac's absence. Seurat, who hired the adjacent studio, refused to give Gauguin the key. He knew nothing about their agreement and thought Gauguin was coming to copy his friend's art. Pissarro also got involved and took Seurat's side in this escalating row. Pissarro was spending increasing amounts of time with Seurat and Signac, while Gauguin was becoming closer to Degas. Gauguin thought Pissarro was just a follower now and that there was no unity or personality left in his work. He called Seurat "a little green chemist who piles up tiny dots."

"Gauguin left the café without saying good-bye to me and Signac," Pissarro wrote to his son Lucien. He complained about Gauguin's cold ambition, his sales tricks, his competitive attitude, and his bossiness. Things would never be entirely right again between Gauguin and his teacher. Gauguin's work at the eighth Impressionist exhibition may not have been a huge hit, but he did sell three works. With that money and the occasional loan, he could pay for Clovis's school and, like many other painters, leave the expensive city of Paris to spend the summer in the provinces.

Pont-Aven

La Grande Place
in Pont-Aven

Atlantic Ocean

BRETAGNE

CHEMINS DE FER DU NORD-OUEST DE LA FRANCE

Pont-Aven I

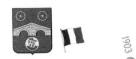
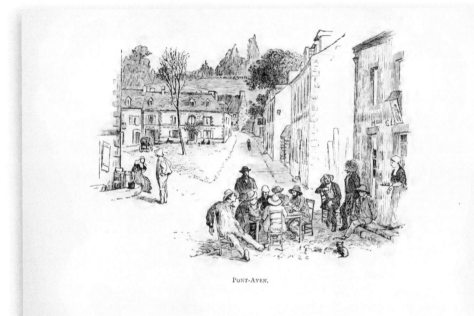

PONT-AVEN.

A group of artists in front of Pension Gloanec. Drawing by Randolph Caldecott for Henry Blackburn's travel guide

THE BRITTANY OF THE BRETONS

Gauguin had his eye on Brittany. This was not a surprising choice. For decades, artists had been going there to capture the landscape, traditions, and remnants of the Celtic period, thanks to the invention of the paint tube, which made it possible to transport paint easily, and to the train connection. Brittany was the perfect place for painters, wrote the enthusiastic journalist Henry Blackburn in *Breton Folk: An Artistic Tour in Brittany*, an 1881 guide to the places that an ambitious painter should definitely visit. The book was illustrated by the famous English artist Randolph Caldecott, whose name was later given to the prestigious Caldecott Medal for illustration. Gauguin also greatly admired Caldecott, particularly the brilliant way he drew geese. That was Gauguin's idea of drawing. He studied Caldecott's geese and, as a result, there are always a few of these creatures to be found in Gauguin's Breton works.

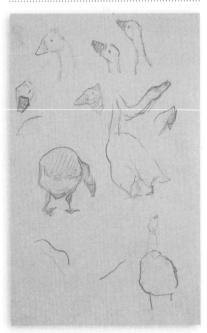

Sketches of Breton geese by Gauguin, 1886.
Art Institute of Chicago

The painter's guide particularly recommended the *département* of Finistère, the western tip of France. According to the guide, it was a backward region, but in a good way. The landscape was rougher and wilder than in Normandy, wrote Blackburn. It was less densely populated and not as popular with tourists. Nowhere in France could a purer peasant population be found; nowhere was the work in the fields carried out with such pride. And nowhere else could such picturesque ruins and hamlets be found. Blackburn went on to describe the menhir-strewn landscapes under the cloudy skies; the wild river Aven, which swirled through the village under the branches of the trees; the proud women, with their starched white caps, big collars, dark skirts, and heavy wooden shoes; and the men in their woolen jackets, baggy knee breeches and gaiters, and broad-brimmed hats, with their long hair blowing in the wind.

The headquarters of the painters was the farming village of Pont-Aven, about four miles from the southern coast. In Gauguin's day, hundreds of artists from all over Europe and America would descend upon the village in the summer. The view of one of the village's many watermills, as seen from the Bois d'Amour, was particularly popular. The main advantage of Pont-Aven was that the locals did not object to posing in their Sunday best. They would sit still for hours, for just one franc. Gauguin, too, made extensive studies of the Breton women in their intricate hats, in chalk, charcoal, and pastels. These figures appeared in his work time and again, sometimes even years later.

Breton Girl, 1886.
Burrell Collection, Glasgow

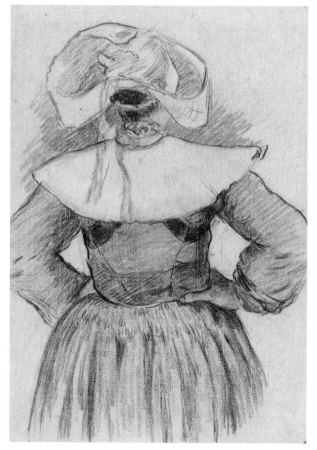

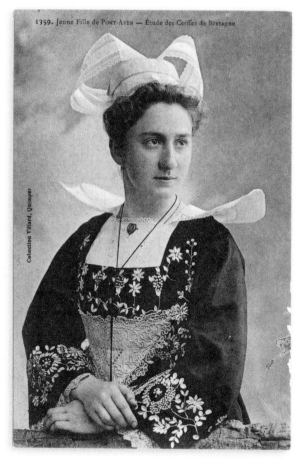

238 PONT-AVEN – La Grande Place – Les Hôtels

La Grande Place
in Pont-Aven, with
Pension Gloanec
on the right

Below: Sketches of seated
Breton women, 1886. Left:
Musée du Quai Branly,
Paris; right: Art Institute
of Chicago

PENSION GLOANEC

Gauguin could not afford to be very choosy. He had picked Pont-Aven because the guesthouse run by the widow Marie-Jeanne Gloanec on La Grande Place was so cheap and, as he had heard in Paris, you could even stay there on credit. If Clovis remained at his boarding school over the summer, Gauguin could just about manage.

Pension Gloanec was indeed the perfect place for the true bohemian, according to Blackburn's travel guide for artists. The other two hotels in Pont-Aven were cheap, but Gloanec beat them all: sixty francs a month, including two good meals with cider every day. With a little creativity, Gloanec could accommodate around fifty guests. The rooms were clean, there was art on the walls, and in the mornings and evenings, both unknown and renowned artists, sometimes even world-famous ones, would sit around the same table outside, talking about art. This continued in the bar until they were finally sent to bed at around midnight, as the staff wanted to sleep. "If only we had gone to Pont-Aven back then," Gauguin wrote to Mette. He calculated for her how much cheaper the houses in Brittany were than in Rouen. Gauguin wrote that he was still as thin as a rake, but that with every bite of the good meals at Pension Gloanec he was putting on weight and feeling better. He planned to stay and work in Pont-Aven for at least a year.

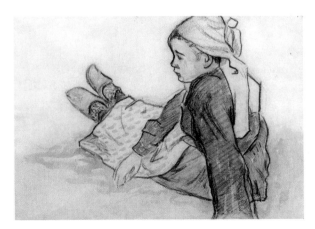

The Scottish painter Archibald Hartrick, who spent that same summer at Gloanec, remembered that Gauguin often dominated the conversation. He described him as a handsome and confident man who went around dressed as a Breton fisherman in a beret and who liked to shock people.

He once saw Gauguin, on a warm day, roaring with laughter as a rowboat pulled him along on a rope like a dead porpoise. He could well imagine that people were afraid of him.

Gauguin wrote to Mette: "I am working hard here, and with results. I am the best painter in Pont-Aven, although of course that does not earn me a cent. Maybe in the future. In any case, I am respected here, and everyone here (Americans, English, Swedish, French) wants my advice. I am also foolish enough to give it to them."

The kitchen of Pension Gloanec, 1892

Breton Peasant Women, 1886. Neue Pinakothek, Munich

Right: Sketches of ceramic works by Gauguin, 1886. Art Institute of Chicago

Paris III

MONSTROSITIES

At the end of the fall, most of the artists left Pont-Aven. The evenings at Gloanec were dull and lonely now, Gauguin complained in his letters. Soon his intentions to stay in Pont-Aven for at least a year were forgotten, and he returned to Paris. When he got there, he took Clovis out of boarding school and sold a small work by Jongkind for 350 francs. He rented the cheapest room he could find and tried to come up with a plan. Maybe, he thought, there was money to be made in ceramics.

Gauguin had already been introduced to Ernest Chaplet, a pioneer in late nineteenth-century French ceramics. Chaplet had been trained at the porcelain factories in Sèvres, but a stay in Normandy showed him the beauty and the possibilities of the much cheaper stoneware that was used there. He experimented with it in his studio on Rue Blomet. As had also been the case with the marble busts of Mette and Emil, Gauguin swiftly mastered these unfamiliar ceramic techniques. First, Gauguin decorated the

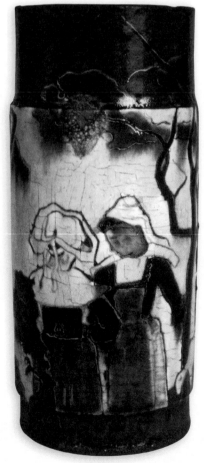

Vase, 1886–87. Koninklijke Musea voor Schone Kunsten van België, Brussels

Ceramics by Gauguin
from 1886 and 1887

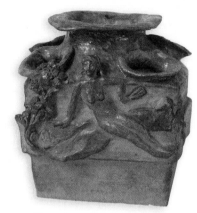

Cleopatra pot
Van Gogh Museum, Amsterdam
(Vincent van Gogh Foundation)

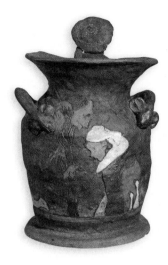

Untitled 52
Private collection

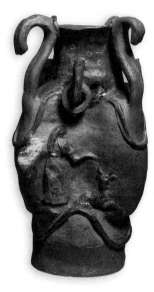

Pot with Women and Goats. The
Metropolitan Museum of Art, New York

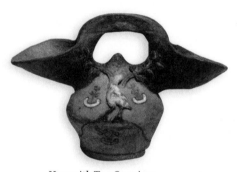

Vase with Two Openings
Petit Palais, Musée des Beaux-Arts
de la Ville de Paris

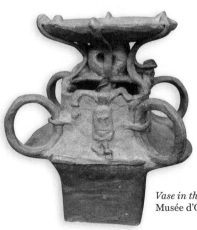

Vase in the Shape of a Fountain
Musée d'Orsay, Paris

objects that Chaplet made on his potter's wheel; then, he ventured to make the pieces himself, assembling them by hand. Within a short space of time, he made fifty-five pots, decorated with the motifs he had seen in Brittany. Breton women in their caps and with their hands on their hips and with their geese: they reappeared in a simplified form in relief or in the glaze on these pieces. Sometimes the pots were given four handles or two spouts, or one or more faces. Gauguin wrote to Mette: "I am now making ceramic sculptures. Schuffenecker and the ceramicist say that they are masterpieces, but they are probably too artistic to sell."

"You will probably yell when you see these monstrosities," Gauguin wrote to an acquaintance. They were unique objects that in no way resembled what the French ceramicists were making. An art critic who once went to look at the work immediately recognized the Inca influences: Gauguin's ceramic work was an interpretation of the pre-Columbian ceramics of Peru, which also incorporated people and animals. The critic was very enthusiastic. He actually thought the pieces were better than Gauguin's paintings. "It is a pity though," he wrote, "that the artist was such a thoroughly unpleasant individual." Gauguin just shrugged his shoulders. He was, after all, a wild man from Peru.

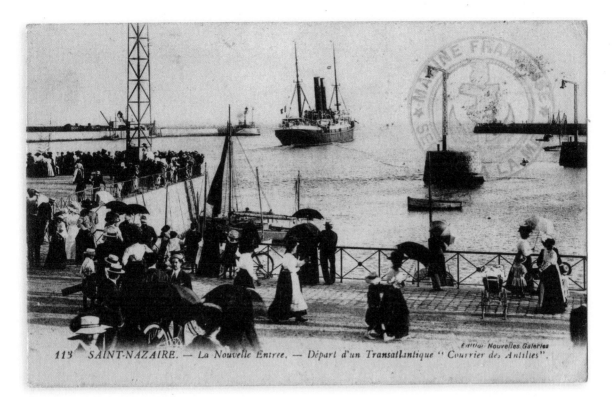

113 SAINT-NAZAIRE. — La Nouvelle Entrée. — Départ d'un Transatlantique " Courrier des Antilles".

A Compagnie générale transatlantique ship leaving Saint-Nazaire, ca. 1900

AWAY FROM FRANCE

For "un homme pauvre," a poor man like Gauguin, Paris was a "dry desert." He was soon making plans to go traveling again. This time he wanted to go much farther away, to an exotic paradise, where he could live in nature. At first, he had plans to go into business in Guadeloupe or Madagascar, but it ended up being Panama. In 1881, the French had embarked on a huge project there: digging a canal, over fifty miles long, straight through the Colombian province of Panama, along the railroad line that had previously been built there by the Americans. During his days as a stock trader, Gauguin had made a lot of money on his shares in the project. Gauguin knew it was possible to find a job in Panama within three days. If he could not get a post with the Compagnie universelle du canal interocéanique de Panama, there was still money to be earned via his brother-in-law, Juan Uribe, a Colombian businessman who lived in the capital. Given his extensive experience as a stock trader, Gauguin expected to be able to pick up his financial career again. His traveling companion, the academically trained painter Charles Laval, would be able to accept commissions for portraits in Panama. They would not need much money because, as Gauguin believed, the food grew on trees. When he went to say good-bye to the Schuffeneckers, he suddenly found himself face-to-face with Mette. It was an awkward encounter. Mette had come to Paris to fetch Clovis, without telling her husband, as she was afraid of getting pregnant again.

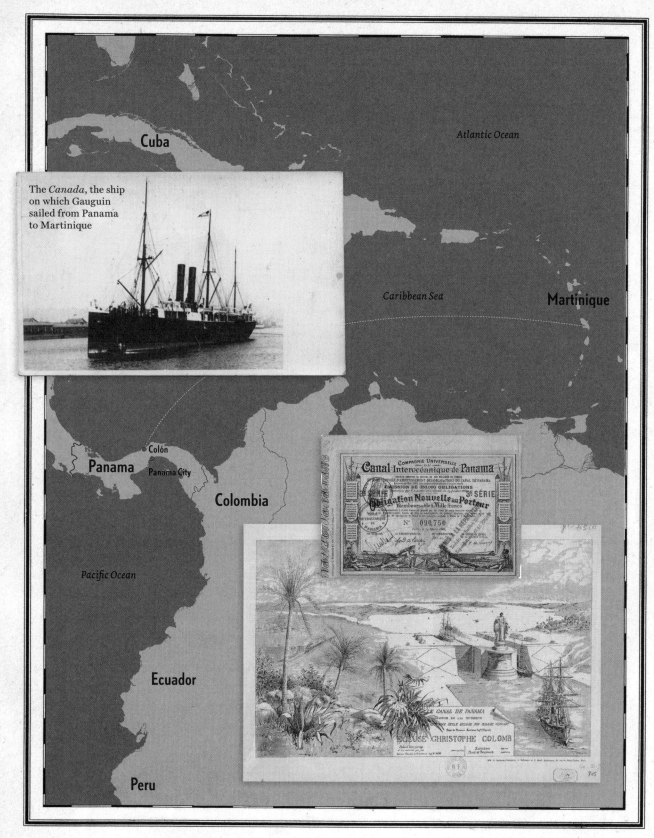

Cuba

Atlantic Ocean

The *Canada*, the ship
on which Gauguin
sailed from Panama
to Martinique

Caribbean Sea

Martinique

Colón

Panama

Panama City

Colombia

Pacific Ocean

Ecuador

Peru

Panama

Excavation work on
the Panama Canal

A MUDDY HELL

"We are in completely the wrong country!" Gauguin wrote to his friend
Schuffenecker, soon after stepping ashore in Panama. It was raining.
Panama was a muddy hell, full of excavators, locomotives, and dredg-
ing equipment, all powered by steam. Colón was a harbor town next to
a swampy river delta. Due to the work on the canal, the population had
exploded from 3,000 to 21,000 inhabitants, far too quickly, and bar-
racks had been built for the laborers, often adventurers who came to
work from all over the world. Fires and insurrections among the work-
ers occurred on a daily basis. Gauguin noted that the police had difficulty
keeping order in Colón. After being caught urinating in public, Gauguin
was taken to the police station by two police officers, a two-hour walk,
and then they sent him away with a fine. "They walk five steps behind
you, everywhere you go," wrote Gauguin. "If you make one wrong move
here, you get a bullet in your head."

A visit to the island of Taboga, off the coast of Panama City, was a dis-
appointment. Gauguin had heard that it was an island paradise, but it
was just a tourist trap. To make matters worse, Uribe turned out not to
be a successful businessman at all. He had just made a loss and was run-
ning a small store where he could not afford to have an employee. He was
not very welcoming either. Gauguin managed to get a jacket out of him
and then he was out on the street again, without a cent. Two months of
work, Gauguin resolved, and then he could go back to Martinique, where
they had made a stopover during the crossing.

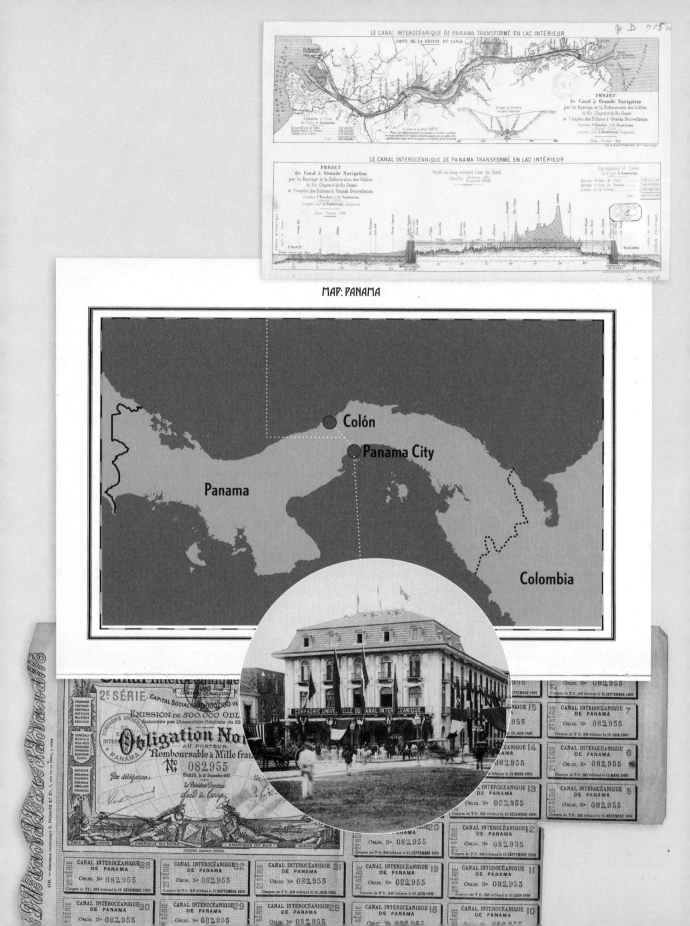

MAP: PANAMA

WORKING IN COLÓN

In 1887, when Gauguin and Laval were in Panama, the French plans for the Panama Canal were failing. The initiator, Count Ferdinand de Lesseps, also the developer of the Suez Canal, had just backtracked on the idea that he could build a Panama Canal without locks. Gustave Eiffel, whose tower was being constructed in Paris, was willing to come up with a new design, this time with locks. But it was too late. They were practically out of money, and there were constant setbacks. One of the most serious problems was that diseases such as malaria and yellow fever were spreading. Although the city of Colón had rapidly expanded, matters such as drainage and sanitation had not grown at the same speed. Around twenty thousand people died during the Panama project, many of them as a result of disease.

The good news for Gauguin was that new workers were always needed. It was not long before he had found a job. "I have to dig from half past five in the morning until six in the evening in tropical sun and rain. At night we are devoured by mosquitos," he wrote to Mette, who had apparently complained in a letter to him about how difficult life was for her as a single mother with five growing children. However, it is hard to say if Gauguin truly stood with a shovel in the mud in Panama. The paper on which he wrote letters to Schuffenecker came from the Department of Public Works in Colón, and Gauguin is generally believed to have succeeded in finding an office job. After fifteen days, he was out of work again, as the department was shut down. A year later, the company went bankrupt. The construction of the Panama Canal was suspended for fifteen years. Then a fresh attempt was made, this time by the Americans, and the first ship sailed along the Panama Canal in 1914.

Their Panama adventure had earned Gauguin and Laval just enough money to pay for the journey back to Martinique.

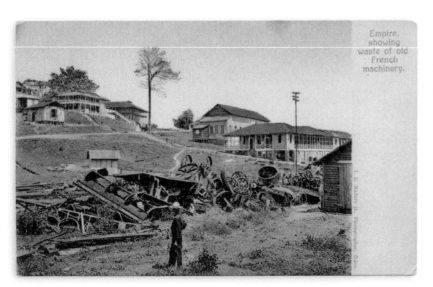

American postcard showing what remained of the old machines left behind by the French after their failed attempt to dig the Panama Canal

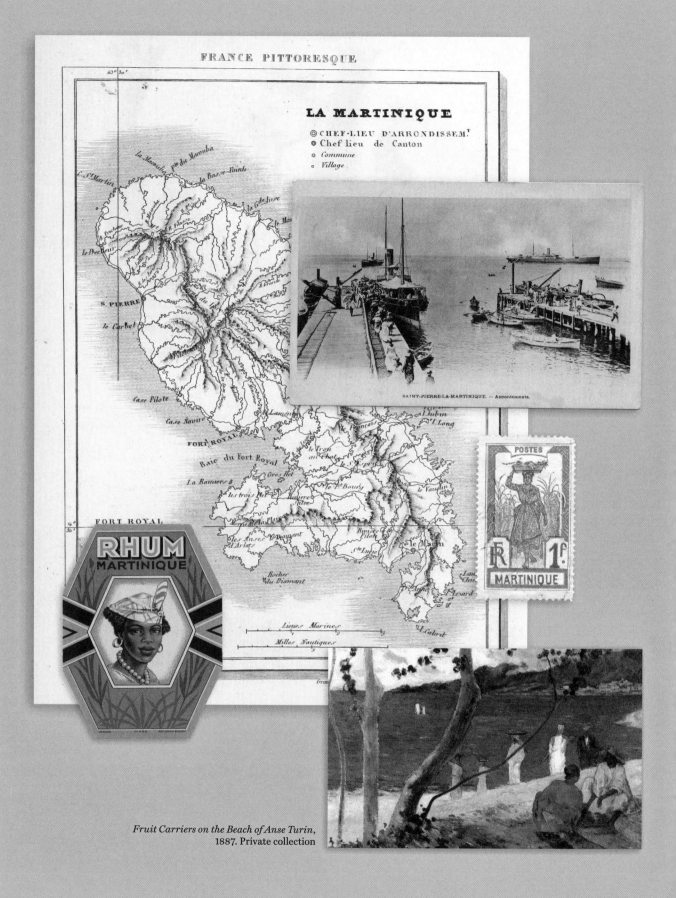

LA MARTINIQUE

◎ CHEF-LIEU D'ARRONDISSEM.^T
◉ Chef lieu de Canton
○ Commune
◦ Village

SAINT-PIERRE-LA-MARTINIQUE. — Appontements.

POSTES

RF 1.f

MARTINIQUE

FORT ROYAL

RHUM
MARTINIQUE

Fruit Carriers on the Beach of Anse Turin,
1887. Private collection

Martinique

ARRIVAL **JUNE 1887**
DEPARTURE **OCTOBER 1887**

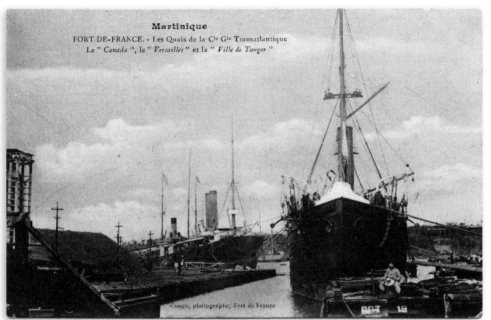

Martinique
FORT-DE-FRANCE. - Les Quais de la Cⁱᵉ Gⁱᵉ Transatlantique
Le " *Canada* ", le " *Versailles* " et la " *Ville de Tanger* "

Gauge, photographe, Fort de France

Ships of the Compagnie générale transatlantique in the harbor of Fort-de-France, Martinique. Foreground, the *Canada*

PETIT PARIS

Saint-Pierre in 1887 was "the sweetest, queerest, darlingest little city in the Antilles," wrote the Greek-Irish journalist and cosmopolitan Lafcadio Hearn. He was living in Martinique when Gauguin was staying there, and it is quite possible that they met. Hearn gave a beautiful description of how the traveler, leaning on the rail of his ship, saw Saint-Pierre coming into view, and he did not stint on the adjectives. It was as if the city had slipped from the flaming greenery and the purplish shadows of the then-dormant volcano Mount Pelée and down to the coastline. The yellow of the houses, red of the tiles on the roofs, and white of the cathedral towers formed a striking contrast with the blue of the tropical sky, wrote Hearn. The city was founded back in 1635 by the French, who had driven out or murdered the original inhabitants. In the nineteenth century, it became so prosperous as a result of the sugar industry and the slave trade that it became known as the Paris of the Caribbean, and Saint-Pierre was as French as could be, with a Rue Victor Hugo, squares with fountains, a Jardin des Plantes with a waterfall, luxurious hotels, a Notre Dame–like cathedral, and a large theater with eight hundred seats. The most celebrated artists from Paris liked to come to Martinique to perform operas, plays, and concerts.

But Gauguin and Laval had not fled Paris and traveled to Martinique via Panama in order to find themselves in a second Paris. They could not afford that either. On a plantation just outside the village of Le Carbet, two miles from Saint-Pierre, they found an abandoned slave hut where they could live for free.

Huts of former slaves, like the ones around Le Carbet

154

20569 T Luxuriant Tropical Verdure along the Canal, Fort de France, Martinique, F.W.I.

Meadville, Pa., New York, N.Y., Chicago, Ill., London, England.

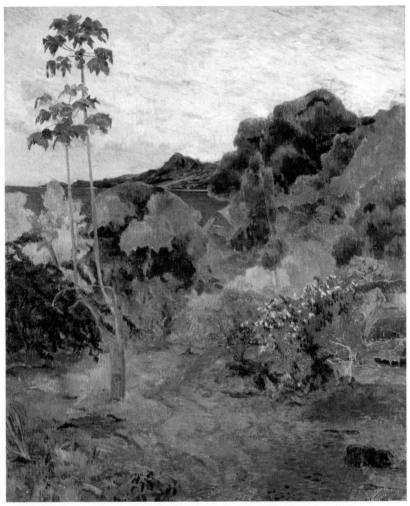

Martinique Landscape, 1887. Scottish National Gallery, Edinburgh

IN PARADISE AGAIN

Gauguin and Laval lived in Le Carbet among the descendants of Africans who had worked in the sugar plantations until slavery was abolished in 1848. "It is paradise here," Gauguin rejoiced in a letter to Mette. Just steps from his door was the sea and the beach with coconut palms, while above him grew all kinds of fruit trees. It was exactly as he had imagined. Gauguin hoped that Mette and the children would join him in Martinique one day. She had no need to worry, as there were schools in Martinique, too, and besides, he wrote, "Europeans in Martinique are treated as if they are as rare as white blackbirds."

He captured the exotic nature of Martinique in the painting *Martinique Landscape*. It shows the view from a point on the coast, near Saint-Pierre, where the city can be seen at its most beautiful: in the sweep of the bay and against the backdrop of Mount Pelée. Oddly, there is no sign of the city in Gauguin's painting. Gauguin simply omitted whatever did not fit his image of paradise.

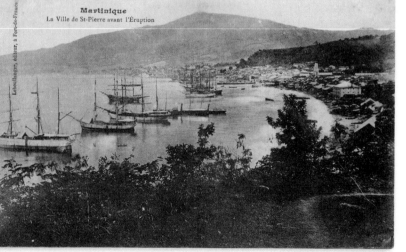

View of Saint-Pierre

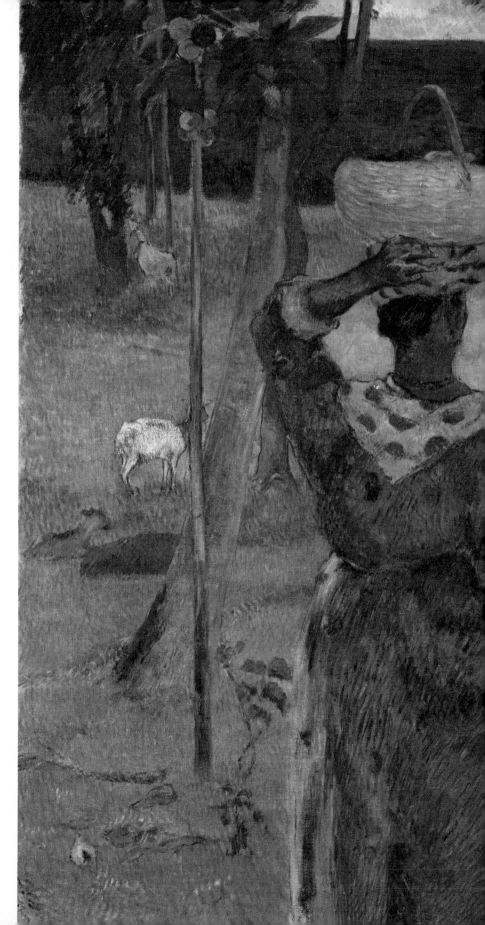

The Mango Trees, Martinique, 1887.
Van Gogh Museum, Amsterdam
(Vincent van Gogh Foundation)

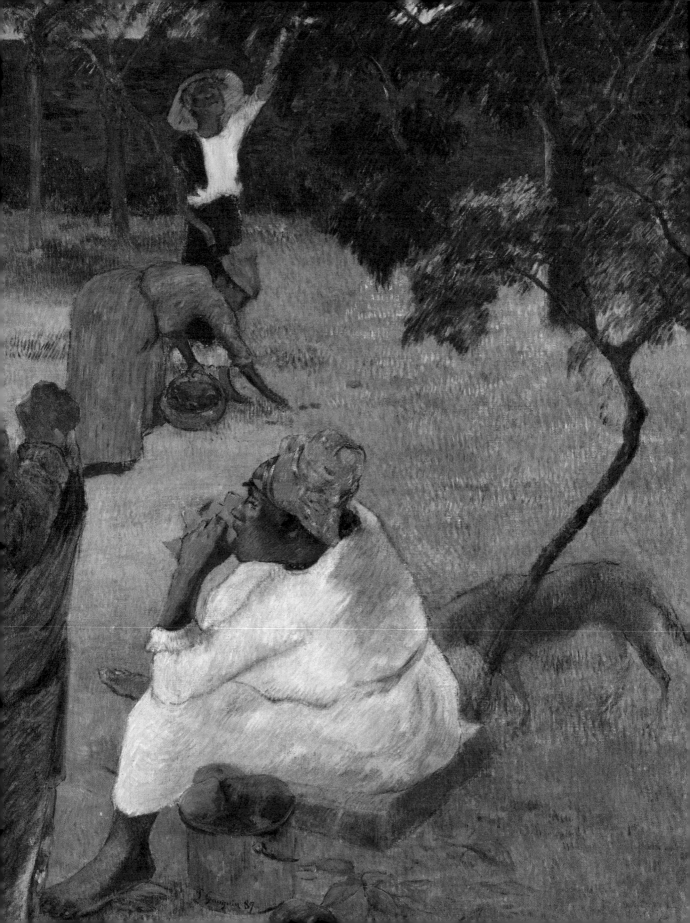

This can also be seen in his paintings of the *porteuses*, the women he often saw walking past his hut, transporting a wide variety of products to and from the market in Saint-Pierre on top of their knotted headscarves. In the late nineteenth century, these women were as representative of Martinique as rum and sugar. They appeared on stamps and rum labels and were very popular with European photographers. As soon as Gauguin arrived on Martinique, he began sketching these *porteuses*, and then they started to appear in his paintings, small at first, and becoming larger. His paintings were increasingly moving away from his Impressionist work, and from realism, too: the women whom Gauguin painted were mainly resting under trees or by the water. In reality, they were extremely industrious women who worked long days and carried heavy weights over great distances.

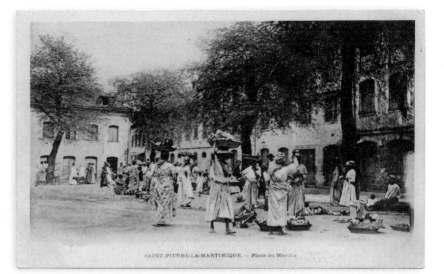

SAINT-PIERRE-LA-MARTINIQUE. — Place du Marché.

Head of a Woman from Martinique, 1887. Van Gogh Museum, Amsterdam (Vincent van Gogh Foundation)

Head of a Woman from Martinique, with Headscarf, 1887. Ny Carlsberg Glyptotek, Copenhagen

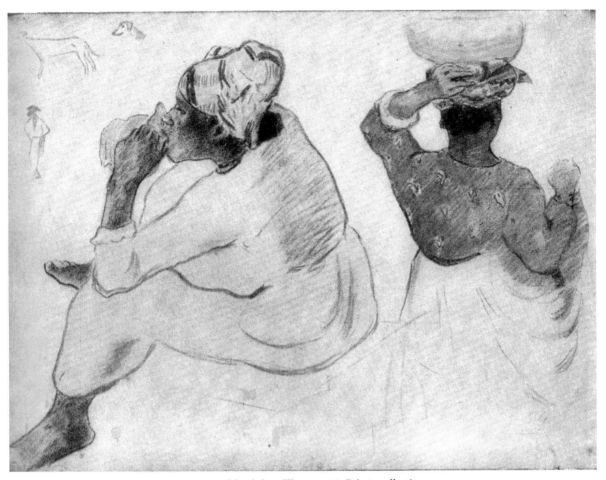

Martinican Women, 1887. Private collection

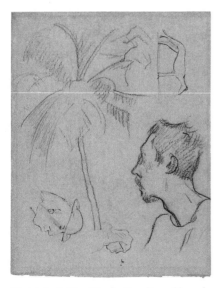

Sketch including Charles Laval's profile and
a palm tree, 1887. Art Institute of Chicago

MALARIA AND DYSENTERY

Then Gauguin became ill. He believed that he had contracted malaria
and dysentery in Panama. The doctor advised him to return to Paris
as quickly as possible. He informed Mette, who had apparently writ-
ten a letter asking him for money, that he was unable to help her, as he
was critically ill. It sounded serious. "I am a skeleton, still too weak to
whisper. I was so ill that at night I thought I was dying. Now it is get-
ting better, although I am still suffering from terrible stomachache.
What little I have to eat is incredibly painful. I can barely write, as I'm
so lightheaded. I spent the last of my money at the pharmacy and the
doctor. He said it is essential for me to return to France, at least if I
want to get better. Ah, poor Mette, I wish I were dead. That would be
the solution."

It was Schuffenecker who helped Gauguin. He sent money for his
return trip, and invited his friend to stay with him when he was in
Paris, so that he could recover.

JAPAN

In the second half of the nineteenth century, a Japan craze hit Europe, which lasted for decades and became known as "Japonism." For two centuries, Japan's borders had remained closed to all foreigners, with the exception of the Dutch. In 1853, the borders opened up and trading with Japan was once again possible. Europeans eagerly paid for lacquered boxes, bronze sculptures, and trinkets made of porcelain, ivory, and mother-of-pearl. Kimonos, parasols, fans, curtains, screens, furniture, and even entire trees were shipped from Japan. In Parisian Impressionist circles, Japanese woodblock prints became a subject of study. The first prints are thought to have come to France as packing material in a crate of porcelain. Degas and Henri de Toulouse-Lautrec started to make collections. Artists adopted stylistic elements from Japanese prints, and Japanese motifs, such as women in kimonos, found their way into French art in particular. There were dozens of Japanese and Chinese stores in Paris. One of the most famous ones belonged to Siegfried Bing, who actually had a number of branches in Paris. He imported Japanese and Chinese objects and sold them to collectors, sometimes for a lot of money, but he also had an attic full of prints that he was prepared to sell at a friendly price to the painter Vincent van Gogh. Vincent and his brother Theo built up a collection of hundreds of Japanese prints. Van Gogh actually painted copies of some of them, so that he could understand them better. He also hoped to make money by selling Japanese prints and organized an exhibition of them at his favorite café, Le Tambourin. He saw Japan as a paradise. He imagined that Japanese artists lived surrounded by nature that was full of light and bright colors, "that they loved one another and stuck together and that there was a certain harmony among them, and that by nature they led a kind of brotherly life, and not a life full of intrigues."

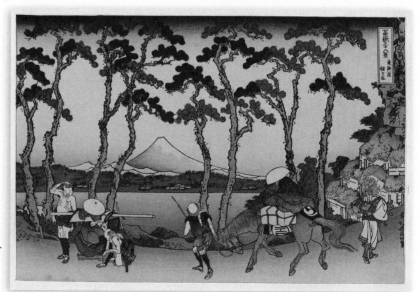

Katsushika Hokusai, *View of Mount Fuji*, 1830–32

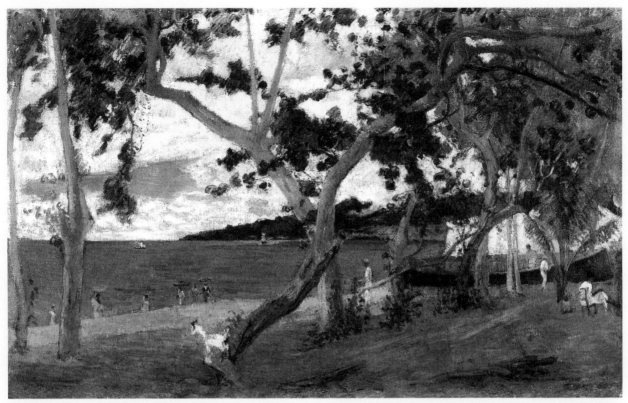

Coastal Landscape, Martinique (The Bay of Saint-Pierre), 1887.
Ny Carlsberg Glyptotek, Copenhagen

Gauguin, too, was enthusiastic about Japanese art. Around the beginning of the 1880s, he began to make an entire series of designs in the shape of fans. Japanese prints appeared in his still lifes, and Gauguin would later specialize in making woodcuts. In the Martinique works, various features typical of Japanese printed art can be seen: large areas of bright colors, trees that have been cropped, diagonals running straight across the picture, simplified figures, and unusual perspectives, sometimes even without a horizon.

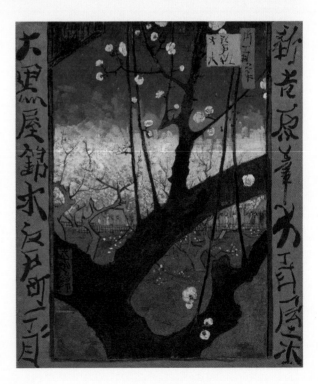

Vincent van Gogh, *Flowering Plum Orchard (after Hiroshige)*, 1887. Van Gogh Museum, Amsterdam (Vincent van Gogh Foundation)

Paris sketches by Vincent van Gogh on the menu of Grand Bouillon–Restaurant du Chalet, 1886. Van Gogh Museum, Amsterdam (Vincent van Gogh Foundation)

Paris IV

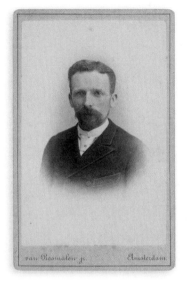

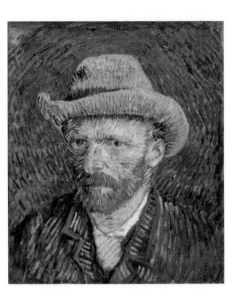

Left: Theo van Gogh, and right: Vincent van Gogh, *Self-Portrait with Gray Felt Hat*, 1887. Van Gogh Museum, Amsterdam (Vincent van Gogh Foundation)

MEETING THE VAN GOGH BROTHERS

In November 1887, newly back in Paris, Gauguin visited an exhibition at a restaurant in Montmartre. Grand Bouillon–Restaurant du Chalet was located in a former dance hall with a glass dome in the roof. It was so big that it employed around thirty waitresses. Vincent van Gogh often went there to eat, and to sketch all over the menu while he was eating. He had received permission from the restaurant's owner to put on an exhibition there. This exhibition included works by the painter Émile Bernard, whom Gauguin had previously met in Pont-Aven, and by Louis Anquetin, Henri de Toulouse-Lautrec, and the Dutch artists Arnold Koning and Vincent van Gogh himself. Van Gogh called the group the "Painters of the Petit Boulevard," because, as Montmartre painters, they distinguished themselves from the painters of the Grand Boulevard, such as the more established artists Degas, Monet, and Pissarro, who exhibited around Place de l'Opéra. At the exhibition, Gauguin saw that he was not the only artist to take inspiration from Japanese art. Van Gogh, Bernard, and Anquetin were clearly also familiar with the woodcuts. Bernard and Anquetin had even taken a step further, making the lines in their works extra thick, a convention inspired by the stained-glass windows in Breton churches. A critic dubbed this phenomenon "Cloisonnism," as it resembled a style of enamelwork in which areas of color are separated by metal wires.

Paul Gauguin in 1888

Gauguin only just made it there in time to visit the exhibition at Du Chalet. When the hotheaded restaurant owner announced that the work was not exactly improving his guests' appetites, the equally temperamental Van Gogh pulled the paintings off the walls, loaded them onto a handcart, and left the building. Van Gogh had sold nothing during the exhibition, and no reviews were published. However, he was satisfied, as he had swapped two oil sketches of sunflowers for Gauguin's *On the Banks of the River at Martinique*.

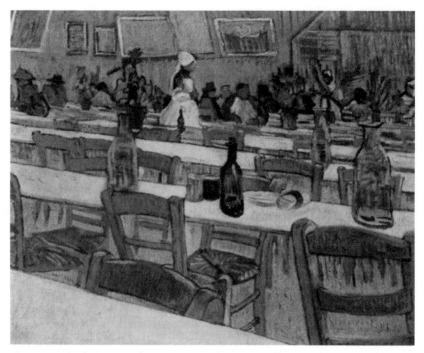

Vincent van Gogh, *Interior of a Restaurant*, 1887. Private collection. The interior of Grand Bouillon–Restaurant du Chalet on Avenue de Clichy, where the painters of the Petit Boulevard exhibited

On the Banks of the River at Martinique, 1887. Van Gogh Museum, Amsterdam (Vincent van Gogh Foundation)

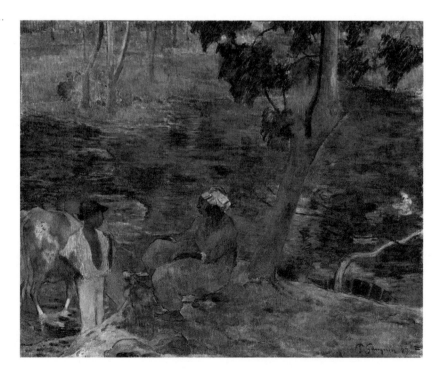

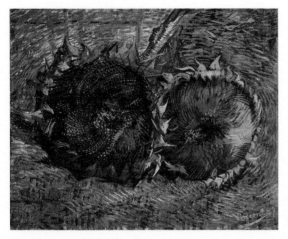

Vincent van Gogh, *Two Sunflowers*, 1887.
Kunstmuseum Bern, Switzerland

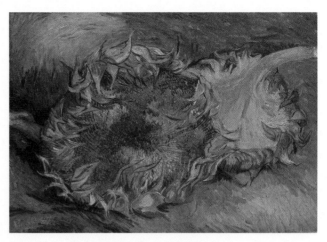

Vincent van Gogh, *Two Sunflowers*, 1887.
The Metropolitan Museum of Art, New York

Vincent van Gogh and Gauguin most likely met for the first time at the restaurant Du Chalet, but we cannot be absolutely certain. What we do know is that, at some point in December, Van Gogh went to view Gauguin's work at Schuffenecker's house, where Gauguin had been staying since his return to Paris. Van Gogh had brought his brother Theo, an art dealer at the high-end Boussod, Valadon & Cie. Theo van Gogh purchased some work by Gauguin right there and then. He not only took some ceramics and two paintings by Gauguin on consignment, but also bought a painting for the collection that he wanted to create with Vincent. That work, *The Mango Trees, Martinique*—at the time it was called *Les négresses*—cost 400 francs. It was an expensive purchase that would always hang in the most prominent place in his house, directly above the couch.

Vincent van Gogh was, if anything, even more delighted about Gauguin's work, referring to the women in *The Mango Trees* as "high-quality poetry." He had plans to go in search of the colors and the light of Japan, but Gauguin had actually gone ahead and traveled to Martinique. Van Gogh thought that Gauguin should immediately be named as the leader and teacher of the painters of the Petit Boulevard.

Receipt for the purchase of *The Mango Trees*, January 4, 1888

Pont-Aven II

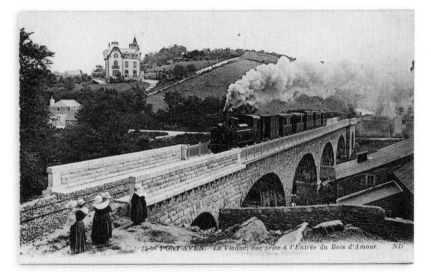

Train at Pont-Aven, ca. 1900

SICK AT PENSION GLOANEC

At the end of January, Gauguin set off once again for Pont-Aven. He wanted to stay at Pension Gloanec and further recover from the diseases he had contracted in Panama. A few weeks later, Vincent van Gogh also left the busy metropolis of Paris. He took the train to the south of France, impatiently gazing out the window to see if the landscape was becoming "more Japanese" yet. He intended to go to the town of Arles in Provence and recover from the city life of Paris, which had been far too hectic for him. There was a thick layer of snow on the ground in Arles, and Van Gogh could not wait for spring to arrive so that he could work outside. Meanwhile, he was in regular contact with his brother in Paris and with Gauguin, who had made a vague promise to come to Arles, in Pont-Aven. Vincent wrote to Theo about how badly Gauguin was doing in Pont-Aven. For weeks, he lay sick in bed in his room at Pension Gloanec, and he complained in his letters about pain in his guts, gloominess, boredom, the weather, and, above all, the agony he suffered because of his constant lack of money. Gauguin asked Vincent to ask his brother if one of his paintings had been sold yet. And might it be a good idea to reduce the price? Gauguin did not dare to bother Theo about this himself.

Breton Girls Dancing, Pont-Aven, 1888. National Gallery of Art, Washington, DC

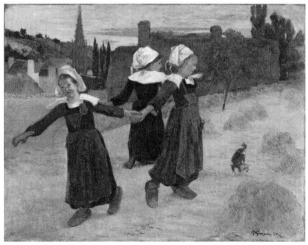

"It is not going well for poor Gauguin," Vincent wrote to his brother. "But what can we do?" In the meantime, he thought hard about a solution. Maybe it would be best if Gauguin, as he had already more or less promised, came as quickly as possible to Arles, and Theo could increase the monthly allowance so that Gauguin and Vincent would be able to live and work together. In June, Theo made a proposal to Gauguin: if he went to Arles and sent a painting a month, he would receive 150 francs a month. Gauguin agreed. He was feeling a lot better by then, but he put off his departure for Arles. He wanted to work in Brittany. Dressed as a Breton in an embroidered waistcoat, a beret, and wooden shoes, he walked through Pont-Aven. Brittany, he wrote, was wild and primitive: "The dull sound of my wooden shoes on the cobbles, hollow and powerful, is the note I am seeking in my paintings."

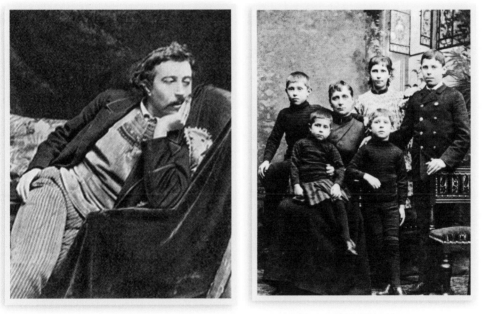

Left: Paul Gauguin, here in a Breton waistcoat

Mette in 1888–89 with, from left to right, Clovis, Pola, Aline, Jean-René, and Emil

To Mette, who by then had been taking care of their five children on her own for three years, he wrote that he was immersing himself in "the nature of the people and the places" in Brittany. This was of vital importance. To do so, he had to constrain his emotional, sensitive side and liberate his wild side, so that it could take its course, freely and forcefully.

His artist friends also came to Pont-Aven, including Laval, who was finally back from Martinique, and Bernard, who brought along his mother and his sister, Madeleine, this time. As the bar at Pension Gloanec was now much busier, the group arranged to use a new room, an attic above the post office on Rue du Gac, where the "School of Pont-Aven," as they would later be known, could work and talk about art without being disturbed.

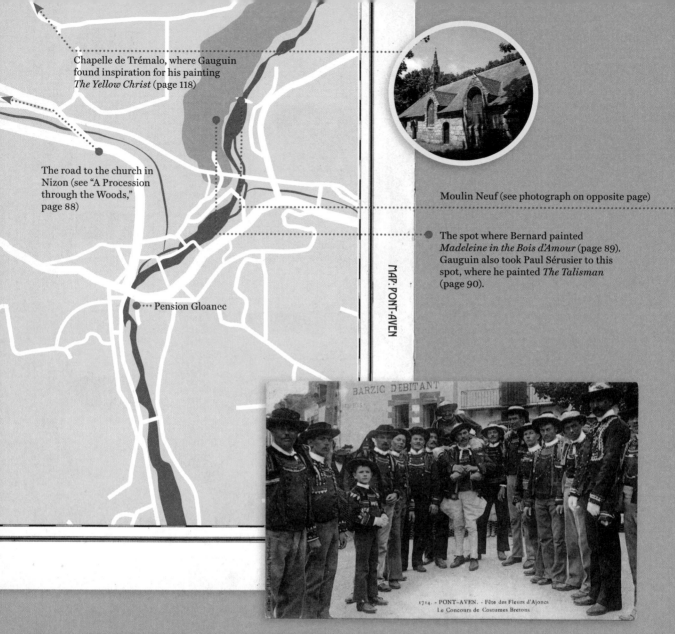

Chapelle de Trémalo, where Gauguin found inspiration for his painting *The Yellow Christ* (page 118)

The road to the church in Nizon (see "A Procession through the Woods," page 88)

Pension Gloanec

Moulin Neuf (see photograph on opposite page)

The spot where Bernard painted *Madeleine in the Bois d'Amour* (page 89). Gauguin also took Paul Sérusier to this spot, where he painted *The Talisman* (page 90).

MAP: PONT-AVEN

BARZIC DÉBITANT

1714. - PONT-AVEN. - Fête des Fleurs d'Ajoncs
Le Concours de Costumes Bretons

6055. - PONT-AVEN. - La Gare - Vue intérieure

Collection Villard, Quimper

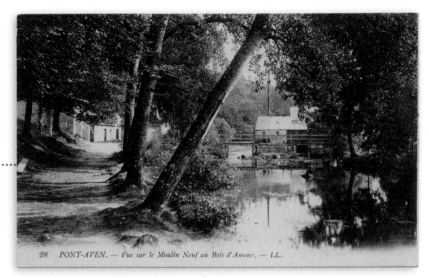

28 PONT-AVEN. — *Vue sur le Moulin Neuf au Bois d'Amour.* — LL.

THE BOIS D'AMOUR

The view from the Bois d'Amour of one of the village's many watermills was popular with the hundreds of painters who came to Pont-Aven in the summertime. According to Henry Blackburn's tourist guide to Brittany for artists, you could not enter the woods without spotting an artist or two at work on their easels. It was impossible to wander through the woods without hearing an impatient cough, pointing out that you were blocking the view of someone who stood at a canvas, with a smoldering pipe in his mouth and a felt hat on his head. The painters of the School of Pont-Aven also regularly went to the woods to work.

An artist who has been working *en plein air* in the Bois d'Amour at Pont-Aven. Drawing by Randolph Caldecott for Henry Blackburn's *Breton Folk: An Artistic Tour in Brittany*

RETURNING FROM LABOUR, PONT-AVEN.

A PROCESSION THROUGH THE WOODS

During his second stay in Pont-Aven, Gauguin became fascinated by the Catholicism of the region, which had Celtic characteristics. He looked at churches and chapels and visited the local *pardons*. During these summer festivals, worshipers, dressed in their full Breton finery, would go in a procession to a church or chapel to honor saints, after which they would dance the gavotte and take part in riding and wrestling contests. On one such occasion, Bernard made his painting *Breton Women in the Meadow*, a work featuring a group of large figures on a green background, in which he had clearly further developed the technique of Cloissonism, working with strong outlines. He lent Gauguin some paints in colors that did not appear in the Impressionist palette, and Gauguin went on to paint his famous work *The Vision after the Sermon*, also featuring a group of Breton women. When leaving church, they are seized by a vision of Jacob wrestling with an angel. This depiction has no connection to reality. A tree bisects the whole image, as is often the case in Japanese prints. The background is entirely red, just as the background of Bernard's painting is green. Gauguin described this work as "Synthetist" and it would later earn him the title "Leader of Symbolism," although Bernard would then claim that Gauguin had stolen the idea from him. The painting was also his final farewell to Pissarro's Impressionism. Gauguin's former teacher did not have a good word to say about the work. He saw Gauguin as a *bricoleur*, someone who constructed his own style by using other artists' building blocks.

Gauguin, himself rather impressed by *The Vision after the Sermon*, wanted to donate the work to Brittany and, more specifically, to an old church in Nizon, just outside Pont-Aven. He had the work framed and added the words "a gift from Don Tristán de Moscoso." As there was no walkable road to Nizon, the work had to be carried through the wood, with Bernard and Laval helping

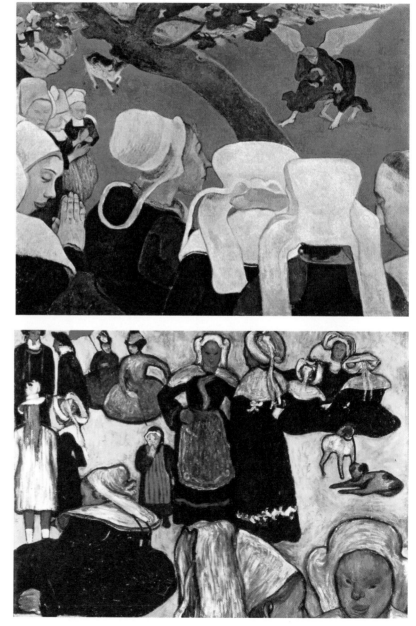

Above: *The Vision after the Sermon*, 1888. Scottish National Gallery, Edinburgh

Below: Émile Bernard, *Breton Women in the Meadow (Le pardon de Pont-Aven)*, 1888. Private collection

Gauguin. It was a small procession through the Bois d'Amour, past the ruins of the Château de Rustéphan, across a buckwheat field. Once they arrived at the church, Gauguin looked for a spot where the painting could be displayed to its advantage. Meanwhile, Bernard went to fetch the priest, to inform him of the gift that had just been bestowed upon his church. The curious priest followed Bernard into the church, but when he saw the painting, the color drained from his face. Gauguin attempted to explain how the primitive work matched the equally primitive wooden statues in the church, but the priest refused to accept the painting and thought they were making fun of him. In the end, the work had to be carried back to Pont-Aven. The mood on the way back was somber: even if Gauguin tried to give his work away, people did not want it.

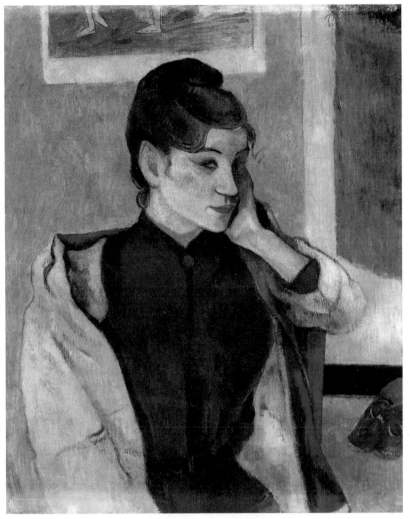

Portrait of Madeleine Bernard, 1888. Musée de Grenoble, France

Émile Bernard, *Madeleine in the Bois d'Amour*, 1888. Musée d'Orsay, Paris

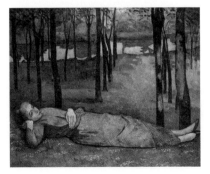

MADELEINE

Meanwhile, letters still kept arriving from Arles. Time and again, Vincent van Gogh asked when Gauguin thought he would be coming. He had even found a house where they could work together. But, time and again, Gauguin put off his departure, because his illness had flared up again or because his bill at the guesthouse had become too high, in spite of Theo's monthly contribution. Another factor was involved. Gauguin had fallen hopelessly in love with Madeleine, the seventeen-year-old sister of Émile Bernard. Both Gauguin and Madeleine's brother Émile painted portraits of her in Pont-Aven. Bernard painted her as a young and very religious girl, stretched out on the banks of the Aven in the Bois d'Amour. Gauguin depicted her as a challenging woman, much older than she was in reality. He did not stand a chance with her and, to make matters worse, she became engaged to Gauguin's disciple, Laval.

When Theo van Gogh announced that he had sold some ceramics by Gauguin for 300 francs, it was time to leave Pont-Aven. On October 21, Gauguin sat waiting at Pension Gloanec with his packed belongings for the coach that would take him to the station at Quimperlé for a journey of two days and two nights, which would bring him to Vincent van Gogh in Arles. A nervous painter came up and spoke to him, the twenty-four-year-old Paul Sérusier. He wanted to talk to the great Gauguin about painting. Gauguin had just enough time for a quick lesson. He took Sérusier to the place in the Bois d'Amour where Bernard had painted his sister Madeleine and ordered Sérusier to paint what he saw. He asked him: "How do you see that tree? Green? Then make it green—and use the best green on your palette." Sérusier painted a landscape made up of unmixed colors on a small panel. The work, called *The Talisman*, would later make a devastating impression on Gauguin's friends in Paris. It was the start of a new painting movement, the Nabis, the prophets, and Gauguin remained their great role model.

Paul Sérusier, *The Talisman*, 1888.
Musée d'Orsay, Paris

Arles

Arles Station

116 ARLES. — La Gare. — LL. SELECTA

THE YELLOW HOUSE

Vincent van Gogh's house was close to the station in Arles and looked out over Place Lamartine with its park and, beyond, the towers of the Porte de la Cavalerie, the northern entrance to the old town center of Arles.

Vincent van Gogh had done his best to comfortably furnish his house, which he described as a "fresh butter yellow." He had hung paintings throughout, including in the bedrooms, and he had bought furniture, including twelve chairs for if they had visitors. Specially for Gauguin's arrival, he had had gas lights installed, so that they would be able to work on into the evenings.

Inside the house, it was chaos, thought Gauguin, with bulging boxes full of empty paint tubes without caps and paintings in garish colors on the crooked walls, and the place itself was tiny. Van Gogh had some good news for Gauguin when he arrived: Theo had sold one of Gauguin's paintings and would be sending 500 francs. The first day, Van Gogh gave Gauguin a tour of Arles and they visited the brothel Maison de tolérance no. 1. Gauguin had little enthusiasm for the Arlésiennes, who were considered to be among the most beautiful women in France. He knew at once that Arles was no match for Pont-Aven.

However, he still began a reorganization of the household, particularly the finances. This was a sensitive issue, as, by Gauguin's standards, Van Gogh was a spendthrift. He lived on around 240 francs a month in Arles. That was including all the costs for the interior of the Yellow House, but not materials such as paints and canvas, which his brother sent from

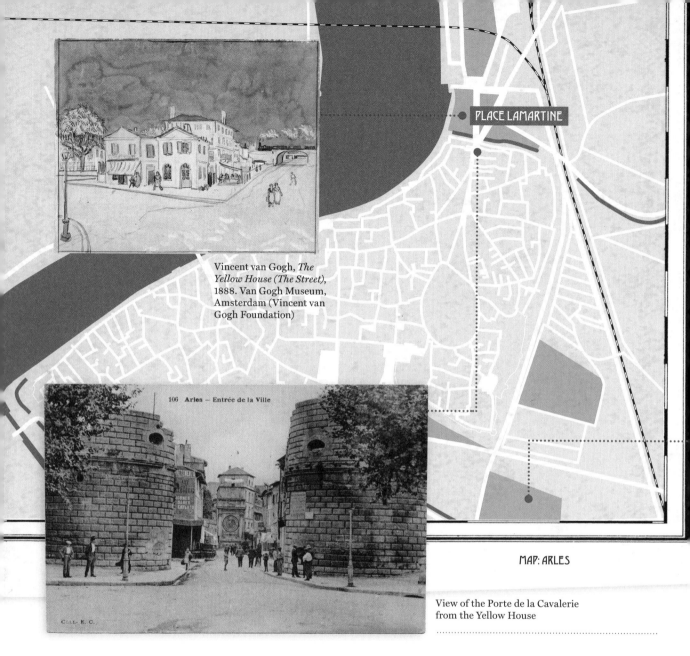

Vincent van Gogh, *The Yellow House (The Street)*, 1888. Van Gogh Museum, Amsterdam (Vincent van Gogh Foundation)

PLACE LAMARTINE

106 Arles — Entrée de la Ville

MAP: ARLES

View of the Porte de la Cavalerie from the Yellow House

Paris. By way of comparison, his friend Joseph Roulin worked for the post office in Arles, and he and his wife and three children had to get by on a salary of 135 francs.

Gauguin bought a roll of cheap burlap, which they prepared for use as canvases. With a great deal of tact, he introduced a system dividing Theo's money between two boxes. One box had a list for noting expenditure on going out, prostitutes, and tobacco, with at the bottom "unforeseen expenses such as rent." What was left over went into the other box and was intended for food.

As part of the savings plan they stopped going to restaurants. Gauguin cooked their meals on a small gas stove, as what Van Gogh prepared was inedible. He mixed the ingredients the same way he mixed his paint, Gauguin remarked. "I have to tell you that he can cook *perfectly*," wrote Van Gogh. He wanted Gauguin to teach him how to cook, as it was a "very handy" skill.

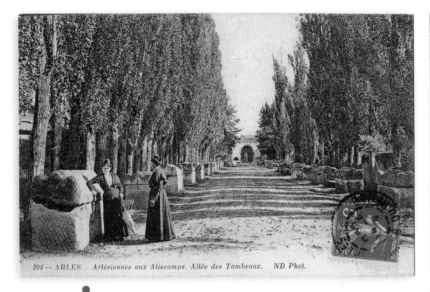

204 — ARLES. *Arlésiennes aux Aliscamps. Allée des Tombeaux.* ND Phot.

Vincent van Gogh, *Les Alyscamps*, 1888.
Private collection

Les Alyscamps (The Three Graces at the Temple of Venus), 1888. Musée d'Orsay, Paris

GAUGUIN AND VAN GOGH

Van Gogh took his guest to places that were worth painting. There are various locations in Arles where they sat together and painted. For example, Les Alyscamps, a Roman necropolis to the south of the town. For fifteen hundred years, the distinguished citizens of the town were buried here, some of them in impressive tombs. In the nineteenth century, it was a popular walking area.

Gauguin and Van Gogh painted at a fast pace. Gauguin sent one painting after another from Arles to Theo, who sold another three works by Gauguin in November. It was going so well that Gauguin even sent some money to Mette with the promise that more would most likely follow.

His greatest admirer was, of course, Vincent van Gogh, five years his junior. Gauguin, "the man who comes from afar," proved to be a "most excellent friend" and was a "very great artist." In return, Gauguin had certain criticisms of Van Gogh's work. He admired Van Gogh's Alyscamps painting and said that he thought his sunflowers were better than Monet's. He actually owned a number of works by Van Gogh. But his letters to his friends tell a different story. He

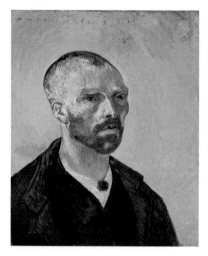

Vincent van Gogh, *Self-Portrait*, 1888. Harvard Art Museums/Fogg Museum, Cambridge, MA

thought that Van Gogh, like Pissarro, was elaborating upon Seurat's uninteresting Divisionism. Gauguin saw it as his noble duty to teach Van Gogh a thing or two. First, he needed to stop using the Divisionist style of painting and the strongly contrasting shades. Then, he taught Van Gogh to paint not only from nature: "Gauguin has made it rather clear to me that it was time for me to start varying a little—I am beginning to make compositions from memory and for that work all my studies will always stand me in good stead, as they will remind me of things I have seen before," Van Gogh wrote to Theo. Gauguin had sowed seeds in fertile ground. "The student is advancing in leaps and bounds, without losing any of his own originality," wrote the modest teacher. He reported that his student thanked him every day for the lessons.

What Gauguin, in turn, owed Van Gogh, he wrote, was that he confirmed the ideas he already had. That was not entirely fair. Because of Van Gogh, Gauguin started painting portraits again. He also tried out Van Gogh's "garish colors," became even more interested in the Japanese woodcut techniques, and even ventured to try his subjects.

BAD WEATHER

Both painters agreed, given Gauguin's work from Martinique, that the future of painting was not in Paris but in the south or even farther away, in the tropics. At the same time, Van Gogh was afraid that Gauguin would leave him. Gauguin was indeed making long-term plans for a future studio in a tropical land, but also more short-term plans. He corresponded from the Yellow House with Schuffenecker and Bernard about the World's Fair that would open in Paris in spring 1889. Although they did not have an official invitation, Schuffenecker had arranged for them to exhibit work at a café on the site, which would

Self-Portrait with Portrait of Émile Bernard (Les misérables), 1888. Van Gogh Museum, Amsterdam (Vincent van Gogh Foundation)

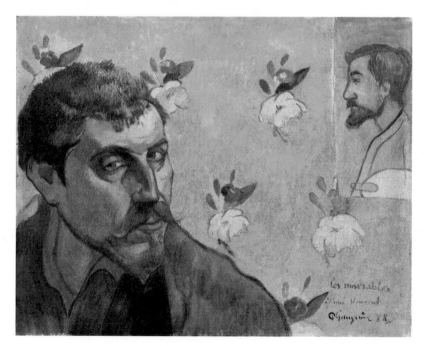

mean that, technically, they would be exhibiting work at the World's Fair. In those same letters, Gauguin poured his heart out about Van Gogh, as their discussions about art, which had initially been interesting, had become ever-more heated since the first month. "We do not often agree, particularly not when it comes to art. He loves painters I cannot stand and loathes painters I admire. Then I say: 'You're right, boss,' to keep the peace. He admires my paintings, but when I am working on them, he always thinks it should be different here or there."

After a trip to the Musée Fabre in Montpellier, Van Gogh wrote to his brother: "The discussions are excessively electric. Sometimes when we have finished, our heads are as empty as an electric battery when it's run down."

As, increasingly often, it was too cold and wet to work outside, they were forced to work together in the downstairs room of the Yellow House, a room of about 250 square feet. That did not exactly improve the atmosphere. At the beginning of December, Gauguin made an ape-like portrait of Van Gogh, working frantically on one of his sunflower paintings. "It's certainly me," wrote Van Gogh when asked if he recognized himself, "but gone insane." Gauguin gave the portrait to Theo with the modest words that perhaps it was not much of a likeness, but that he had tried to show something of Vincent's inner character. Theo thought it was a brilliant portrait and praised Gauguin to the heavens. He wrote such things as: "Gauguin whispers words of consolation for those who are not happy or healthy," and "In him, nature itself speaks." Schuffenecker, who had gone to see his friend's latest work at Theo van Gogh's gallery, wrote that Gauguin the giant stood alongside Rembrandt and Delacroix and that he would "finish" all of his contemporaries (apart from Degas).

627 - MONTPELLIER - La Gare P. L. M.

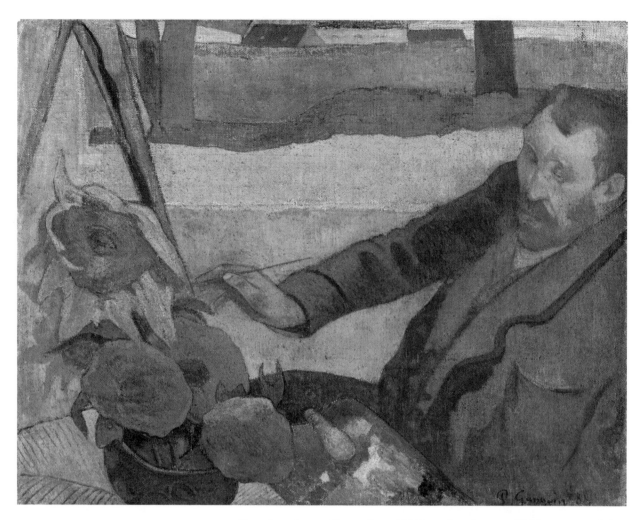

Vincent van Gogh Painting Sunflowers,
1888. Van Gogh Museum, Amsterdam
(Vincent van Gogh Foundation)

Two days later, Gauguin told Theo that he would like some of the money from the sale of the paintings, as he was leaving Arles. "All in all, I am forced to return to Paris. Vincent and I absolutely cannot live side by side without our conflicting temperaments causing great turmoil, and he and I need peace for our work." Then he changed his mind and told Schuffenecker that he was going to stay in Arles for a while, but that he was also ready to leave: "My situation here is difficult. I have much to thank Theo and Vincent for, and in spite of some disagreement I cannot hold a grudge against a kindhearted person who is sick and suffering and who asks for me."

THE EAR

Gauguin and Van Gogh were heading for disaster, and this came on December 23, 1888, when Van Gogh cut off his left ear after Gauguin told him he was leaving. The newspaper reported under the heading of "Chronique locale" that Van Gogh, the painter from Holland, had gone to Maison de tolérance no. 1 at half past eleven at night. He asked for a woman called Rachel "and handed her his ear, saying: 'Look after this carefully.' " The police went to the Yellow House and found "the poor madman showing barely any sign of life, after which the unfortunate man was admitted to the hospital."

Two eye-witness accounts survive. They are quite different, but have one thing in common: they are both from Gauguin. A few days later, he told Bernard what had happened, and Bernard passed it on to the art critic Albert Aurier. In that scenario, Van Gogh acted so insanely after Gauguin had told him he was going to leave him that Gauguin could no longer stand it. He spent the night before his departure for Paris at a hotel, while Van Gogh cut off his ear at the Yellow House. Then Van Gogh pulled a hat on over his bleeding head and offered the ear in an envelope to one of the prostitutes, who fainted in the doorway. Van Gogh was taken to the hospital, and Gauguin sent a telegram to Theo on December 24. Theo caught the night train and on Christmas morning he was at his brother's bedside. Gauguin reported that Van Gogh, once he was at the hospital, had to be locked in his room, because he wanted to sleep with the other patients, chased the nurses, washed in the coal shed, and fired off religious monologues.

Gauguin wrote the second version of the story fifteen years later, when Van Gogh was more famous than Gauguin could ever have thought possible. That version contains bizarre events, and it is hard to imagine why they were missing from his first account. This time Van Gogh's insanity was targeted directly at Gauguin. It began while they were living together. Van Gogh threw a glass of absinthe at him in a bar. Sometimes Gauguin woke up at night in the Yellow House and discovered that Van Gogh was watching him in the darkness.

During his walk on the evening before his departure, Gauguin heard familiar, rapid footsteps behind him. When he turned around, he was facing Van Gogh, who was holding an open razor. When Gauguin looked right at him, he turned and ran away. So, Gauguin wanted to say, it was not that strange that he preferred to spend his last night in Arles at a hotel. He did not fall asleep until around three o'clock. When he went back to the Yellow House early the next morning, the place was swarming with people, including gendarmes. The Yellow House was covered in blood, and there were soaked towels everywhere. Van Gogh was dead, an officer in a bowler hat informed him. "What did you do to your friend?" Indignation, anger, sadness, and shame—all those feelings went through Gauguin, he remembered fifteen years later. When he discovered that Van Gogh was merely unconscious, he took to his heels. It is not known where Gauguin spent his last night in Arles. Van Gogh, in the hospital, repeatedly asked for him, but in vain. The next day, Christmas Day 1888, Gauguin, probably with Theo, traveled back to Paris.

Gauguin concluded this second version of the ear incident in his 1903 memoirs with the question of whether he had been negligent, an accusation that was thrown at him for the rest of his life: "Should I have disarmed him and tried to calm him down? I have often questioned my conscience, but I have no reason to reproach myself."

Paris v

THE PRADO AFFAIR

It was clear that Gauguin was not entirely indifferent to the question of guilt. On the night of December 28, with a sketchbook under his arm, Gauguin headed to Place de la Roquette to attend the beheading of a criminal known as "Prado." The Prado case had been widely covered in the press in the preceding months, and Gauguin and Van Gogh had been following it closely in Arles.

The thief and murderer refused to give his real name, but people were convinced that it was the Spanish Count Linska de Castillon, who was said to have roamed the world and who, like Gauguin, had lived in Lima. He left behind a trail of lovers, all of whom he had delighted with stolen jewelry and all of whom knew him by a different name. Prado had been found guilty of robbery and of slashing the throat of a prostitute with the nickname "La crevette" (the shrimp). In court, the Count made quite an impression, with his flamboyant hairstyle and charisma. He continued to maintain, in countless letters to the press, that he was innocent. His time in prison was spent reading the work of the author Victor Hugo, who had died three years previously and who was strongly against the death sentence. Hugo was moreover the creator of Jean Valjean, the character in the world-famous novel *Les misérables* who was persecuted his whole life for stealing a loaf of bread. Jean Valjean was the "innocent wrongdoer" with whom Gauguin identified in the self-portrait he had sent to Vincent van Gogh (see page 94). Gauguin wanted to attend the execution, not for enter-

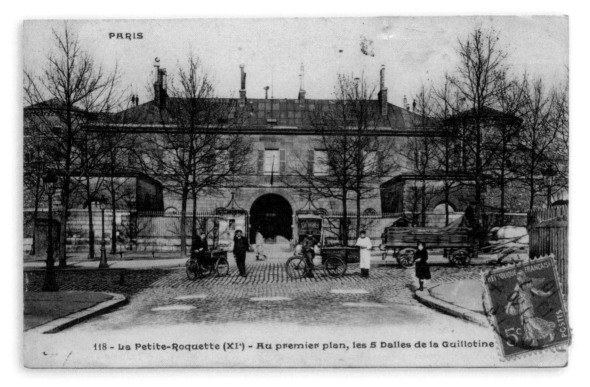

118 - La Petite-Roquette (XIᵉ) - Au premier plan, les 5 Dalles de la Guillotine

tainment, he said, but because he wanted to witness a martyrdom. As he waited for the event, surrounding by the roaring crowd, he did some sketches of the guillotine.

Prado was not led out through the prison gate until after six in the evening. He was wearing a coarse shirt that had been cut open at the shoulders and neck. His flamboyant hair had been shaven off. He did not resist, but appeared to be hypnotized, a journalist reported. It looked as if the execution were going to go wrong. During the first attempt, only part of his chin was cut off. The blade had to drop again to separate the head from the body. Gauguin missed that moment in the crush. However, he did see the head of Prado subsequently lifted into the air.

A few weeks later, Gauguin made a bizarre self-portrait in the form of a jug. A head without a body, with the ears cut off. The blood runs down the cheeks and the hairline, as if a crown of thorns had been there.

The square where Prado was guillotined

Jug in the Form of a Head, 1889.
Kunstindustrimuseet, Copenhagen

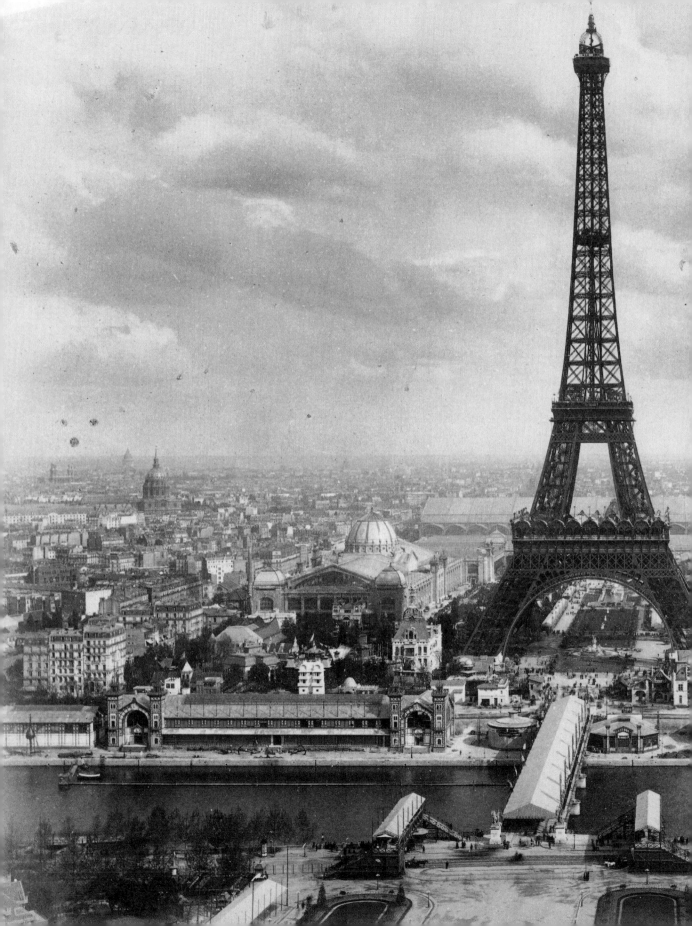

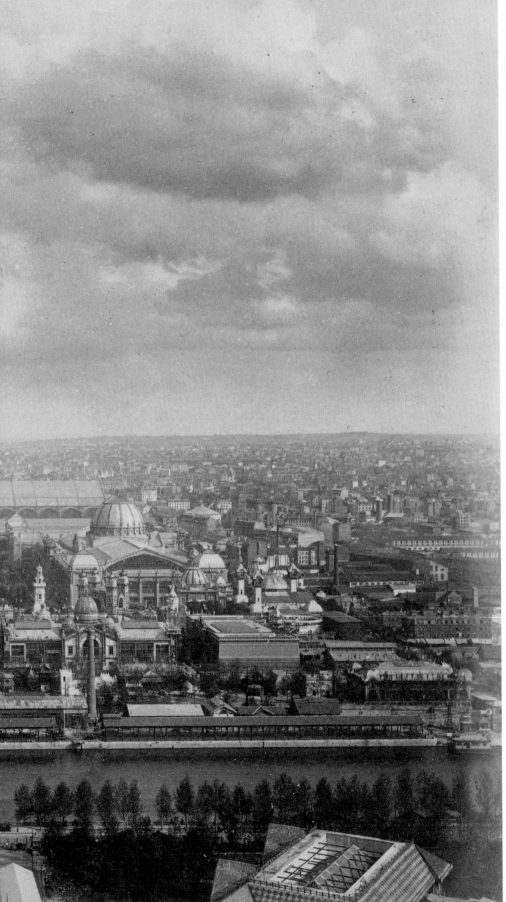

Paris during the
1889 World's Fair

THE WORLD'S FAIR

Although Gauguin's reputation was not improved by his part in the ear incident, the Van Goghs themselves did not hold it against him. As soon as he was home from the hospital, Vincent continued his correspondence with his dear friend Gauguin, playing down his "perfectly ordinary artistic folly." Had it really been necessary to make his brother come all the way from Paris to Arles? Vincent even suggested a new collaboration. Theo was embarrassed. He was upset that Gauguin had witnessed this family drama. Although the stock market, and therefore the art market, had slumped again, he continued to support Gauguin financially, and so Gauguin was able to rent a studio on Rue du Saint-Gothard. Theo also advised Gauguin

and Bernard to experiment with printing techniques. Theo knew that collecting graphic work by painters was popular. There was money to be made. Just as Gauguin had embarked upon making ceramics, he now threw himself into the printing process. And just as with ceramics, when he had made the most bizarre and unsellable objects, he immediately started experimenting with printing. He drew his designs not on wood or stone, but on zinc. Like the burlap he had painted on in Arles, zinc was a coarse support. It was also cheaper than lithography. He printed his work on bright yellow paper, which he may have seen before in cheap advertising prints or Japanese woodcuts. Perhaps it reminded him of his bedroom

Handy program booklet for visitors to
the Paris World's Fair in 1889

in the Yellow House in Arles, with the sunflowers on the wall and the light shining through the yellow curtains. Although printmaking was new to Gauguin, his subjects remained the same. The zincographs feature the reappearance, in simplified form, of the Breton women, seen from behind, with their hands on their hips, the women in Dieppe braving the waves, the *porteuses* from Martinique, and the washerwomen of Arles. In ten prints, with a print run of fifty, the places that had been important to Gauguin returned. The World's Fair could begin.

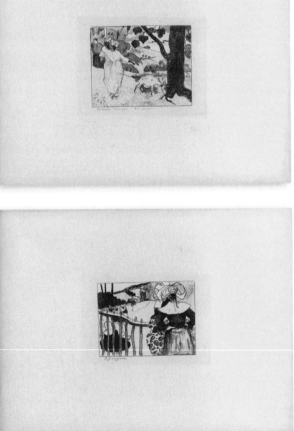

Four zincographs by Gauguin, 1889.
Van Gogh Museum, Amsterdam
(Vincent van Gogh Foundation)

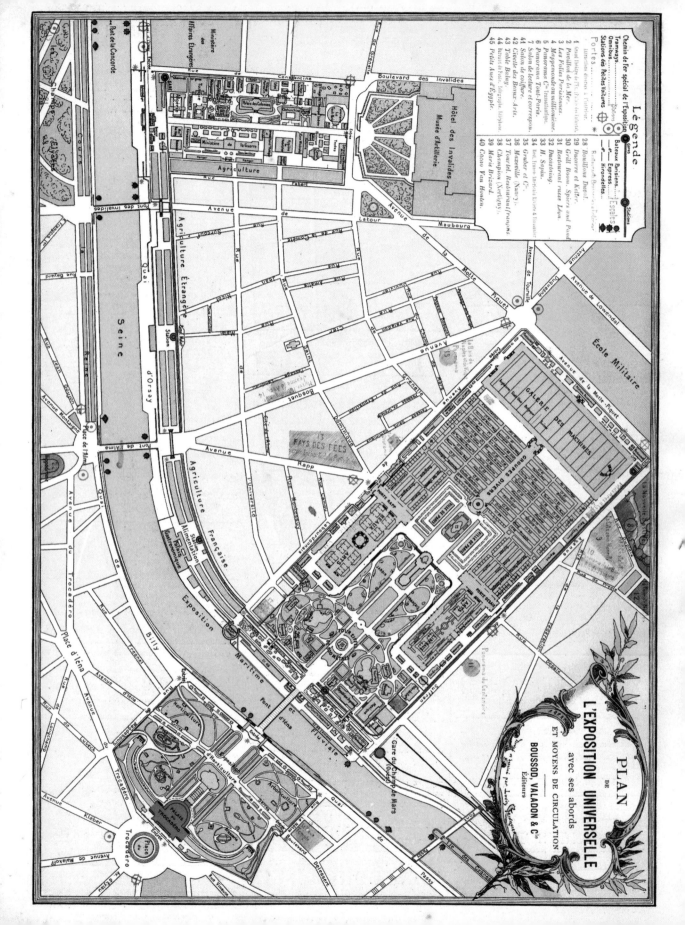

Légende

Chemin de fer spécial de l'Exposition Gares
Tramways
Omnibus Stations
Bateaux Parisiens. Stations
Express.
Hirondelles.

Stations des Petites Voitures

Portes
lumières éteintes à l'intérieur
lumières éteintes à l'extérieur

1 Seul Buste de l'Exposition
2 Pavillon de la Mer.
3 Les Folies Parisiennes.
4 Métempsychose vaillonnaise.
5 Panorama C.ie Transatlantique.
6 Panorama Tout-Paris.
7 Salon de lecture et correspon.
28 Bouillons Duval.
29 Duserre et Keller.
30 Grill Room, Spiers and Pond.
31 Restaurant russe Léon.
32 Dacosteng.
33 H. Sapin.
34 Rest. Irven Américain Roters à l'Instructeur
35 Gruber et C.ie
41 Cécile des Beaux-Arts.
42 Cicotte des Beaux-Arts.
43 Table Bolog.
44 Renaut de Poste, Télégraphe, Téléphone.
45 Petits Ânes d'Égypte.
36 Mazeville (Nancy).
37 Tourtel, Restaurant Français.
38 Champion (Vertigny).
39 Marie Brizard.
40 Cacao Van Houten.

PLAN
DE
L'EXPOSITION UNIVERSELLE
avec ses abords
ET MOYENS DE CIRCULATION

BOUSSOD, VALADON & C.ie
Éditeurs

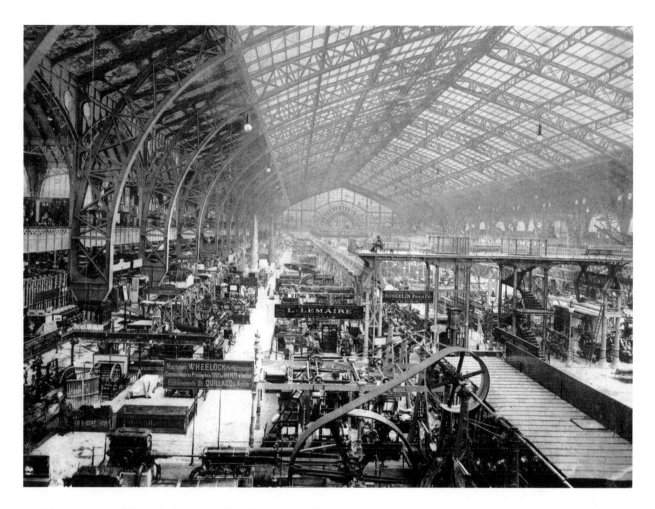

The 1889 World's Fair was the fourth to be held in France. At these nineteenth-century exhibitions, many countries presented their latest developments and inventions in a wide range of fields, showing them to the rest of the world. The World's Fair of 1889 broke every record, just as a World's Fair should. Over a six-month period, the fair was attended by thirty-two million visitors, who could be transported around the site on a two-mile rail track.

The Galerie des machines at the Paris World's Fair

The Eiffel Tower was constructed specially for this exhibition. At a height of 1040 feet, it was the tallest building in the world, even higher than the Great Pyramid of Giza. It did not have to surrender this title until 1931, to the Chrysler Building in New York, which is six feet higher. The host country used this World's Fair as an opportunity to commemorate the French Revolution of a hundred years before, but also wanted to demonstrate that it had completely recovered from the defeat of the Franco-Prussian War of 1870. For France, this World's Fair was a propaganda machine, with the Galerie des machines exhibiting the impressive French industrialization in a space of over half a million square feet.

CAFÉ VOLPINI

French art was also playing an important home game at the temporary Palais des Beaux-Arts. The Impressionists knew not to expect an official invitation to exhibit there, and Gauguin and his friends were certainly not welcome. Schuffenecker came up with a cunning plan. He arranged for exhibition space at one of the venue's many cafés, for a number of artists, including himself, Gauguin, Bernard, and the painter George-Daniel de Monfreid, who was to become a good friend of Gauguin's. The manager of the café, Monsieur Volpini, had ordered huge mirrors to decorate the temporary building on the Champ-de-Mars, but they were not delivered in time. There would be space on the walls for at least one hundred works by the Groupe Impressionniste et Synthétiste. There were seventeen paintings by Gauguin alone. The folder of zincographs was "visible sur demande," and could be viewed on request from the staff, as the prints were too fragile to hang on the walls. Synthetism would finally become as established as Impressionism, Gauguin predicted.

However, this prediction did not come true. The Synthetists had to make do with exactly one positive review, praising Gauguin, Bernard, and Anquetin's daring exercises in simplification. Another critic complained that it was impossible to study the works in the busy café, as waiters with trolleys had to keep coming past. Customers were also in the way, along with tables, chairs, bars with beer pumps, and an entire orchestra led by the Russian Princess Dolgorouki, not to mention the cashier's immense bosom. Not one of the hundred works on display was sold. No one requested to view the series of zincographs that would become known as the Volpini Series. Eventually, Gauguin gave them away to friends.

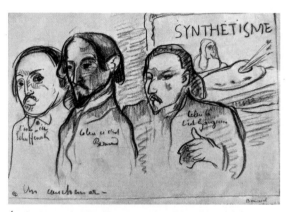

Émile Bernard, *Schuffenecker, Bernard, and Gauguin during Their Volpini Exhibition*, 1889. Private collection

...

Left: Princess Dolgorouki and her orchestra

Below:
One of the many cafés at the 1889 World's Fair

COLONIAL EXHIBITION

The World's Fair had a large influence on Gauguin. Although he spent most of the spring and summer of 1889 in Brittany, he visited the fair a number of times. He is believed to have had a brief affair with a Caribbean woman there, and he went to the show *Buffalo Bill's Wild West*, where he saw reenacted battles between cowboys and Indians, in which the cowboys always won, and the famous sharpshooter Annie Oakley, who had smuggled her favorite gunpowder into the country in her underwear. Gauguin bought a Stetson, according to experts most likely the Boss of the Plains model. He would wear that cowboy hat for years, to many people's annoyance. At the exhibition site, a large section was set aside for a *village global*, with reconstructed houses from all over the world. This was recommended in a guide with the catchy slogan: "Traveling around the world, not in eighty days, not in eighty hours, but in one hour, or an hour and a half, without the danger of being killed or eaten, certainly has its advantages!"

Annie Oakley in 1885

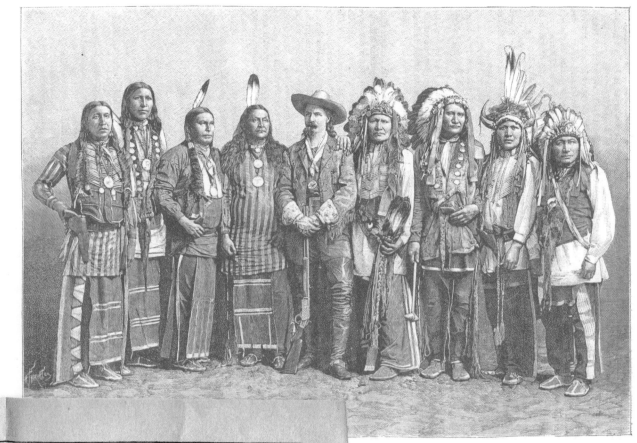

Performers in *Buffalo Bill's Wild West* show

Germains. Grec. Romain-Italien. Huns.
Gaulois. Gallo Romain.

Esquimaux. Peaux Rouges. Aztèques. Incas.
Afrique.

The colonial exhibitions made the greatest impression on Gauguin. These state-sponsored displays were designed to justify the aggressive and highly controversial colonial expansion. Brochures encouraging emigration to the French colonies were even handed out at the site.

There was a plaster replica of part of the famous Cambodian temple Angkor Wat. A hundred donkeys had been imported from Egypt, where France had helped to construct the Suez Canal, and they wandered around a winding street of the kind that was to be found in Cairo, with weather-beaten houses, little stores, and a mosque with an 85-foot-tall minaret. A Dutch entrepreneur who had connections in Paris had imported an entire village from Java in the Dutch East Indies, complete with straw and bamboo huts and sixty-five Javanese people. In this *kampong*, visitors could try Javanese delicacies, as well as enjoy Dutch treats such as Van Houten cocoa or *jenever*, Dutch gin.

Aboriginal inhabitants of the French colonies were also brought to Paris by the dozen. A *village nègre*, effectively a human zoo, was created, where a total of four hundred people could be "viewed" as they were doing crafts, making music, dancing, cooking, or praying in front of their huts. Every Tuesday there was a "festive" parade of all the people from the French overseas territories.

MARCHETTI

THE EGYPTIAN QUARTER AT THE EXPOSITION UNIVERSELLE

Riding a donkey in the Egyptian street at the World's Fair

EXPOSITION UNIVERSELLE DE 1889

Kampong Javanais

Javanese dancers in the reconstructed *kampong*

PIERRE LOTI

Pierre Loti was the pseudonym of the naval officer and world traveler Julien Viaud. As a young homosexual, he fled the provinces, went to sea, and became one of the most famous French authors of Gauguin's day. He wrote articles for *Le Figaro* and *Le Monde*, and his novels were reprinted over and over. They were sentimental stories, mostly about a naval officer who went to the French colonies and entered into a "temporary marriage" with a very young local woman. No one was shocked about it at the time. His readers entered a fantasy realm when they read his descriptions of exotic paradises and willing women who apparently had nothing else to do but bathe in a river with flowers in their hair. And all of them were so grateful that a white European man wanted to live with them for a little while. The stories ended badly, with the officer boarding his ship, disappearing over the horizon, and returning to Europe, the center of the civilized world. In short, by today's standards these stories are packed with colonialism and eurocentrism. In Gauguin's day, they were bestsellers. They offered an escape for anyone who wanted to exchange the industrialized nineteenth-century life for an untouched paradise, just for a while. Loti's novels were seen as realistic, though, and were taken completely seriously. Loti was respected even in the highest literary circles. In 1891, he was admitted to the ranks of the forty *immortels* of the Académie française, beating Émile Zola in the race, who, by contrast, described the great poverty and injustices of nineteenth-century France. The writer Henry James considered Loti "a man of

genius," and moreover one of the few who was not afraid of being taken for a madman. Loti was indeed very eccentric. He had furnished the house where he was born, in Rochefort, to the north of Bordeaux, as a museum, with features including a Japanese pagoda, a mosque, and a Renaissance hall. He slept in a bare monastic cell. Having brought back many bizarre objects from his travels, he bought his neighbors' house when he ran out of space. Loti liked to be photographed in his naval uniform, a

cape, or garments and headgear that he had brought back from his travels.

Gauguin became acquainted with Loti's books through Vincent van Gogh, who was a huge reader. In the summer before Gauguin went to Arles, Van Gogh was captivated by Loti's latest novel, *Madame Chrysanthème*. He also must have recommended it to Gauguin, as Van Gogh noted in a letter that Gauguin exchanged a small drawing for a French lieutenant's copy of the book in Arles. Gauguin later read a biographical novel by Loti that was to have much more influence on him, *Le mariage de Loti (The Marriage of Loti [Rarahu])*, in which an English naval officer married the fourteen-year-old Tahitian girl Rarahu.

Pierre Loti in various costumes, photographed in his house

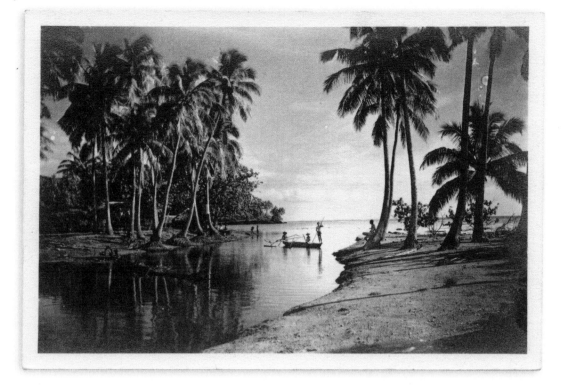

THE COLONY OF TAHITI

Tahiti, the island where Gauguin would make his most famous paintings, had been a French colony for fewer than ten years and it was presented for the first time at a European world's fair in 1889. The French colonists had sent material for three traditional oval Tahitian huts, a modest contribution, which nevertheless made an impression on Gauguin. He also read the promotional catalogue with interest, as he wrote to Bernard that Tahiti seemed like an attractive destination. In the brochure, based on the work of Loti, who had once been there for ten weeks, it said that no one had to work in Oceania, just reach up an arm now and then to pick a banana off a tree. There were also the Tahitian women, dressed only in a pareu, a wraparound skirt, the ultimate source of inspiration for sculptors, with their big dark eyes, full lips, white and regular teeth, and voluptuous bodies. The Tahitian women who had been brought to Paris for the exhibition, for a few francs and a return ticket, did not meet those expectations at all. A number of sophisticated older ladies stepped off the boat, dressed in the French style, in high-necked silk dresses with long sleeves. As the Tahitian ladies at the World's Fair did not fit the image that was sketched in the brochure, they were not allowed to be seen at the fair. The men, dressed in dark suits, complete with silver watch chains, did not want to show themselves there. They declared that, as French citizens, they would not be gaped at like animals in a zoo.

The Palais des colonies could also be visited at the exhibition. This was a temporary pavilion where thousands of agricultural and domestic objects and musical instruments from the colonies were on display. Gauguin may well have seen the award-winning photographic exhibition with images of Tahiti. The photographs show bathing and fishing Tahitians, endless vistas, waterfalls, portraits, and the "improvements" that the French had made to their colony, such as harbors and bridges. The photographs created such an impression of paradise that they were often stolen by visitors, who were still recovering from their alarming visit to the Galerie des machines, with its thousands of machines banging away. The pictures were constantly being reprinted and finally they were displayed inside locked cabinets. It was as if the exhibitions had been made specially for Gauguin, with his longing for the "primitive" life. He sketched the buildings and the many items of headwear that he saw around him, and became fascinated by the Javanese dances, which he actually thought were Cambodian. He pocketed a piece of plaster that had fallen off the Angkor Wat temple so that he could take it back to Brittany. Meanwhile, he was thinking about a destination that was much farther away than that.

Picture by Charles Spitz, which Gauguin saw at the photographic exhibition

EXPOSITION UNIVERSELLE DE 1889

COLONIES FRANÇAISES (PALAIS CENTRAL)

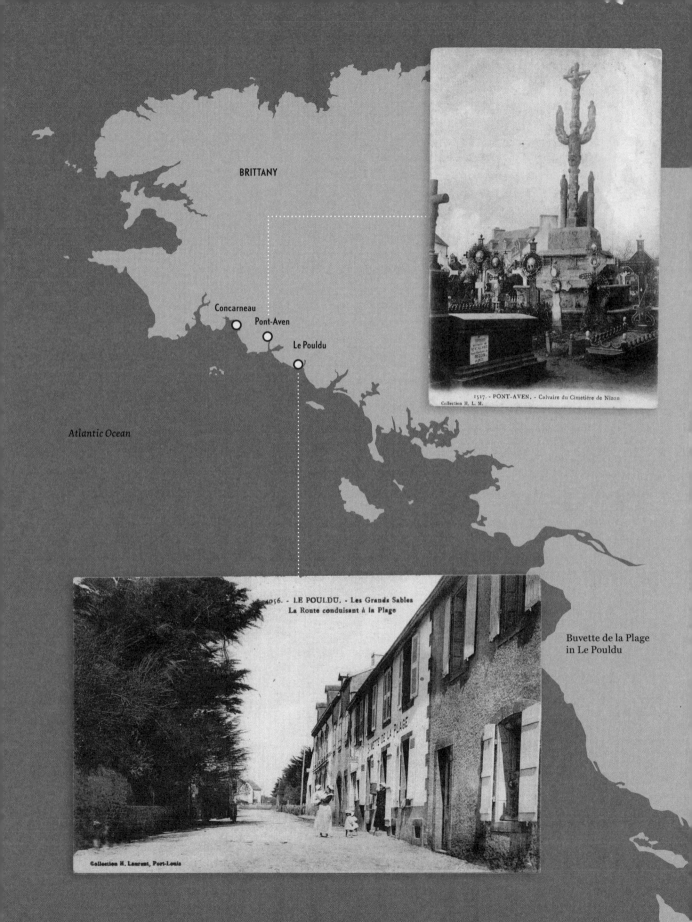

BRITTANY

Concarneau
Pont-Aven
Le Pouldu

Atlantic Ocean

1517. - PONT-AVEN. - Calvaire du Cimetière de Nizon
Collection H. L. M.

4056. - LE POULDU. - Les Grands Sables
La Route conduisant à la Plage

Collection H. Laurent, Port-Louis

Buvette de la Plage
in Le Pouldu

Brittany

LE POULDU

Things were going badly in Paris, Gauguin wrote to Mette at the beginning of 1889, before the World's Fair began. Stocks were tumbling further every day. Selling his works via Theo van Gogh was not working out as well as hoped. Funds were coming in only sporadically. So, with the money he still had, Gauguin escaped the expensive city of Paris once again and went to work in Brittany. Pont-Aven and Pension Gloanec were so packed with painters that Gauguin had soon had enough. From early 1889 to the end of 1890, whenever he did not actually have to be in Paris, he rented cheap rooms in the area around Pont-Aven. He also found accommodation at the Buvette de la Plage, an inn a few villages away, in Le Pouldu, an impoverished hamlet. Not only was the local peasant population a lot more surly than in the friendly Pont-Aven, the surrounding countryside was also rougher. Gauguin was pleased about that. Marie Henry, the owner of the Buvette de la Plage, was so attractive that she became known as "Marie Poupée" (Marie Doll). She was a businesswoman and she did not provide credit, as Gauguin had been accustomed to at Pension Gloanec. When the money ran out again, Gauguin went back to Pension Gloanec for a while or visited other painters in the area.

The Kelp Gatherers, 1889. Museum Folkwang, Essen, Germany

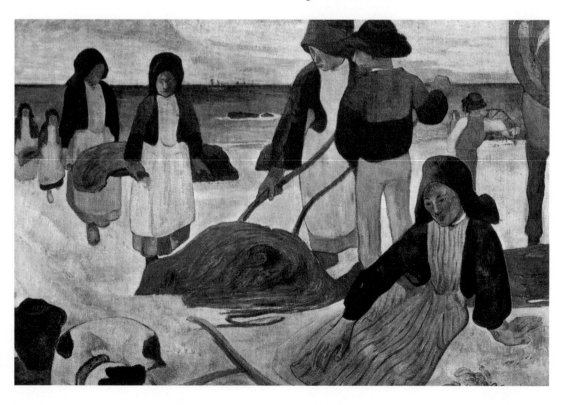

2475. - LE POULDU. -

grands Sables

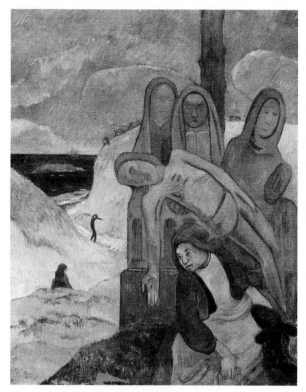

The Green Christ, 1889. Koninklijke Musea voor Schone Kunsten van België, Brussels

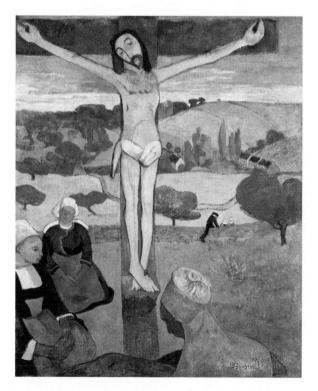

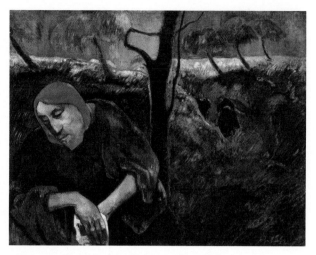

Christ in the Garden of Olives, 1889. Norton Museum of Art, West Palm Beach, FL

SYMBOLISM

As usual, Gauguin gathered students around him in Le Pouldu. Bernard's father, recalling Gauguin's unseemly flirtation with his daughter, forbade his son to visit Gauguin, but Sérusier regularly went there to work with Gauguin and to philosophize about religion. According to Bernard, who was apparently still allowed to correspond with Gauguin, there was a rumor going around Paris that Gauguin had founded a monastery in Le Pouldu and that he walked along the beach every day with a flock of attentive disciples. That was a gross exaggeration, replied Gauguin. What was true was that, following his discussions with Sérusier, he had made a number of works depicting Christ, which came almost entirely from his memories and imagination and were packed with symbolism. Still depressed after the huge failure of the Volpini exhibition, Gauguin also made the work *Christ in the Garden of Olives*, with himself as the suffering Jesus. It was pointless sending this painting to Theo van Gogh, he wrote to Bernard. Like the rest of his work, it would not be understood. For that reason alone, he had made up his mind to leave France and go traveling. In November, he applied for a colonial position in Tonkin, a French protectorate, now the north of Vietnam. Much to his annoyance, he was rejected because he was a painter. Everything around him seemed to be collapsing, he wrote.

The Yellow Christ, 1889. Albright-Knox Art Gallery, Buffalo

MEIJER DE HAAN

The Jewish painter Meijer de Haan, who met Gauguin at Theo van Gogh's house, had also come to Brittany to work. His family owned a flour and bread factory in Amsterdam, where De Haan also worked, although he was officially registered as an artist. He had just spent eight years working on a painting of the seventeenth-century philosopher Uriel da Costa. The canvas was more than 13 feet wide and 6½ feet high, and it was lambasted in Holland, so it was hardly surprising that De Haan wanted to go abroad for a while.

In the fall of 1889, De Haan, who had a monthly allowance of 300 francs, rented the top floor of Castel Tréaz on the Grands Sables beach in

Castel Tréaz on the Grands Sables beach in Le Pouldu. Gauguin and De Haan worked on the top floor.

Le Pouldu. He and Gauguin would be able to work there during the daytime. It was a large, bare room, with a panorama window that looked out onto the sea and the beach, where the locals would come to pick seaweed from between the rocks after fall storms. De Haan and Gauguin worked hard at Castel Tréaz. De Haan, who was searching for a new direction, received lessons from Gauguin and paid his bills in return. Gauguin's colors soon appeared in his paintings, and he was able to write home that he had found his new path. They ate together and spent the evenings at Marie Henry's inn, where Gauguin made sketches of De Haan reading by lamplight, and talked about the English-language philosophical and religious books that Gauguin needed to read.

Left: *Portrait of Meijer de Haan by Lamplight*, 1889. Museum of Modern Art, New York

Right: *Self-Portrait*, 1889. National Gallery of Art, Washington, DC

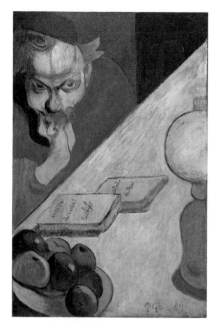

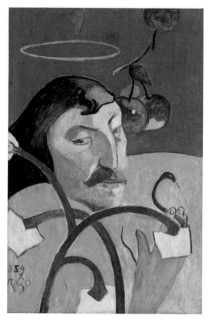

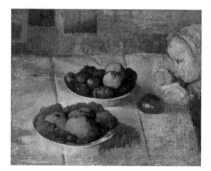

Meijer de Haan, *Still Life with the Profile of Mimi, Marie Henry's Daughter*, 1889. Van Gogh Museum, Amsterdam (Vincent van Gogh Foundation)

Gauguin's carved wooden shoes

YET MORE SYMBOLS

After a month and a half, they were thrown out of Castel Tréaz by the owner for making too much noise. Perhaps because they both wore wooden shoes? Such shoes belonging to Gauguin and De Haan have survived from 1889. Gauguin's are decorated with carvings. De Haan's, which he left with Marie Henry, have painted flowers. The painters received permission from Marie Henry to use the dining room as a studio during the daytime. In the winter, they came up with the idea of painting the walls and the cabinet doors. The following year, it would be the ceiling's turn. They received help from Sérusier and Charles Filiger, another painter in the School of Pont-Aven.

The theme of the wall paintings was initially peasant life in Le Pouldu. De Haan painted women preparing flax and made an affectionate portrait of Marie Henry and her daughter, Mimi. Gauguin's portraits included one of himself and one of De Haan, and he added all manner of symbols to them. He depicted himself with a halo, sitting between the snake and the apple in Paradise. On the other panel, De Haan appeared beside a basket full of apples and books that emphasized his learning, but Gauguin had also given him a demonic mask. De Haan did indeed have quite a striking appearance. His back was hunched and he had bright red hair, but his face is what really fascinated Gauguin, so much so that it turned up years later in his Tahitian paintings.

Meijer de Haan's painted wooden shoes, which he left behind with Marie Henry

TRAVEL PLANS

The situation appeared to improve in the spring. Gauguin had met a Breton ship's doctor, Charles Charlopin. He was also an inventor and claimed he was about to strike it rich. He had applied for a patent on a futurist steam engine, which eliminated all the flaws of previous models. As soon as the money arrived, Charlopin would purchase thirty-eight of Gauguin's works for the sum of 5,000 francs. And then Gauguin could finally go traveling. It was almost unbelievable. Charlopin reassured Gauguin that all he had to do was be patient for another month. Theo van Gogh had also offered to cofinance the trip. Feverish letters went back and forth between Bernard and Gauguin about the final location of the Studio of the Tropics. Bernard had just read *Le mariage de Loti* and was in favor of Tahiti. Gauguin thought it was a very long way, "even farther than China." It was also a pretty expensive journey. He suggested the French protectorate of Madagascar as a destination and he reassured Bernard about models. The women there were at least as willing as the ones in Tahiti. Gauguin claimed: "A woman from Madagascar has a heart, just as much as a Frenchwoman, but is far less calculating." When Bernard then sent him a government brochure once again praising the beauty of Tahitian women, Gauguin was persuaded.

In the summer of 1890, both men were shocked to hear the news of Vincent van Gogh's death. He had moved from the south of France to be closer to his brother Theo in Paris and had settled in the village of Auvers-sur-Oise, where he shot himself in the chest in a wheat field and later died at his guesthouse. Gauguin sent a message of sympathy to Theo. To Bernard he wrote that, in spite of the terrible news, it was good that this poor soul's suffering had come to an end. Gauguin had seen it coming.

The dining room at the Buvette de la Plage

Letter from Gauguin to Bernard, written in Le Pouldu

Paris VI

488 bis. LE POULDU — L'Hôtel des Grands Sables

Marie Henry's hotel in Le Pouldu, with staff and guests

DEBTS WITH MARIE HENRY

By the fall of 1890, it was clear that the money from Charlopin would not be coming. There was no prospect of money from Theo van Gogh either. He had been admitted to the hospital in Paris in October with a neglected case of syphilis and died in a clinic in Utrecht less than six months after his brother. There was more bad news. Meijer de Haan had been called to account by his brothers, not only for getting the unmarried mother Marie Henry pregnant, but also because they thought he should stay away from Gauguin, who had a bad influence on him. They did not want to hear about the plans to travel to the tropics and threatened to stop his allowance if De Haan did not return to Paris.

Gauguin stayed behind in Le Pouldu, having once again hit the rocks. He could not leave, as he was unable to pay the bill for his accommodation, which in the meantime was continuing to rise. He was forced to stop smoking and did not even have any money for stamps, as he wrote in a letter that was nevertheless delivered to Bernard. Bernard then spotted an opportunity to sell 500 francs worth of Gauguin's paintings to a friend. Gauguin paid off some of his debt to Marie Henry, left all his work there as a guarantee for the remainder, and ran off to Paris.

After an argument with his friend Schuffenecker, he moved into a hotel on Rue Delambre, where De Haan was also staying. He was preparing to travel up to Amsterdam for a good conversation with his brothers. Before he left on his journey with Gauguin, he wanted to say farewell to his family. However, he did not come back to Paris. He wrote to say that he was ill, and he stayed in the Netherlands.

THE AUCTION

Gauguin made an extremely useful contact in Paris: at a café he met the journalist and author Charles Morice, who was enthusiastic about his work. At that time, in literature, music, and theater, practitioners were distancing themselves from the aim of reproducing reality, just as Gauguin was doing with his art. They were also drawing on symbols from the past. Morice, who recognized symbolist elements in Gauguin's recent work, introduced him to the poet Stéphane Mallarmé, who in turn put him in touch with the famous writer Octave Mirbeau. Mirbeau wrote an effusive article praising Gauguin for *L'Écho de Paris*. The article was also printed in the catalogue of an exhibition of Gauguin's work that was quickly organized. In the recently founded magazine *Mercure de France*, the art critic Albert Aurier proclaimed Gauguin the leader of the Symbolist painters. Gauguin immediately subscribed to the magazine.

Bernard, who had read that Gauguin was taking all the credit for a style of painting that they had developed together and that he was allowing people to call him the leader of the Symbolists, was furious. He went to the exhibition with his sister in order to ask for an explanation. Things would never be right between Gauguin and Bernard again, and it looked like Gauguin would have to go to Tahiti on his own.

The next day, at the Hôtel des Ventes auction house on Rue Drouot, thirty works by Gauguin went under the hammer, and thanks to the publicity they were nearly all sold. This earned him 9,635 francs, enough for the

crossing to Tahiti and to get by for a few months, but first he bought a sewing machine for the twenty-year-old Juliette Huet, with whom he had had a brief relationship and whom he was sad to leave. Gauguin did not say a word about this huge amount in his letter to Mette, although he did send clippings of the reviews. He even wrote that the auction had been more of a moral success than a financial one. He did, however, suggest that he should come to Denmark to say good-bye before his departure for Tahiti. He wanted to see his children.

Auction house Hôtel des Ventes on Rue Drouot in Paris

Catalogue for Gauguin's very successful auction in 1891

Copenhagen II

FAREWELL

So as not to embarrass Mette in front of her family and friends, Gauguin suggested that he should stay incognito at a hotel in Copenhagen. Maybe he was disappointed that she actually went ahead and booked a hotel room for him. His children later said that they could vividly remember this encounter. They greeted their father, whom they barely recognized, in clumsy French. Arm in arm with Emil and Aline, the apple of his eye, Gauguin, in new shoes and a new beret, walked out of the station. He stayed a week, during which he had photographs taken with his children and rode around town with them in an open carriage. He had never been kinder and more affectionate to his children than that week in 1891. Gauguin noticed that Mette kept her distance. He suspected that this had something to do with her family, who could not stand him.

In Paris, on March 23, there was a farewell dinner at Café Voltaire, the place where the Symbolists met, for around forty people, with an admission price of five francs. They dined magnificently. Then there was a benefit performance of poems and short plays, which made a disappointing one hundred francs for Gauguin. All of his new Symbolist friends were there. Gauguin was so touched that he managed only to stammer a brief word of thanks instead of giving a glowing farewell speech.

Gauguin stayed at Hotel Dagmar when he visited Copenhagen

The next day, he wrote a proud account of the evening to Mette. He promised that within three years at most she would no longer have to work. Then, with gray hair and surrounded by children—"the flesh of our flesh"—the two of them would lead a peaceful and happy life. From: Your Paul.

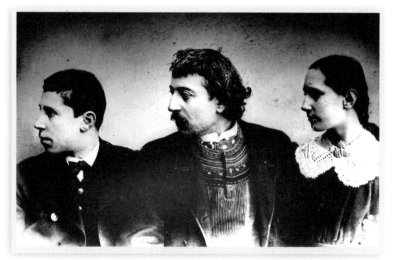

Emil, Gauguin, and Aline in Copenhagen, 1891

TO TAHITI

"For the last thirty days, I have done nothing but eat, drink, and stare at the horizon." Now and then a porpoise jumped out of the water, but that was all, Gauguin wrote to Mette during his journey to Tahiti. He often looked at the photograph of Mette and the children that he had taken with him. On April 1, 1891, he had boarded the *Océanien*, one of the ships of the Messageries maritimes shipping company. The ship took him via the Suez Canal and Aden, Mauritius, Madagascar, Melbourne, and Sydney to Nouméa in the French colony of New Caledonia, where he had to wait nine days for a ship to take him to the island of Moorea, off the coast of Tahiti. Two days after that, he arrived on a ship called the *Durance* in the bay of Papeete, the capital of French Polynesia and of Tahiti. The journey had taken two months in total.

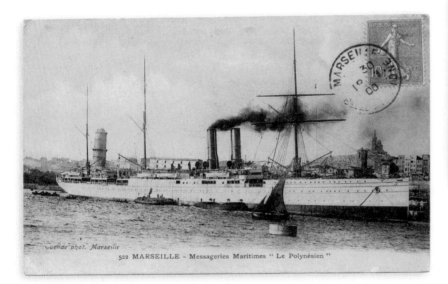

522 MARSEILLE - Messageries Maritimes " Le Polynésien "

In 1891, there were a number of ways to travel from France to Tahiti. Three or four times a year, a ship left Bordeaux for French Polynesia, loaded with wine, cognac, cheese, preserved foodstuffs, and everything that the Frenchman might need overseas. The journey went via the Cape of Good Hope, Australia, and New Zealand, and took no less than four months. A much faster option was the rather expensive route in a westerly direction, on a Compagnie générale transatlantique ship. These ships sailed from Le Havre to New York, after which the traveler took a train to San Francisco before completing the journey by ship. If everything went as planned, that route could be done in six weeks. Gauguin chose another option: the Messageries maritimes connection. These ships, which left Marseille every forty days, sailed to Australia or New Zealand, where the traveler had to take another ship that continued to French Polynesia.

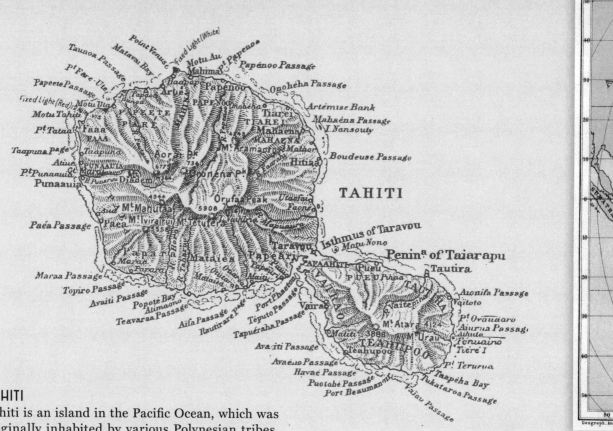

TAHITI

Tahiti is an island in the Pacific Ocean, which was originally inhabited by various Polynesian tribes. These groups had carefully divided the island into districts, which were ruled by tribal chiefs. The arrival of the Europeans, from 1767 on, had catastrophic consequences. The whalers and merchants introduced prostitution, weapons, alcohol, and diseases, which reduced the number of inhabitants by tens of thousands. Then the English missionaries arrived, with the aim of converting the Polynesians to Anglicanism. They received help from a Tahitian tribal chief who, with the support of the British, had been crowned King Pomare of Tahiti. He proclaimed strict laws, as passed on to him by the English. For example, Tahitians were no longer allowed to go around in just a pareu with a flower behind their ear. Women had to cover their entire bodies. Dancing was forbidden, as was singing songs other than hymns. Tattoos below the navel were banned, and Anglicanism became the official religion. Two French Catholic priests were expelled from the country, which prompted the French to come and take a closer look. They sought affiliation with the tribal chiefs who were not support-

Tahitian women in "English" body-covering clothing

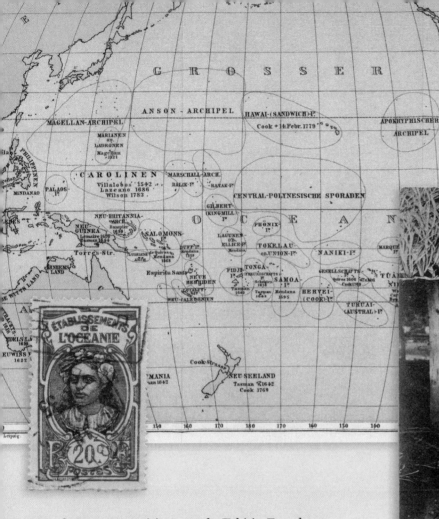

A Tahitian woman with a Bible

ers of Pomare, promising to make Tahiti a French protectorate and allowing the country to retain its independence. At the point when Gauguin arrived, Tahiti had been a French colony for about ten years, and King Pomare V was sitting on the throne in a purely ceremonial role. Under pressure from the French, he had handed over Tahiti in exchange for a monthly payment of 5,000 francs. After more than a century of European domination, there was nothing left of either the Tahitian religion or the mythology that was one of the main reasons why Gauguin was going there.

Papeete was a town with three thousand inhabitants, who did not always live in harmony with one another. Two thousand Tahitians lived there, but it was the one hundred or so French colonists, who only spent time with their own kind, who called the shots. They were posted there from France for three years and did not necessarily know very much about the ins and outs of life in Tahiti. There was also a group of around two hundred French former soldiers and sailors who had settled permanently in Tahiti. They ran cafés and stores and were annoyed by the ignorant and conceited French elite. In addition, there were three hundred British and American businessmen and planters who had lived in Tahiti for generations and had married into the highest Tahitian circles. Finally, there were also around three hundred Chinese people who had been brought to Tahiti in the mid-nineteenth century to work on plantations and who were now running stores, market stalls, and eating places.

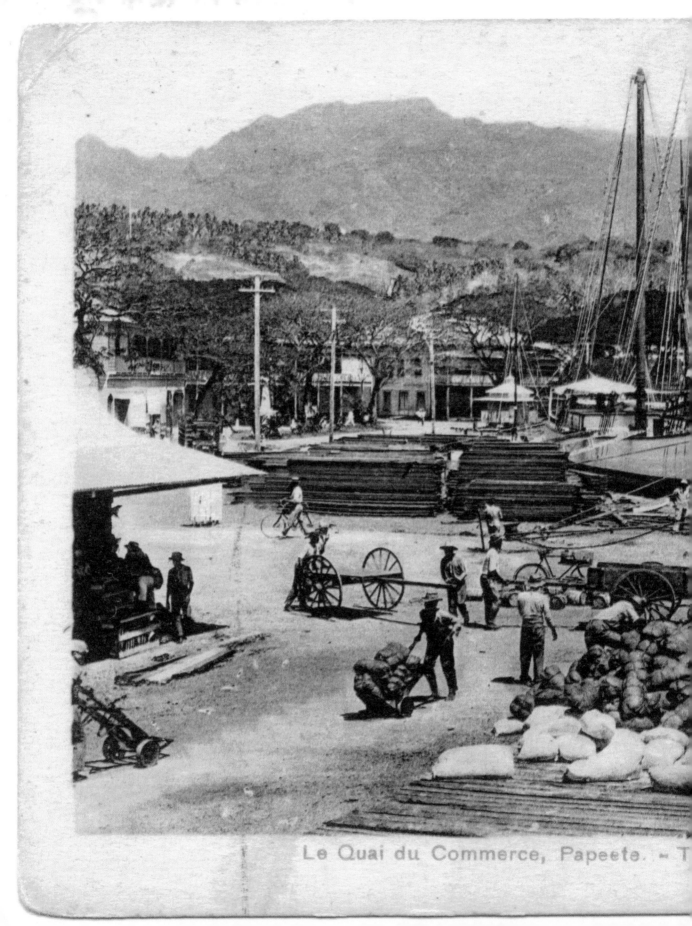

Le Quai du Commerce, Papeete. — T

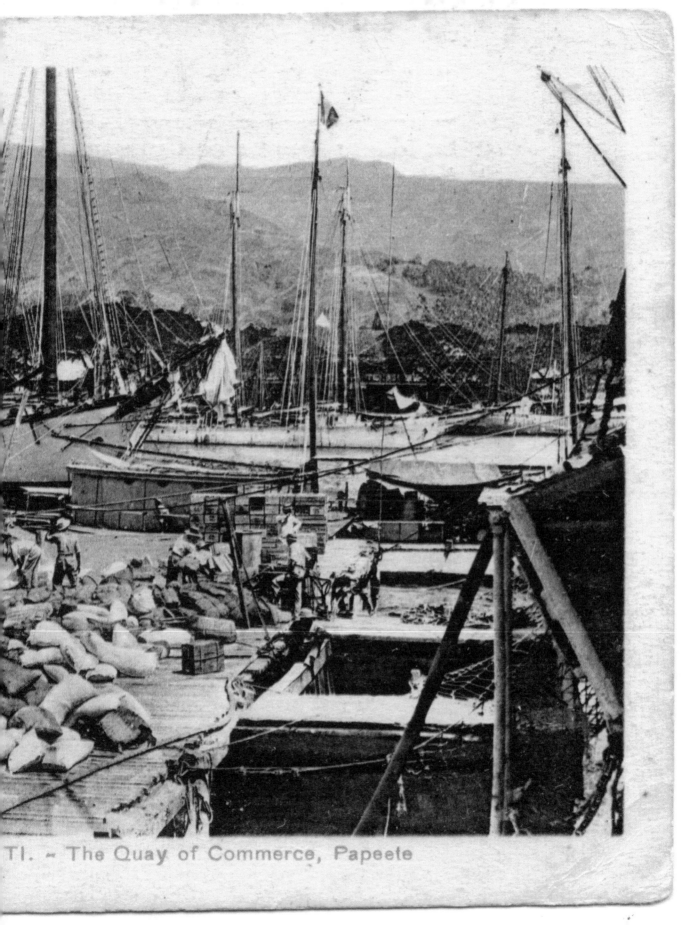

TI. ~ The Quay of Commerce, Papeete

Tahiti ı

THE MAN-WOMAN

On June 9, 1891, two days after Gauguin's forty-third birthday, the *Durance* dropped anchor in the bay of Papeete. It was a disappointment for Gauguin. What Gauguin saw did not even remotely resemble the images of paradise that the brochures and the books by Pierre Loti had promised. He saw no sign of the huts with palm thatches that he knew from the World's Fair. There were European houses on the waterfront, and the women on the shore wore European clothing.

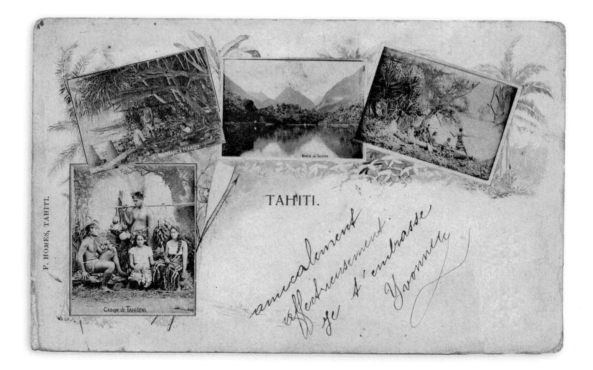

The Tahitians on the beach were dumbfounded when they saw a man with a cowboy hat and salt-and-pepper hair down to his shoulders stepping out of the rowboat. They called him a *taata-vahine*, a man-woman, and made fun of him. We know this from the young naval officer Paulin Jénot, who had been sent to the harbor to welcome the guest from France. He became friendly with Gauguin and, once back in France, he wrote a detailed account of Gauguin's first days in Papeete, during which Gauguin visited him nearly every day, at the hottest time of the day. Gauguin gave Jénot painting and mandolin lessons, so that they could play duets.

Spécimens exacts des Couleurs pour l'AQUARELLE

Spécimens exacts des Tubes pour la PEINTURE à l'HUILE

Jénot tried to teach Gauguin a few words of Tahitian. This was not a success, although Gauguin thought that it was an easy language. He simply could not remember words, and he mangled his sentences.

Jénot also reported that Gauguin had brought with him from France two mandolins, a guitar, a hunting horn, and piles of music by composers including Schubert and Schumann, plus enough painting equipment that he could work at least a couple of months without any worry. There was a large collection of tubes of paint from Lefranc & Cie in Paris, rolls of canvas of various qualities, and substances for preparing the canvases.

Gauguin regularly sat and worked in Jénot's house. One day he turned up with gouges and chisels to carve a Tahitian bowl in which the dish *poi*, a vegetable stew, was served. Jénot kept the bowl that Gauguin carved. When, in 1906, he visited a Gauguin retrospective at the Petit Palais in Paris, he saw to his amazement another wooden bowl that Gauguin had carved in exactly the same way.

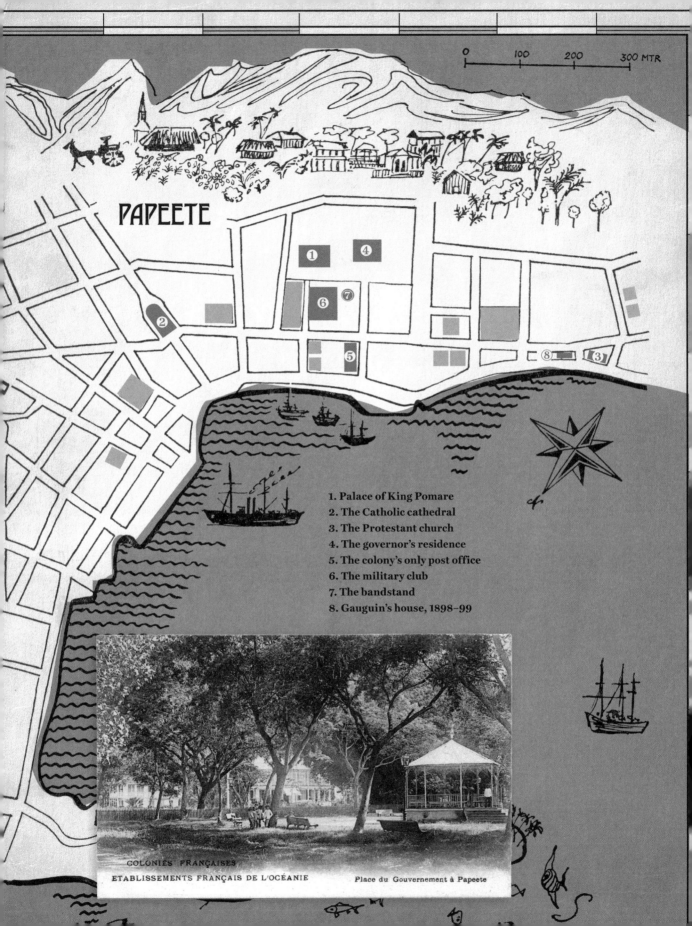

PAPEETE

1. Palace of King Pomare
2. The Catholic cathedral
3. The Protestant church
4. The governor's residence
5. The colony's only post office
6. The military club
7. The bandstand
8. Gauguin's house, 1898–99

COLONIES FRANÇAISES

ETABLISSEMENTS FRANÇAIS DE L'OCÉANIE Place du Gouvernement à Papeete

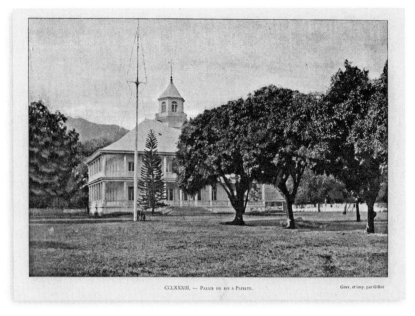

CCLXXXIII. — Palais du roi à Papeete. Grav. et imp. par Gillot

Le Tombeau du Roi Pomare V. - TAHITI. - Tomb of King Pomare V.

The royal mausoleum in Arue

King Pomare V

Left: The bandstand, where a band played twice a week

THE FIRST WEEK

Gauguin was, he wrote to Mette directly after his arrival in Tahiti, very satisfied with his welcome from Étienne Lacascade, the governor of French Polynesia. As a recently arrived Frenchman, he was invited to dinner at the homes of French dignitaries. They showered him with commissions for portraits. Gauguin, who had been planning to leave the capital as soon as possible after his arrival, as he had done in Martinique, postponed his departure to the wilderness for a while. He wanted to acquire as many assignments as possible before he left. He had his hair cut short and bought a white tropical suit.

"Tomorrow I am going to meet the royal family," he wrote to Mette. According to Jénot, Gauguin knew practically nothing about the country where he intended to live for three or so years. For example, he thought that Tahiti was still a kingdom and that King Pomare had the power, while Lacascade had a sort of administrative function, which was a completely incorrect impression of the state of affairs. King Pomare and his family did admittedly live in the most impressive building in Tahiti—a wooden palace next to the government building—but the royals had barely any power. King Pomare spent his days drinking various kinds of imported alcohol and died of this unbalanced diet exactly three days after Gauguin's arrival. So, less than a week after he got to Tahiti, Gauguin walked in the funeral procession to the cemetery in Arue and the mausoleum of the royal family, which, according to biographer David Sweetman, bore a close resemblance to a liqueur bottle. During this occasion, which was attended by Tahitians from all the districts, Gauguin made his first sketches of the Tahitian woman, the *vahine*, his ideal of beauty.

Dancing *vahines*

THE CERCLE MILITAIRE

On Gauguin's first evening in Tahiti, Paulin Jénot introduced him to the Cercle militaire, the club for French officers, where he was welcomed with a garland of flowers. The clubhouse was in the park opposite the palace, and there was a large banyan tree in front of it in which a platform had been built, where the officers could drink their absinthe in peace. From this platform, they had a clear view of the bandstand, where a band played on Wednesday and Saturday evenings. Dozens of *vahines* would turn up in their finest dresses and dance around the bandstand with Tahitians, French sailors, and soldiers. The evening concluded with *La Marseillaise*, the French national anthem, after which the dancers would hurry to the Chinese quarter to drink tea. Gauguin did not stand at the side and watch, as was fitting for a Frenchman with an official mission, but threw himself into the festivities. He took different women home with him and was not exactly discreet about it. The French elite were scandalized and

French dignitaries in Papeete. Front center, Governor Lacascade

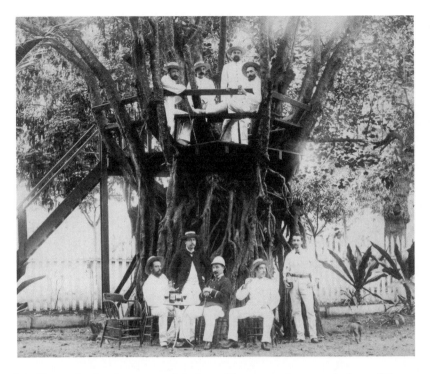

his dinner invitations soon dried up. The portrait commissions did not come to much either. Gauguin began a portrait of Suzanne Bambridge. Her father, who had commissioned the portrait, paid 200 francs for it, but was not pleased with the unflattering picture. It ended up in the attic and Gauguin could forget about any other portrait commissions. Tahiti is becoming French, too, Gauguin complained to Mette. He had ended up in the Europe he had fled. He wanted to leave Papeete as soon as possible and head into the jungle in search of the unspoiled Tahiti.

A street in Papeete

THE ROAD TO MATAIEA

When he was back in Paris, Gauguin wrote an autobiographical novel about his journey to Tahiti, called *Noa Noa*, which is very similar to Loti's romantic *Le mariage de Loti*. The protagonist found his hut between the mountains and the sea in the district of Mataiea, where he did not feel like a prisoner, as he had in European houses. He sat at the tide line, and the villagers wandered around half-naked, as did he. They threw out a fishing net or chopped coconuts down from a tree. The protagonist was struck by the deafening silence on the first night, when all he could hear was the beating of his own heart.

According to the Swedish anthropologist Bengt Danielsson, who lived in Tahiti fifty years after Gauguin and spoke to people who had known him, the image that Gauguin sketched of Mataiea did not exactly match reality. Danielsson said that Gauguin had no need to hack his way through the jungle to get there, as there was a road along the coast that linked the villages. There was even a daily coach from Papeete. Three benches had been installed in the coach, so that nine passengers in total could sit in it. The coach, which had a mailbox attached, was pulled by two to four horses. Around five hundred people lived in Mataiea, which was around twenty-eight miles from Papeete, in 150 huts and houses around the bay. It was, in fact, quite a developed area, with a Protestant and a Catholic church and a Catholic primary school. French colonists lived there, making their money by growing sugarcane. A Tahitian who had become wealthy by trading oranges offered Gauguin a brand-new Western-style house to rent with verandas on both sides, but

Tahitian men dressed in "English" jackets

to everyone's surprise Gauguin preferred the house where the orange trader himself lived, an oval bamboo hut with a view of the sea, a roof made of palms, and dried grass on the floor. He had no immediate neighbors, but still did not live far from the civilized world. Danielsson writes that he must have been able to hear the church bells ringing from his hut. There was, of course, also a gendarme in Mataiea, who fined Gauguin almost immediately after his arrival for nude swimming.

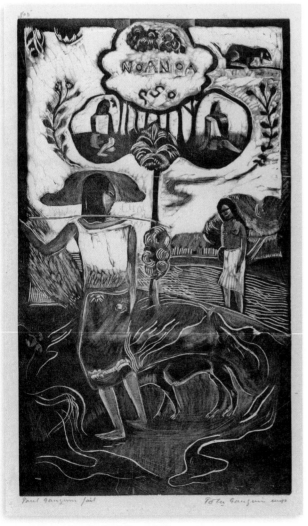

Noa Noa, woodcut by Paul Gauguin from 1894–95.
National Gallery of Art, Washington, DC

NOA NOA

Gauguin's everyday life, as described in *Noa Noa*, should also be taken with a pinch of salt, writes Danielsson. The protagonist is a civilized but stupid Westerner, who discovers that money buys you nothing in the "jungle." On the second day, he runs out of provisions. With a rumbling stomach, he sits outside his hut, philosophizing about the wealth of nature that is reserved for those who have learned how to fish, hunt, and climb trees. He turns down an invitation to eat with one of his neighbors and, full of shame, retreats to his hut. A few minutes later, a girl places some cooked vegetables and fruit in front of his door, wrapped in leaves. Without saying a word, he accepts the food.

In reality, there was a village store in Mataiea, where Gauguin bought imported and expensive foodstuffs such as white bread, beans, macaroni, rice, canned meat, butter, cheese, and sugar, and where he could also get French wine, absinthe, and tobacco. No fresh foods were sold at the store, as the Tahitians caught their own fish and wild pigs, grew their own vegetables, and headed into the mountains on Saturdays to look for wild red bananas. They spent a large part of the day with their families, gathering food, just enough for themselves. Selling food was not the norm. Gauguin had no land, of course, and he knew nothing about peasant life in Tahiti. He was neither a hunter nor a fisherman, did not know the mountains, and had no idea where to find bananas. Even if Gauguin had spent all day looking for food, he still would not have been able to live like a Tahitian, claimed the anthropologist Danielsson. Besides, he would have had no time left to paint.

The protagonist of *Noa Noa* did learn how to live as a Tahitian among the Tahitians. He was accepted by the community and went out fishing with the men. He went into the mountains with a friend named Jotefa, where, with blood-covered hands, he chopped down a tree in a kind of blind frenzy, until it was "just as dead as the old civilization within me," after which he was reborn as a Tahitian.

TEHA'AMANA

It was clear that Gauguin, like the writer Pierre Loti, wanted to have a Tahitian wife in his paradise. He found his Eve when he borrowed the gendarme's horse and went out to explore the eastern coast. Teha'amana was offered to him by her mother, who probably thought she was dealing with a rich Frenchman. Teha'amana, who is called Tehura in *Noa Noa*, was thirteen according to Gauguin, of marriageable age by Tahitian standards. However, he still explained in passing to the reader of *Noa Noa* that a thirteen-year-old in Tahiti was comparable to an eighteen- or twenty-year-old in France.

The marriage was soon agreed upon. Gauguin asked if she was scared of him. No. If she wanted to live in his hut. Yes. If she had been sick. No. Then Teha'amana walked behind Gauguin's horse, followed by her family. A little later, the procession stopped at a hut, where, much to Gauguin's surprise, some foster parents of Teha'amana lived. They wanted to negotiate with him. He was told that Teha'amana could stay with him for a trial period of eight days. Then, in consultation with a number of other parents, it would be decided if the marriage could go ahead.

Postcard with photographs of Tahitians. The picture in the middle is possibly Teha'amana.

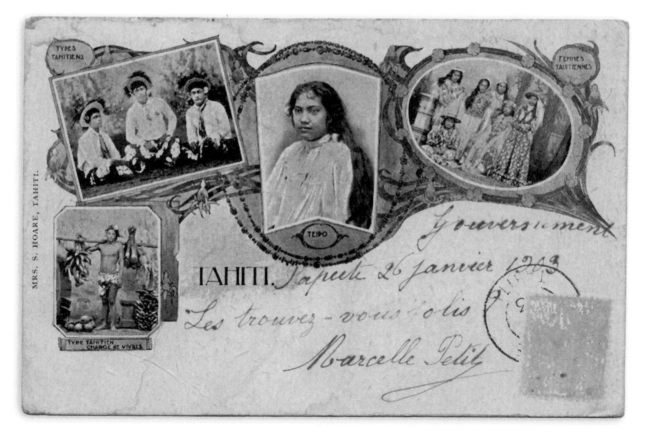

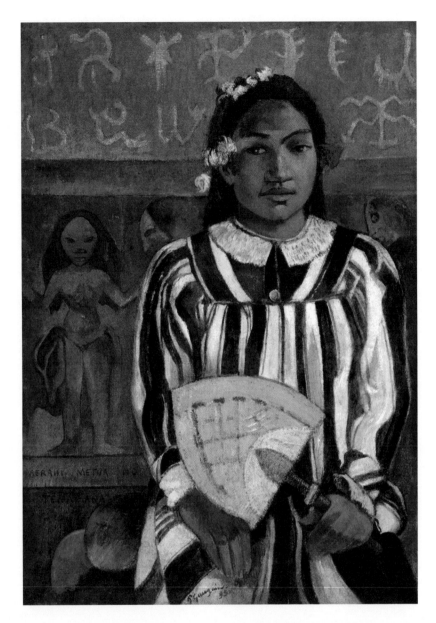

Like most of Gauguin's women, little is known about Teha'amana. There is a photograph, but it has never been proved that it was her. Equally, we do not know for certain that she was really thirteen. It is not very likely that she told Gauguin all kinds of exciting stories about magic and about the gods of Polynesian mythology, as there was very little left of them after a century of European domination. Those stories in *Noa Noa* were clearly from a book that Gauguin had borrowed and from which he copied into a notebook all the parts that he found interesting. There is even a theory that the character of Tehura, as she is presented in *Noa Noa*, is a combination of different models and lovers that Gauguin saw during this period.

This tendency to combine sources applied to his painting as well. Gauguin also made use of the collection of postcards and clippings of art that he pinned to the walls wherever he was living. In a letter to an artist acquaintance he called this collection "my little friends." One of the pictures that Gauguin had with him was of Édouard Manet's 1863 painting *Olympia*, a work that had caused a commotion because it clearly depicted a naked prostitute looking directly at the viewer from the canvas. Shortly before his departure for Tahiti, Gauguin had made a copy of the painting. It must have inspired him to make his work *Manao tupapau*, which according to Gauguin meant "Spirit of the Dead Watching"; this, too, was intended as a controversial painting.

In *Noa Noa*, he told the story behind this work. Gauguin's coach broke halfway home after a visit to Papeete, so he had to walk the rest of the way. He arrived late at night. The light at home had extinguished because the oil had run out. Gauguin lit a match and saw Teha'amana lying petrified on the bed. It took her a moment to recognize him, then she became angry, as she had had to wait so long for him. What had he been doing all that time in Papeete? Had he been with other women?

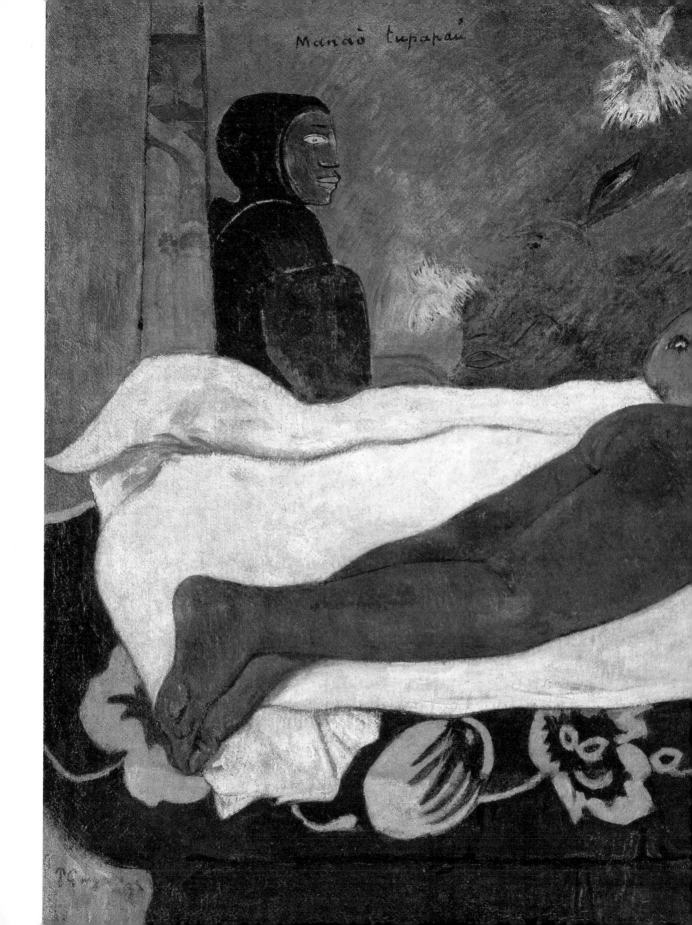

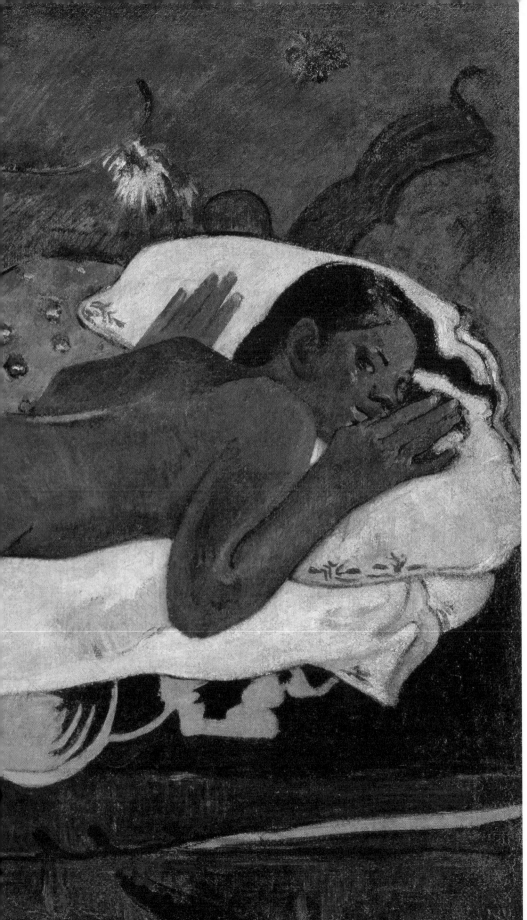

Manao tupapau (Spirit of the Dead Watching), 1892. Albright-Knox Art Gallery, Buffalo

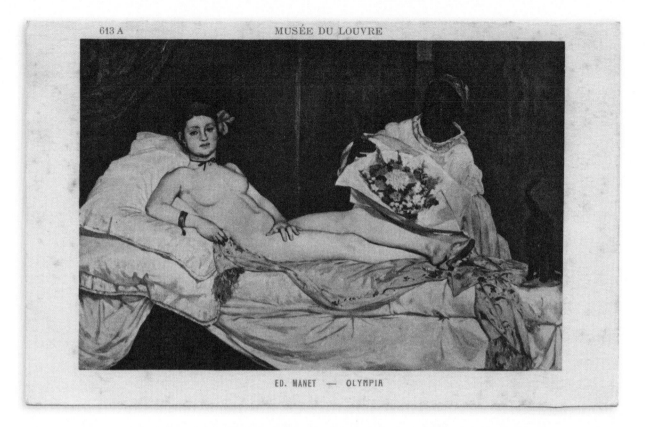

Édouard Manet, *Olympia*, 1863.
Musée d'Orsay, Paris

"I have painted a nude of a young girl," wrote Gauguin to Mette, who was arranging an exhibition of Gauguin's work in Copenhagen. She would be certain to see *Manao tupapau*. It was on the verge of indecency, according to Gauguin, but that was precisely the intention. Regarding the fear on her face, he mentioned that Tahitians were afraid of the spirits of the dead and never slept without a burning lamp in the room. This was in case critics asked Mette difficult questions about the work.

He did not add that Teha'amana was his lover, let alone that she was pregnant by him and that Juliette, his mistress in Paris, had since given birth to his child. Gauguin did write to De Monfreid about this though. "I am going to be a father here in Oceania. Good Heavens, I seem to be sowing seeds everywhere! It can't do any harm here, as children are welcome and are raised by all of the family." Teha'amana's child was never mentioned in subsequent letters. Maybe she had a miscarriage or perhaps she gave the child to foster parents.

Right: The post office in Papeete

BACK TO FRANCE

"I am starting to believe that everyone in France has forgotten me," Gauguin wrote after just a few months in Tahiti to De Monfreid, who had gradually taken over Schuffenecker's role as confidant and agent. Mette and the children did not write nearly often enough either, he grumbled. She could spare half an hour for him once a month, couldn't she? In a fit of homesickness, Gauguin began to make a book specially for his favorite child, Aline, with notes, memories, and reviews clipped out of French newspapers, in which he underlined his own name (see page 157). What was worse, though, was that absolutely no money was coming in. Morice, who had been going to send him 500 francs, did not deliver. Mette was going to sell some paintings and send him the proceeds, but she needed money herself. Gauguin also became ill, coughing up a large amount of blood every day. He was admitted to the hospital in Papeete with what was most likely a neglected case of syphilis, although he wrote about heart problems in his letters.

36 - TAHITI - Le Port de Papeete — The port of Papeete - Inter Island trading Schooner

In order to save money, he left the hospital after a few days, against the doctor's express advice.

Whenever a mail boat moored in Papeete, Gauguin slowly traveled the thirty miles in the coach to the post office, after which he had to travel the same distance back to Mataiea, usually empty-handed. It was both tiring and time-consuming. On June 1, 1892, there was still no money. Gauguin had actually wanted to travel on to the Marquesas Islands, also part of French Polynesia, but, he had heard, more authentic than Tahiti. Now he had to change his plans. He wrote a letter to the Department of Fine Arts in Paris to say that he would like to return. He did not hear until November that his repatriation had been approved, as long as Governor Lacascade paid for his return journey. The governor loathed the artist and refused to pay, so Gauguin sent a number of pleas to influential people in Paris. In the spring of 1893, he finally received some money for paintings that had been sold and heard that he would be getting a return ticket. The message had been passed from ministry to ministry. Gauguin heard from Lacascade that his ticket had been approved. Third class. He was furious.

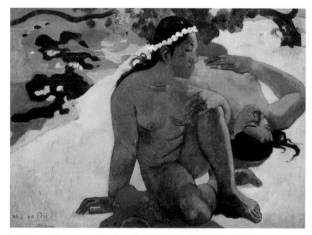

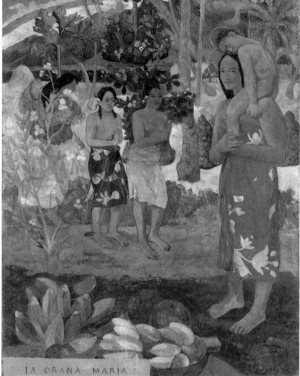

Tahitian Women on the Beach, 1891. Musée d'Orsay, Paris

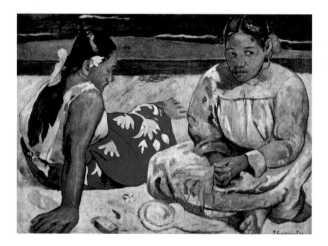

Above: *Ia orana Maria (Hail Mary)*, 1892.
The Metropolitan Museum of Art, New York

Left: *Aha oe feii? (Are You Jealous?)*, 1892.
Pushkin State Museum of Fine Arts, Moscow

FAREWELL TO TEHA'AMANA

On June 4, 1893, Gauguin boarded the *Duchauf-fault*, with luggage including sixty-six paintings that are considered to be among his masterpieces. In *Noa Noa*, he sketched his farewell to Teha'amana, who sat, sad but calm, after nights of crying, on a rock on the shore with her feet in the water. The flower from behind her ear had fallen onto her knees. The scene appears to have been taken directly from *Le mariage de Loti*, although in that case it was Loti who cried when saying farewell.

On board the ship, he wrote to Mette: "In the last six months, I have regained my strength and put on a little weight. You will find a husband to embrace you not too much like a skinned rabbit and by no means impotent."

In New Caledonia, Gauguin had to spend more than three weeks at a hotel before he could board the *Armand Béhic* for Marseille. His arch enemy, Governor Lacascade, was also on board, on his way to an inferior post in the Indian Ocean, having been demoted, which somewhat eased Gauguin's suffering. Gauguin paid out of his own pocket for a second-class passage. He would not give Lacascade the pleasure of seeing him among the rabble. He arrived in Marseille at the end of August. No one was waiting for him. Gauguin had less than four francs in his pocket and had to borrow money to travel to Paris.

Paris VII

THE INHERITANCE

Less than a month later, Gauguin went traveling again, this time to visit his family in Orléans. His Uncle Zizi, his father's brother, had died. There was frequent correspondence between Denmark and France. Mette, who was, after all, looking after five children, was very interested in this inheritance. Meanwhile, Gauguin wanted, as quickly as possible, to have back the paintings that had been exhibited with Van Gogh's in Copenhagen. Degas had been able to arrange for a solo exhibition at the famous Parisian gallery Durand-Ruel, and the Tahitian works must be included. Gauguin wrote to Mette that she should not expect too much from the inheritance. Once all of the property was sold, there would be 9,000 francs at most, and he had to share that with his sister, Marie, who was now living with her husband in Colombia. He also had to invest in the exhibition at Galerie Durand-Ruel, wrote Gauguin, which would hopefully be a resounding success. Both of their futures would depend on it.

FIRST SOLO EXHIBITION

Gauguin had Degas to thank for the fourteen-day solo exhibition at Galerie Durand-Ruel. He had put in a good word for him, as Durand-Ruel had little faith in Gauguin's work. The agreement was that Gauguin would pay all the costs and make all the arrangements himself. He had around forty-five works framed, in simple white frames, and he had invitations, a poster, and a catalogue printed. On November 10, 1893, he awaited the guests for the opening of an exhibition of forty-one paintings from Tahiti, three from Brittany, a ceramic piece, and a number of wooden sculptures. The forty-five-year-old artist had dressed up for the occasion. He made a dramatic entrance, in a dark blue cape, a belt with a large buckle, checkered pants, and a Russian fur hat. Gauguin gave Degas a carved walking stick from the exhibition to take home.

According to Gauguin, eleven of the works were sold, including two to Degas, although Durand-Ruel's paperwork does not show that a single transaction took place. Gauguin wrote to Mette that the exhibition sadly had not been a success in terms of sales, but that it was certainly an artistic success. He had received a lot of attention from the press, both positive and negative. During that time, thanks to his former friend Bernard, selections of Vincent van Gogh's letters were regularly

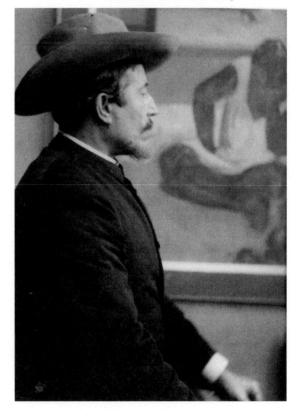

Gauguin during the exhibition
at Galerie Durand-Ruel in 1893

1098 — PARIS. L'Eglise Notre-Dame du Travail. Rue Vercingétorix, possédant la Cloche offerte par l'Empereur Napoléon III, qui fut baptisée le 4 juin 1860. L'Impératrice Eugénie et le Prince Impérial furent parrain et marraine.

printed in *Mercure de France*, and these marked the beginning of Van Gogh's worldwide fame. All of Paris knew the identity of the "G." who was mentioned in the letters a number of times. Negative attention was, he wrote to Mette, a sign that people were taking him seriously. "I am considered by many people here to be the greatest modern painter."

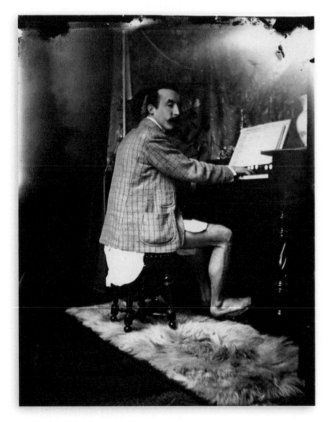

Gauguin sitting at a harmonium in the studio of the artist Alphonse Mucha, 1893–94

..

Left: Rue Vercingétorix

THE YELLOW STUDIO

Gauguin wrote to Mette that he had no time to come to Copenhagen for now, as he was working hard on his book *Noa Noa*, which was intended to show the French armchair traveler what Gauguin's Tahitian work was about. He made a series of woodcuts as illustrations. He suggested to Mette that they should rent a fisherman's hut in Norway in the near future, where he could work and where his family could come and stay during the vacations. He also complained about his health and about his constant lack of money. In a letter a few weeks later, he had to confess that it would unfortunately be another six months before the inheritance was paid out. Mette, who was at the end of her tether, reminded her husband that he had five children in Copenhagen who were entitled to at least half of the inheritance. "How can you accuse me of withholding money?" replied an indignant Gauguin. He sent a list of expenses he had had to incur since his return from Tahiti and a list of his ailments that had flared up again, including a rheumatic pain in his shoulder that spread to his arm and a problem with his heart. If he started coughing up blood again, he warned her, it could prove fatal. In January, he complained again about the deafening silence from Copenhagen. He had not received any mail on his birthday, nor at Christmas or New Year's. Had they forgotten him? But, no, Mette had not forgotten him. She was too angry to write, she told Gauguin's old friend Schuffenecker. Nothing more could be expected from her selfish husband. "He thinks of no one but himself."

Slowly Gauguin became aware that Mette was a lost cause. When the money from the inheritance finally arrived, he rented two large rooms on the top floor of a building on Rue Vercingétorix. He painted the walls chrome yellow and filled them from floor to ceiling with his own works. He had an open house there every Thursday for writers, painters, and musicians. In Paris, he met a Sri Lankan painter's model who was known as Annah la Javanaise. She moved in with him, along with her monkey, Taoa, and a parrot. He also got back in touch with Juliette, who had given birth to his daughter Germaine when he was in Tahiti.

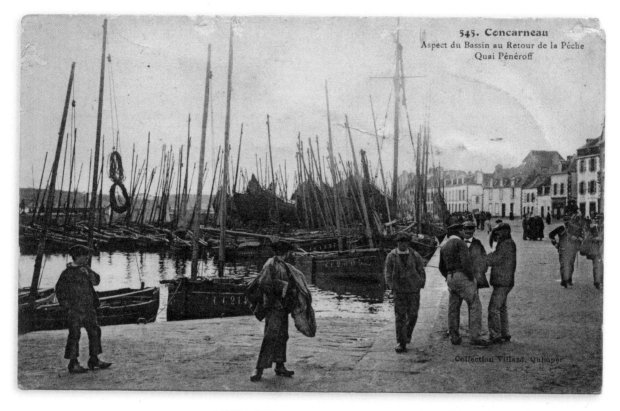

Collection Villard, Quimper

545. Concarneau
Aspect du Bassin au Retour de la Pêche
Quai Pénéroff

SETBACKS

In 1894, Gauguin had to deal with one setback after another. It started when a group of fishermen threw stones at him and Annah during a walk along the harbor in Concarneau, Brittany, because they thought they looked funny. One of the fishermen directly attacked Gauguin, and the artist knocked him down with two blows. Around fifteen men then jumped on Gauguin and he said he could have taken them all on, were it not for the fact that he stepped in a pothole. He lost his balance, fell, breaking his ankle, and had to be carried back to the inn in Pont-Aven. Six months later, he wrote to Charles Molard, his downstairs neighbor in Rue Vercingétorix, that he was recovering. He could now stumble through the village with the aid of a stick. He fought the pain with morphine and put himself to sleep with alcohol.

7.- CONCARNEAU. - Quai Pénéroff et les Sardiniers.

The harbor in Concarneau

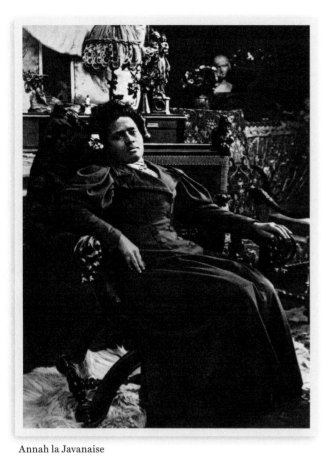

Annah la Javanaise

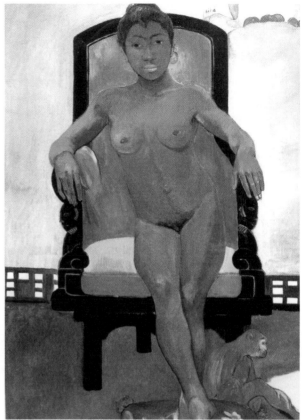

Annah la Javanaise, 1893. Private collection

Meanwhile there was a court case against the brawlers in Concarneau. The verdict was extremely disappointing. Gauguin received only 600 francs in damages, while he had spent a fortune on the doctor, lawyer, and hotel where he was recuperating. He had also started a case against Marie Henry, the landlady of the Buvette de la Plage in Le Pouldu, where he had stayed with Meijer de Haan. She did not want to return the works that Gauguin had left in her care, as he had never paid off his debts. It was hopeless. It all demonstrated that the legal system in France was completely corrupt, Gauguin wrote to Molard.

In the fall, Annah left for Paris—without her monkey, as it had died after eating a poisonous plant. Annah was supposed to prepare the accommodation for the invalid Gauguin's return. However, she used the opportunity to loot his studio and run off with all his belongings. She left only the paintings behind.

After that, at a dinner with other artists, Gauguin announced his return to Polynesia. This time he was leaving France for good. If he had to choose between the "sauvages" of Paris and those in Tahiti, he knew which he would rather have.

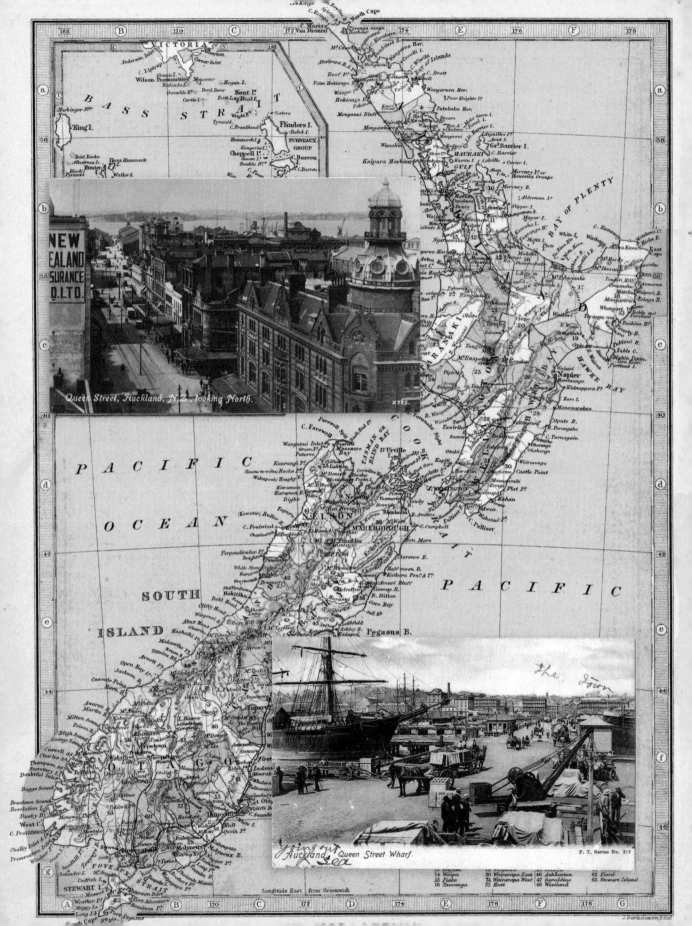

Queen Street, Auckland, N.Z., looking North.

NEW
EALAND
SURANCE
O.LTD.

Auckland, Queen Street Wharf.

New Zealand

ARRIVAL **AUGUST 19, 1895**
DEPARTURE **AUGUST 29, 1895**

AUCKLAND

Gauguin, not on an official mission this time, took the shortest route, via Australia and New Zealand, which was the largest of the Polynesian islands and once the land of the Maoris, but by then a British colony. When he reached the metropolis of Auckland, it turned out that the *Richmond*, the ship that was to take Gauguin to Tahiti, was delayed. Gauguin took the first hotel he found, not far from the harbor, and waited ten days until he could continue his journey. He did not know anyone there, he did not speak English, it was cold, and he was bored at the hotel. One day he dragged himself up a hill to visit the Auckland Institute and Museum. There, to his excitement, he saw authentic Polynesian art of the kind that he had been unable to find in Tahiti. He left the museum with a number of postcards for his collection of "little friends." On August 29, he boarded the ship with the intention of traveling straight on to the Marquesas Islands once he arrived in Tahiti. He had heard that there was more "primitive" art to study there.

Maori hut that Gauguin saw at the
Auckland Institute and Museum

Tahiti II

PUNAAUIA

In Papeete, civilization had advanced in the meantime, much to Gauguin's annoyance. Electric lights had been installed. Next to the palace there was a steam-driven carousel with spotted wooden horses and a shrill whistle. Cycling and tennis in sports clothes were in fashion. As quickly as he could, Gauguin left the town, but he did not take up residence in the distant Mataiea again. Instead, he rented a piece of land only nine miles from Papeete, in the village of Punaauia, where he had a large oval hut and studio built of bamboo and palm leaves. From the hut,

he had a view of the bay and the island of Moorea and he saw the most beautiful sunsets. His inheritance from Uncle Zizi allowed him to give parties and to purchase a horse and carriage, which he needed because of his painful leg. He only had to cross the road in order to visit the grocery store. The Tahitians and the French liked to come to his house, as Gauguin served a good *omelette baveuse*—still soft on the inside—and behind the door there was a vat containing two hundred liters of imported red wine, which was constantly replenished.

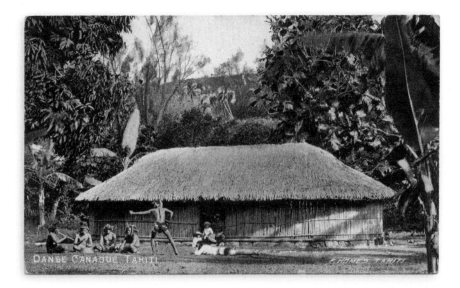

Hut, or *fare*, of the kind that Gauguin had built

Shortly after settling in Punaauia, he sent for Teha'amana. She had since married a boy called Maari, but that did not stop her from moving back in with Gauguin. He welcomed her with all kinds of jewelry, but within a week she returned to her life in Mataiea. Her husband, Maari, later reported that she had fled because of Gauguin's leg, which was covered in festering sores. She thought it was a sexually transmitted disease. A new *vahine* was soon found. Pahura came from a large family in Punaauia. She was fourteen. She looked nothing at all like Teha'amana, and was much less obedient. Although she officially moved in with Gauguin, she spent much of her time with her family.

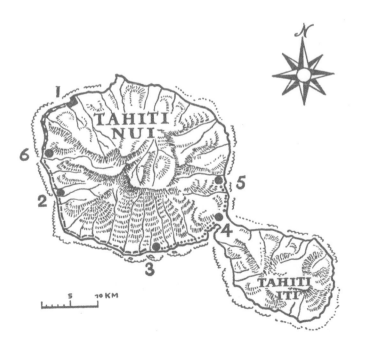

SICK AND BROKE

With the few thousand francs remaining from Uncle Zizi's inheritance, Gauguin should have been able to live in Punaauia for at least a year, according to Bengt Danielsson. But Gauguin raced through the money in six months. Then he was poor again and waited desperately for the mail boat to see if any money had been

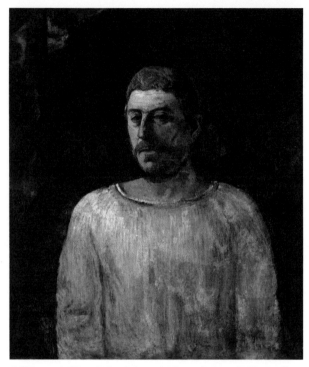

Self-Portrait (Near Golgotha), 1896. Museu de Arte de São Paulo

sent from paintings sold in Paris. He also expected a great deal from the book *Noa Noa*, which was due to be published in France at any moment and should prove at least as popular as Loti's bestseller. But there was no news from the poet Morice, who was supposed to edit the text and find a publisher, and the money did not come either.

Gauguin bartered for food wherever he could, in exchange for paintings that no one wanted. Then his mysterious illness struck again. The symptoms worsened and the pain in his badly healed ankle became so intense that he could not stand at the easel for long but had to take painkillers and lie in bed. "I no longer have the strength for it," he wrote to De Monfreid. He suggested that his friends in Paris should urge their wealthiest acquaintances to send money to Tahiti on a monthly basis, in exchange for paintings. He even sent a list of names and a contract written in semilegal jargon. But it was no good. He was just about the only one who thought it a good idea.

Gauguin dragged himself to the hospital, where he was nursed for eight days. He left without paying. Once he was back in Punaauia, he made the self-portrait in a hospital gown that he called *Near Golgotha*, once again identifying himself with Christ, who was crucified at Golgotha.

Photograph of Gauguin's hut
by Jules Agostini

DOWN TO WORK

After much insistence, Gauguin received a commission from Auguste Goupil, a lawyer who was also a coconut trader. He lived in a big house in the north of Punaauia. He sent his youngest daughter, Vaïte, to Gauguin's hut to pose for him. She remembered it as a very uncomfortable situation. There was no furniture in the house, and Gauguin was naked except for a pareu. He was silent the entire time. Monsieur and Madame Goupil were, however, very satisfied with the result, and they hired the artist as a drawing teacher for their daughters. But this was not the career that Gauguin had dreamed of. He lasted for two months. Then he argued with Goupil and was fired. To annoy Goupil, who had filled his garden with sappy statues, Gauguin carved a provocative sculpture of a naked woman and placed it in his own garden. However, it was Father Michel, the priest from the nearby Catholic church in Punaauia, who was most bothered by it. He demanded that the genital area should be covered and threatened to kick it over. As a precaution, Gauguin warned the police. The priest's only option now was to fight Gauguin from the pulpit. Gauguin was not exactly popular in the rest of the village and in Papeete during this period. Even in the early 1940s, some Tahitian tradespeople would still explode when interested visitors asked about their memories of Gauguin. "He was only nice when he needed something from you!"

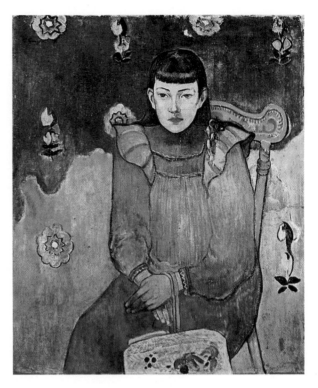

Portrait of a Young Woman, Vaïte (Jeanne) Goupil, 1896. Ordrupgaard, Copenhagen

Vaïte Goupil and her sisters at the easel

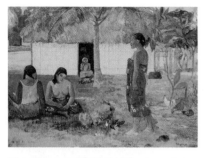

Ne te aha oe riri (Why Are You Angry?),
1896. Art Institute of Chicago

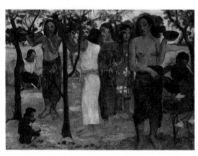

Te tamari no atua (The Son of God), 1896.
Neue Pinakothek, Munich

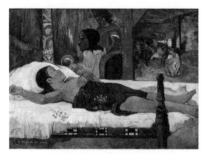

Nave nave mahana (Delicious Day), 1897.
Musée des Beaux-Arts de Lyon, France

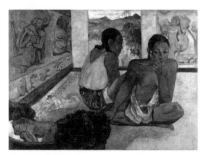

Te rerioa (The Dream), 1897. The
Courtauld Gallery, London

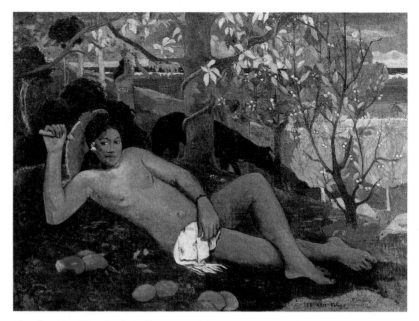

Te arii vahine (The King's Wife), 1896. Pushkin State Museum of Fine Arts, Moscow

PAHURA AND THE MOTHERHOOD SERIES

In spite of the pain in his leg, Gauguin made what he described as "the best I have ever painted." He was talking about *The King's Wife,* a painting in which Pahura is reclining like Eve in this Tahitian paradise and looking out at the viewer without any inhibition. According to the Gauguin biographer David Sweetman, this was a direct message to the art world in Paris. Just before leaving for Tahiti, Gauguin had found no fewer than two poisonous articles about himself in his favorite magazine, *Mercure de France*—not only by the editor-in-chief, but also by Bernard, his former friend. Both accused him of plagiarism. Gauguin was said to have copied everything from Cézanne and Pissarro. With *The King's Wife,* which showed obvious similarities with other works, including Manet's *Olympia,* he wanted to point out that he was not copying, but working in the tradition of European artists.

The year after that, he followed it up with four more paintings of the same size (38 × 51 inches), also showing Pahura, who was now pregnant. According to Sweetman, the paintings form a series depicting various stages of pregnancy and early motherhood. In *The Dream,* the last painting, a contented mother is depicted sitting with her sleeping child. In truth, the daughter of Gauguin and Pahura died a few days after her birth. As always, Gauguin painted the ideal world and not reality. Two years later, on April 19, 1899, Pahura had another child by Gauguin. They called him Emile, like his Danish son, but this time with an *e* on the end.

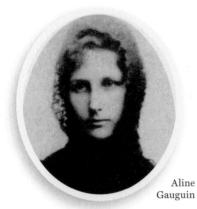

Aline
Gauguin

THE DEATHS OF ALINE AND CLOVIS

The series was only just finished when Gauguin received a brief letter from Mette in April 1897. Without beating about the bush, she informed Gauguin that their nineteen-year-old daughter, Aline, had died of pneumonia, three weeks after returning from a dance party on New Year's Eve with a cold. It was a blunt letter with no affection, Gauguin thought. He sent a furious letter back, but received no response. The news, three years later, that his son Clovis had died of blood poisoning following a hip operation probably never reached him. Mette wrote to Schuffenecker to ask if he would send her Gauguin's address in Tahiti or if he would forward her letter about Clovis's death to him. But Schuffenecker wanted nothing more to do with Gauguin, as he was so shocked about how Gauguin had treated his wife and children.

Gauguin wrote about Aline's death to De Monfreid: "It did not affect me, accustomed as I am to long periods of constant suffering." Not true of course. Gauguin did not have much time to dwell on his daughter's death. He suddenly had to leave his house, as the land he was renting was being sold. He started work on a new house, which was a little to the south. He focused on this new project, this time a wooden house with a studio. He decorated it with carved wooden panels and even managed to obtain a loan for it from the Caisse agricole in Papeete, claiming that he was setting up an agricultural business.

Cover and pages of *Cahier pour Aline*, 1893

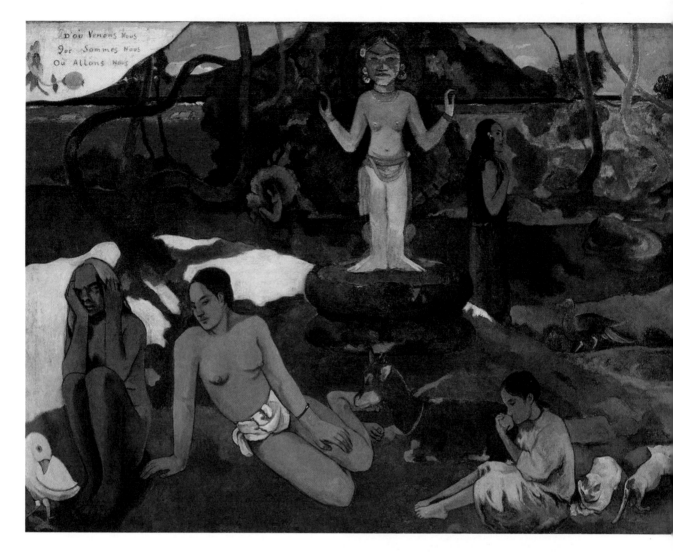

THE TESTAMENT

Then the mysterious illness returned. As well as the usual fever and coughing up blood, Gauguin was struck by a double eye infection that took his sight. He was still suffering from the aftereffects of the broken ankle, and the eczema on his legs looked so serious that, despite treatment with arsenic, leprosy was suspected. He spent most of the day in bed, was unable to work for months, and finally was readmitted to the hospital. During those sleepless nights, he started reading books and writing articles in which he expressed all of his anger and frustration. He began a philosophical reflection on the necessary reforms in the Catholic church, also lashing out at the Protestant church when needed.

When he was home from the hospital, he had a heart attack, then another one the following month. He did not want to return to the hospital though. His body still kept going—in spite of his meager diet of mangoes, guavas, and a few shrimps whenever Pahura could catch them—but he was on the point of collapse. Gauguin did not expect to live to see the publication of *Noa Noa*, but before he died he wanted to make one last painting, one that would surpass all his previous work. In December 1897, Gauguin began his "testament," which is more than 4 ½ × 12 feet, with the title of *Where Do We Come From? What Are We? Where Are We Going?* It was a race against the clock, given Gauguin's failing health. He painted night and day, and the work came into existence beneath his hands,

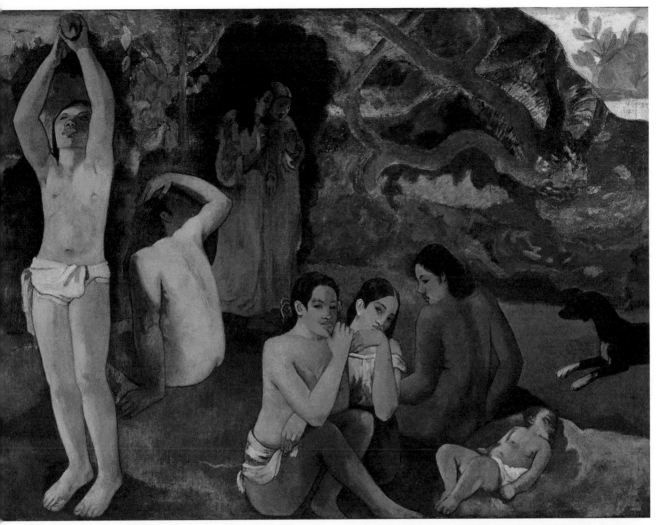

Where Do We Come From? What Are We? Where Are We Going?, 1897–98. Museum of Fine Arts, Boston

The same work, still in the studio

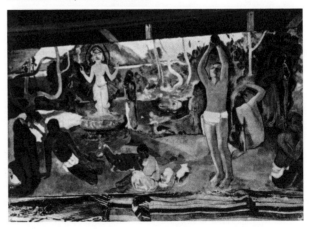

he claimed later. The Christmas boat of 1897 brought the magazine *La Revue blanche* with a first part of *Noa Noa*, which Morice had edited drastically and far too poetically. Gauguin's woodcuts had not been included. Worse, Morice had published it for free in an—in Gauguin's view—inferior art magazine. The mail boat did not bring anything else for him. No letters and no money.

As he was apparently still too healthy to die any time soon, Gauguin decided to put an end to his life himself. On December 30, 1897, he dragged his sick body into the mountains. In a place where no one would be able to find him, he swallowed arsenic, the remedy he was supposed to be rubbing on the eczema on his legs.

"I wanted to be eaten up by the ants," he later wrote in a letter to De Monfreid about his failed suicide attempt. He had vomited up the poison and, after a night of unbearable pain, he staggered back home, where he completed his masterpiece in a single session. It is a dramatic Christmas story. According to the biographer Sweetman, this was a carefully planned PR stunt by Gauguin, and he had already thought out *Where Do We Come From?* in advance. Earlier sketches have indeed been found in Gauguin's papers. Furthermore, the studio happened to have been precisely constructed to accommodate a work of that size.

Daniel de Monfreid, *Portrait of Paul Gauguin*, 1900. Van Gogh Museum, Amsterdam (Vincent van Gogh Foundation)

MEANWHILE IN PARIS

At the beginning of 1898, Gauguin recovered somewhat. He even found a job at the local Department of Public Works in Papeete. His job was to copy documents and supervise other officials, for which he earned six francs a day. He lived temporarily on the outskirts of Papeete, together with Pahura, until she had enough of it and returned to her family in Punaauia. A few months later, as soon as Gauguin received the long-awaited money from Paris, he resigned and returned home, where he found that rats had eaten away at the roof. A number of his works had warped in the rain, and cockroaches had begun to infest the paintings. Gauguin found an officer who was prepared to take *Where Do We Come From? What Are We? Where Are We Going?* and eight other paintings to France. These works left the country in mid-July and arrived at De Monfreid's in Paris four months later, on November 11. Less than a week later, they were hanging on the walls of Ambroise Vollard's famous gallery on Rue Lafitte. The press was full of praise for a change. Vollard, a prominent art dealer, bought all the works. When Gauguin heard, three months later, that he had wheedled them out of De Monfreid for a lousy 1,000 francs, he said: "Vollard is a crocodile of the worst kind." That did not prevent him from working with Vollard, however. He offered something that Gauguin had always wanted: a fixed income in exchange for paintings. Gauguin received 300 francs a month for twenty to twenty-four paintings a year. He insisted that all communication should go through his

loyal friend De Monfreid, so that he would have as little as possible to do with Vollard.

That does not mean, however, that Gauguin immediately started painting. He had acquired a taste for writing. After all, he was the son of a radical journalist and the grandson of a campaigning socialist. He wrote one vicious article after another. The satirical Catholic magazine *Les Guêpes* (The Wasps), which was made in Papeete, was happy to publish them, so Gauguin had plenty of opportunity to spew his bile. He lashed out at both the Protestant church and the colonial authorities, particularly Gustave Pierre Gallet, the new governor.

Coconut trader and lawyer Auguste Goupil

He also blasted the coconut trader and lawyer Auguste Goupil, who had commissioned a portrait from Gauguin and had employed him as a teacher when he was at one of his low points. Goupil had suggested building a railway line from Papeete to Mataiea for the public good, but it just happened to run past his own coconut plantation, as Gauguin mercilessly pointed out.

Before long he was promoted to be in charge at *Les Guêpes*, and writing became a full-time job. He also began his own magazine, *Le Sourire* (The Smile), in which he published caricatures of colonial and ecclesiastical figures in Papeete. By the beginning of 1901, Gauguin had made a complete nuisance of himself in Tahiti, and the governor brought a libel case against him. When things got too hot for him, he decided to carry out an old plan. He sold his house in Tahiti and moved hundreds of miles away, to the Marquesas Islands, where he finally hoped to be free from Western civilization, where the Polynesian cul-

ture had been preserved, and where he could be a native among the natives. His luggage consisted of domestic items, his easel, a camera, a harmonium, a mandolin, a guitar, carvings, and paintings. He also took some wood to make sculptures. The purchaser of the house in Punaauia was furious that the previous owner had left so much junk behind. In the back yard, he burned a large number of dusty sketches, wooden sculptures, and rolled-up paintings.

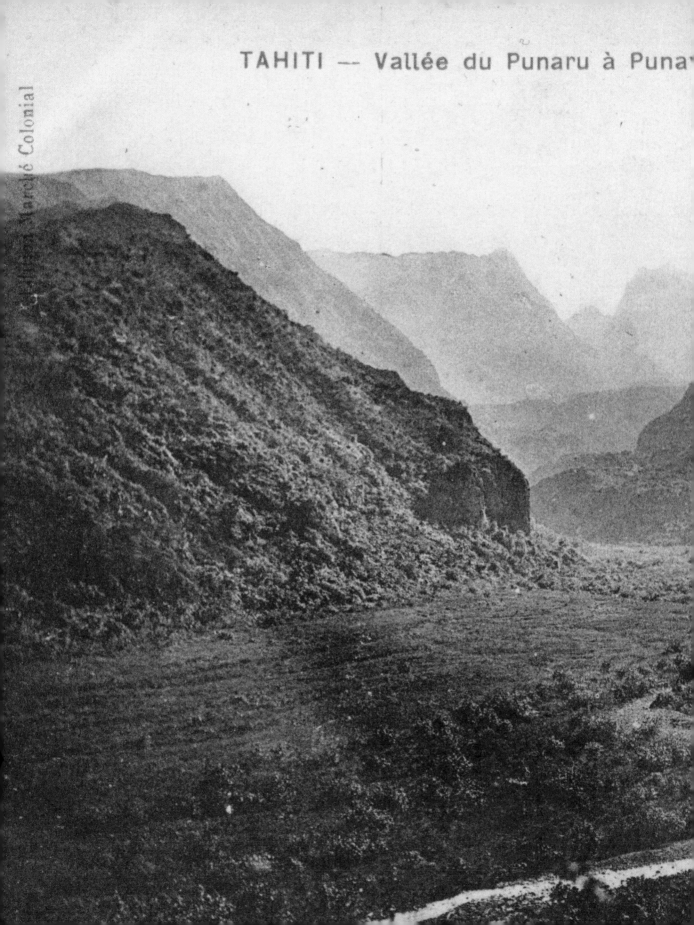

TAHITI — Vallée du Punaru à Puna[...]

HIVA OA

The Marquesas Islands, an archipelago of around fifteen islands in the Pacific Ocean, were—and still are—part of French Polynesia. The French occupied them in 1842 in order to frustrate the British. They had no economic importance. The landscape had a dramatic beauty, but it was also rugged, with forbidding volcanoes, inaccessible bays, and forested mountains. This made it difficult to farm and fish. Various Polynesian tribes, who lived on the breadfruit and fought one another for food, were the original inhabitants of the islands. There were rumors of cannibalism. The French could not endure the life there and preferred to settle on the friendlier and more accessible Tahiti.

This lack of accessibility, however, was exactly what appealed to Gauguin. He assumed that the inhabitants lived in such isolation from the West that their customs, art, and religion had been preserved. But the influence of the West had long since left its mark on the Marquesas, too. Whalers had also introduced alcohol and weapons, which the tribes used against one another. Sexually transmitted diseases had significantly reduced the population. One after another, tikis, the large sculpted figures of Polynesian mythology, disappeared to American and European museums, and the Polynesians allowed themselves to be converted to Christianity, as had happened in Tahiti.

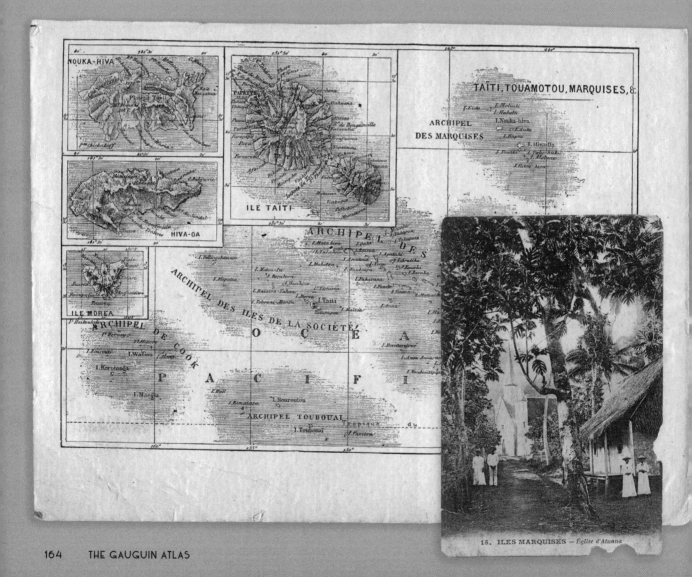

15. ILES MARQUISES — Église d'Atuana

In Hiva Oa, the second-largest island, where Gauguin was to settle, a group of gendarmes kept the peace, functioning when necessary as mayor, magistrate, and lawyer. The Catholic mission also called the shots, with its large church and its girls' school and boys' school, where a total of three hundred students were taught. The local priest, Joseph Martin, had worked his entire career in French Polynesia and had helped to translate the Bible into Tahitian. He had one aim: to get as many children as possible into the Catholic schools. On the west side of Atuona, the settlement that served as the island's capital, there was a smaller Protestant church and a small school under the leadership of Paul Vernier, the local minister. There was huge competition between the Catholics and the Protestants. Whenever Vernier managed to convert someone to Protestantism, Martin would rush there to chase the lost sheep back into the Catholic fold.

Joseph Martin, the local priest

9. - Iles Marquises. - HIVA-OA. - Case indigène et tamb

Congrégation Saint-Joseph de Cluny, 21, rue Méchain. — Paris

MARQUISES. — ATUONA. - Preventorium.

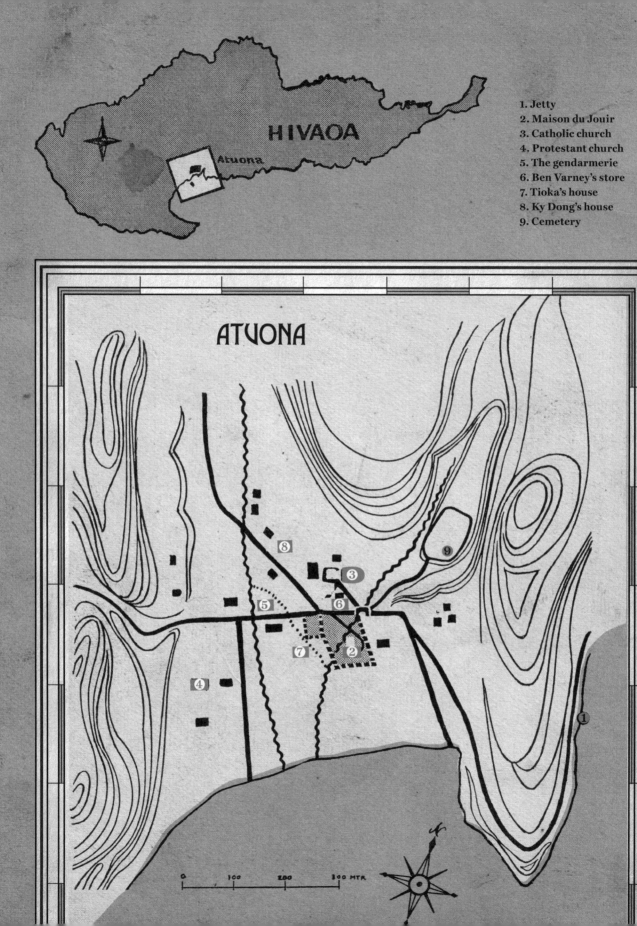

HIVAOA

Atuona

1. Jetty
2. Maison du Jouir
3. Catholic church
4. Protestant church
5. The gendarmerie
6. Ben Varney's store
7. Tioka's house
8. Ky Dong's house
9. Cemetery

ATUONA

0 100 200 300 MTR.

Hiva Oa

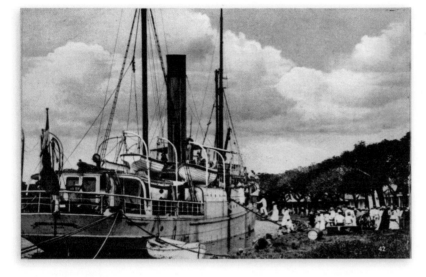

The ship *Croix du Sud*

THE FIRST DAY

On September 16, 1901, after a six-day journey, the *Croix du Sud* moored in the bay of Atuona. The capital city of Hiva Oa was in fact no more than a small settlement, and the inhabitants came to look whenever a ship arrived from Papeete, the capital of French Polynesia. To Gauguin's surprise, he was recognized as soon as he stepped out of the rowboat. Some people knew he wrote for *Les Guêpes*, speaking out against the authorities in both Papeete and Paris.

On the beach, he met an interesting character who would become his friend. This was the twenty-six-year-old Ky Dong, a Vietnamese prince who lived in exile in Hiva Oa because of his rebellion against the French authorities in his own country. Nguyen Van Cam, which was his real name, had studied at the University of Algiers with the intention of taking up an elevated position in Vietnam, but he spent his days in Hiva Oa as a nurse. He was bored, and so the colorful painter was exactly what he needed.

He took Gauguin, who decided there and then to settle in Hiva Oa, to a lady who rented out rooms. Then he gave him a tour of Atuona, introducing him to all the important people. Gauguin actually turned out to know some of them: Dr. Joseph Antoine Buisson had treated him in Papeete, and Désiré Charpillet, the head of the gendarmes, had visited him at his house in Punaauia. They were pleased to see him. During the tour of Atuona, Gauguin, in high spirits, invited every woman he met to come for tea and cakes. Ky Dong dropped off the painter and an entire procession of women at the guesthouse. Gauguin must have thought

The Vietnamese prince Ky Dong

that he had finally arrived in paradise. Ky Dong then hurried to his own home, where, within the space of four days, he wrote *The Loves of an Old Painter on the Marquesas Islands*, a rhyming play. The protagonist is a journalist and Symbolist painter, whose fame resounds throughout the universe and who is wondering why not everyone in Hiva Oa has heard of him.

Ben Varney's grocery store

MAISON DU JOUIR

On the first day, Gauguin started asking around for available pieces of land to build a house on. He had his eye on a plot in the middle of the village, which was close to the American Ben Varney's grocery store and belonged to the Catholic church. So Gauguin decided to go to Mass every day. Father Joseph Martin was happy with this religious parishioner. He already knew that Gauguin had worked for a Catholic, anti-Protestant magazine, and now he saw him sitting in his pews every day, so the sale was settled quickly. Gauguin paid 650 francs and over six weeks he built his most paradise-like home, which he provocatively called the Maison du Jouir (House of Sexual Pleasure). The house was one of the few buildings in Atuona with two stories, and it closely resembled the Maori house that he had seen at the museum in Auckland (see page 151). Gauguin was helped during the construction by his neighbor, Tioka, who was Gauguin's first real Polynesian friend. Tioka suggested to his friend "Koke" (which is how he pronounced *Gauguin*) that, as was customary on the Marquesas Islands, they should swap names as a sign of friendship. So Koke became Tioka, and Tioka became Koke.

MAISON DU JOUIR

The house as described and drawn after Gauguin's death by one of the inhabitants of Atuona.

❶ first floor: two square rooms with a kitchen and carpentry workshop. An open room between them for eating

❷ second floor with sleeping and living sections and studio, carved wooden bed, shelves on the walls with objects on them, two chests of drawers (which were always locked), the har-monium, and the stringed instruments. On the wall, the "little friends" and erotic pictures

❸ entrance door with stairs. Door frame with carved panels

❹ pole with a bottle hanging from it that could be dipped into the well to retrieve water, for diluting absinthe

❺ thatched roof

DECEMBER 2
32 liters red wine 35.20
 francs
20 kilos potatoes 12.00
5 kilos onions 3.50
6 cans tripe 7.80

DECEMBER 4
1 can preserved butter 2.50

DECEMBER 12
1 bag rice 13.00
1/2 kilo starch 0.40

DECEMBER 16
1 can preserved butter 2.50
3 cans asparagus 6.00
2 cans beans 5.00
1 bag salt 0.45
1 bottle tomato sauce 2.00
2 packets tea 2.00
2 cans anchovies 4.00
1 liter vinegar 3.00

DECEMBER 18
10 kilos potatoes 5.00
5 kilos onions 3.50
3 liters red wine 35.20

DECEMBER 26
18 liters red wine 19.80
16 liters rum 56.00
6 cans preserved butter
 14.40
6 cans asparagus 10.80
12 kilos sugar 15.60
1 bag rice 13.00
16.5 liters red wine 18.15
5 kilos onions 3.50
2 kilos garlic 3.00
4 cans asparagus 7.20
1 liter olive oil 5.00

TOTAL: 309.50 FR

Gauguin's Christmas
shopping at Ben
Varney's, 1901

DAILY LIFE

Gauguin had never had it so good. He was living in a big house and had friends from all walks of life. Even the gendarme Charpillet came by now and then for an aperitif. His illness was giving him little trouble, and thanks to the monthly money from Vollard he was a rich man in Atuona. As he had done in Tahiti, he traveled inland to find himself a wife. He came back with Vaeoho, the fourteen-year-old daughter of a tribal chief, who, on November 18, 1901, according to Varney's surviving records, was allowed to select 200 francs of goods at the grocer's store, by way of a dowry. Vaeoho did not have to work very hard, as Gauguin had also taken on a gardener and a cook, as we know thanks to Victor Segalen, a naval doctor who spoke to the staff three months after Gauguin's death. They knew that there was only one rule in the house: Gauguin wanted to eat on time. The cook received instructions early in the morning and then had lunch ready

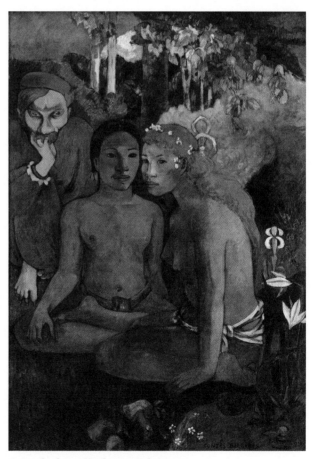

Contes barbares (Barbarian Tales), 1902.
Museum Folkwang, Essen, Germany

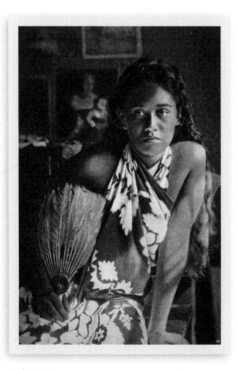

Tohotaua

Menu with a caricature of
the gendarme Charpillet

Père Paillard (Father Lechery),
1902. National Gallery of Art,
Washington, DC

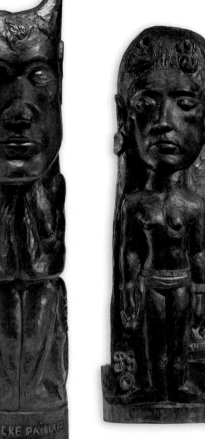

Thérèse, 1902. Private collection

around eleven o'clock. This consisted of expensive imported food, which Gauguin could finally afford, supplemented with fruit and fish that Tioka sometimes brought.

Gauguin rarely ate alone in those early days in Hiva Oa, as indicated by the signed menus that have survived. He gave wild parties at which the wine and absinthe flowed and Gauguin shared his bed with anyone who wanted. Vaeoho, who was pregnant by then, eventually traveled home to give birth to her daughter, Tahiatikaomata. She did not return to Gauguin and it is not known whether Gauguin ever traveled inland to see his youngest child. As far as we know, he never painted Vaeoho. He did, however, paint Tohotaua and her husband, Haapuani, several times, in the most magnificent colors. It had apparently slipped his mind that he had come to the Marquesas Islands to study the authentic Polynesian culture.

THE COURT CASE

The French people in Atuona asked Gauguin—who had been a journalist, after all—if he would convey their grievances to the French administration in Papeete. The taxes they paid went to Paris or were put into projects in Tahiti, but Hiva Oa did not benefit from them at all. To mark the governor's planned visit to Hiva Oa, a letter of complaint should be written. Gauguin was happy to do this and even requested a meeting with the governor. His request was refused, and Gauguin was so angry that he stopped paying taxes. The friendly gendarme Charpillet was instructed to go and collect the tax money from Gauguin. When he got there, a big party was in full swing, and Charpillet was completely ignored.

Father Martin suspiciously watched everything that Gauguin got up to. He had noticed, of course, that Gauguin was no longer coming to Mass, and he had heard that Gauguin was inviting Catholic schoolgirls to his parties and telling their parents that compulsory education was a fabrication of the Church and the gendarmes. Last but not least, Gauguin was

friends with Protestants. From his pulpit, Father Martin began to warn his parishioners about this godless artist. Gauguin reacted as he had done on previous occasions: he carved one wooden statue, called *Père Paillard (Father Lechery)*, with devil's horns and another of the half-naked servant girl with whom the priest was rumored to have had an affair, and he put these on either side of the stairs to his house.

SICKNESS

Nine months after his arrival in Hiva Oa, Gauguin's syphilis flared up again, worse than ever. The eczema was on both legs now, and Gauguin made a walking stick for himself with a handle in the shape of a penis. He bought a horse and cart so that he could travel around the village. Gauguin was deprived of medical care in Hiva Oa. There was no hospital, and Dr. Buisson had been called back to Papeete. Although Ky Dong was a nurse, he knew nothing about diseases. The only person with any medical knowledge was Vernier, the Protestant minister. Gauguin got morphine from him. He also swallowed all the medicine that Varney could import. The empty bottles were found not long ago. However, this did little to help. By the end of 1902, Gauguin could no longer stand at an easel because of the pain, and he spent his days in bed. He wrote *Avant et après*, about his life before and after his rebirth as "un sauvage" in Tahiti. He also bombarded friend and foe alike with letters. He had an opinion about everything, writing an impassioned argument for the conservation of wild pigs in Hiva Oa, and one against his former friend, Charpillet the gendarme, who put people he arrested to work in his own garden. At around the same time, Charpillet was replaced by a new head of the gendarmerie, Jean-Paul Claverie. He was also an old acquaintance of Gauguin: he was the one who had fined him for nude swimming shortly after his arrival in Tahiti. Claverie had heard a lot about Gauguin before coming to Atuona, and he refused to shake his hand. That meant war.

Cover of *Avant et après*, Gauguin's memoir

THE GUARDIAN ANGEL DIES

Sick though he was, Gauguin appointed himself the guardian angel of the people, fighting tirelessly against his enemies, Father Martin and Claverie, the gendarme, who ruled the roost in Atuona. For example, he defended the inhabitants of Hiva Oa who were forced to work on repairing the roads after a cyclone, even though that same cyclone had left them with no roofs over their heads and no food to eat. He intervened in several murder cases, a crime of passion, and a case in which twenty-nine men were convicted of public intoxication. No one listened to him, though. He was thrown out of the courtroom or lost his case because the gendarme had quickly bribed someone. Every time, he dragged himself off to the gendarmerie with new arguments. When he got home one day after yet another endless discussion at the station, he began coughing up blood again. But he still wrote

letters to the authorities on neighboring islands about corruption in Hiva Oa. When that came out, he found himself dealing with a court case. He was accused of libel and ordered to pay a fine of 500 francs and given a three-month prison sentence. As he had no money to travel to Papeete to appeal—Vollard did not always pay on time—he wrote begging letters to Vollard, Morice, and De Monfreid.

By then the syphilis was too advanced for him to continue the struggle. Tioka and Ky Dong looked after their dying friend for two months. In the early morning of May 8, Vernier visited him for the last time. Gauguin died at eleven o'clock that morning. Cause: heart failure. There was an empty morphine bottle by his side.

The next morning, Vernier discovered that Gauguin had been buried in the Catholic cemetery— with a view of the ocean—which he had immortalized not long before his death. In his report to Papeete and Paris, Father Martin wrote: "The only news of note is the sudden death of a despicable individual named Gauguin, an artist of some importance, but also an enemy of God and of all that is decent."

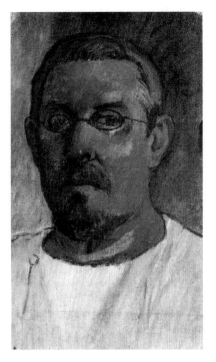

Self-Portrait, 1903. Kunstmuseum Basel, Switzerland

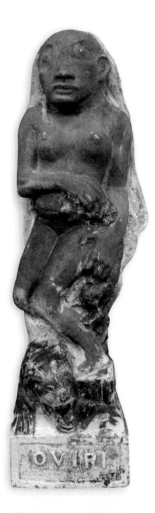

Oviri, 1894–95. Musée d'Orsay, Paris

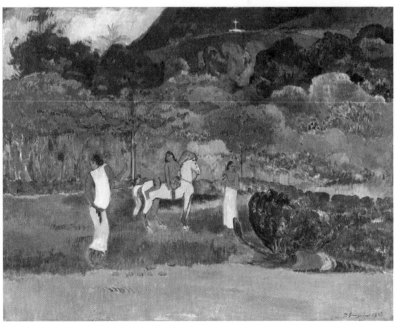

Women and a White Horse, 1903. Museum of Fine Arts, Boston. The cross on the hill marks the cemetery where Gauguin would be buried

AFTER THE FUNERAL

Five weeks after his funeral, Gauguin's personal belongings were auctioned, but not before Claverie, the gendarme, had pulled his erotic pictures from Port Said off the walls and broken the penis walking stick in two, as Vernier protested loudly, shouting that these were works of art. Gauguin's friends in Atuona all bought something to remember him by, Tioka bidding for two pairs of cotton pants and Ky Dong for a pair of enamel signs. Vernier, who had inherited Gauguin's green beret and actually wore it, bought some woodworking tools. Varney managed to get the property, the remaining building materials from the Maison du Jouir, and a mosquito net.

Riders on the Beach, 1902. Museum Folkwang, Essen, Germany

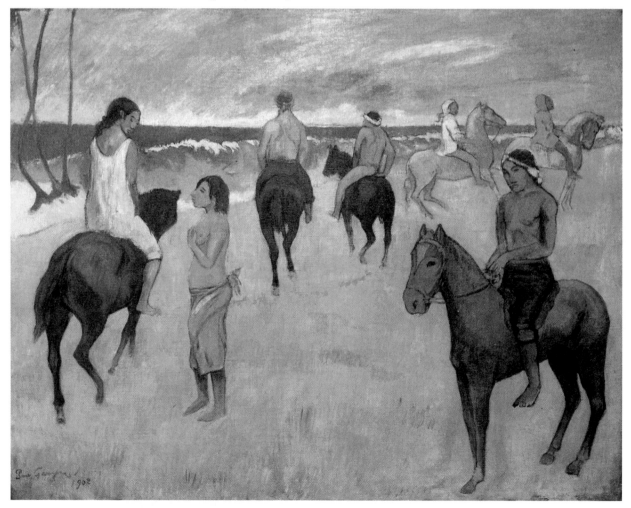

The carved door frames and the rest of Gauguin's work were shipped in fifteen crates to Papeete, accompanied by the naval doctor Victor Segalen. They were stored in King Pomare's abandoned palace, before also being auctioned off. Segalen, who would devote much of his life to promoting Gauguin's work, succeeded in acquiring a number of paintings, graphic works, drawings, a sketchbook, four of the five door panels, Gauguin's palette, and a large number of the postcards and photographs of art that Gauguin had called his "little friends" and that had accompanied him everywhere. They would eventually end up in the Musée d'Orsay in Paris. De Monfreid did his best to honor Gauguin's memory, and he ensured that Mette received a share of the inheritance. The descendants of De Monfreid donated twenty-one works to the Louvre, and these can now be seen at the Musée d'Orsay.

Door frames from the Maison du Jouir. Musée d'Orsay, Paris

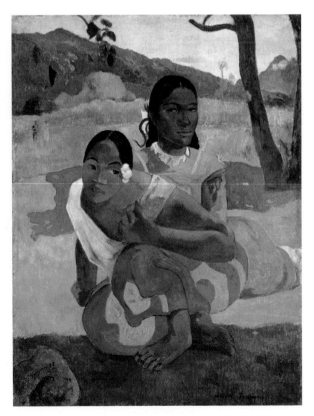

Nafea faa ipoipo? (When Will You Marry?), 1892. Private collection

In 1906, when Gauguin was already well on his way to becoming world famous, a retrospective featuring two hundred of his works took place during the Salon d'automne in Paris, thanks to Morice. The twenty-five-year-old Pablo Picasso saw paintings and ceramics by Gauguin at the exhibition that would lead him to create his radical painting *Les demoiselles d'Avignon*. The painter Henri Matisse also attended and was transfixed by Gauguin's colors, which even inspired him to visit Tahiti. During the 1906 exhibi-

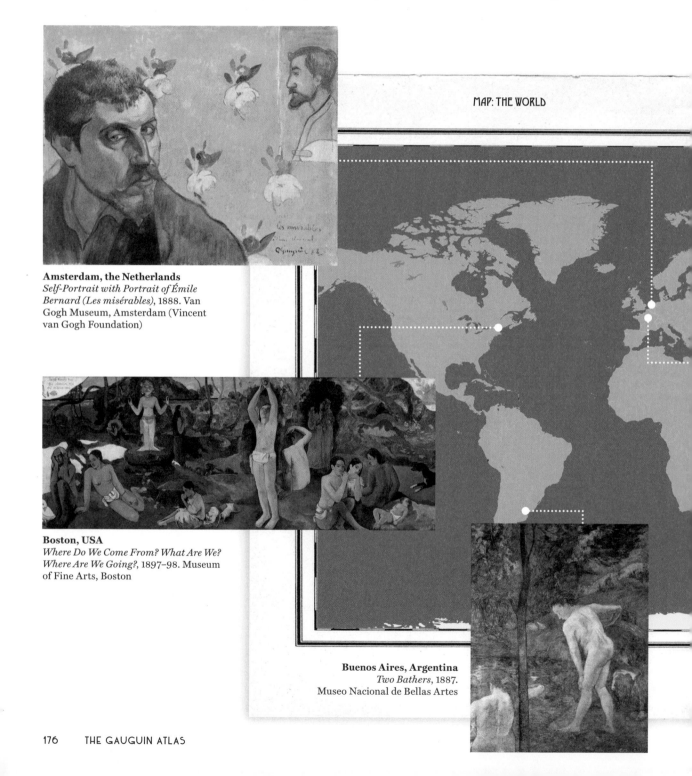

MAP: THE WORLD

Amsterdam, the Netherlands
Self-Portrait with Portrait of Émile Bernard (Les misérables), 1888. Van Gogh Museum, Amsterdam (Vincent van Gogh Foundation)

Boston, USA
Where Do We Come From? What Are We? Where Are We Going?, 1897–98. Museum of Fine Arts, Boston

Buenos Aires, Argentina
Two Bathers, 1887.
Museo Nacional de Bellas Artes

tion, Morice tried to separate Gauguin the artist as much as possible from Gauguin the man. It did not work. The public was unable to see Gauguin's art separately from the incredible life story of the man who had given up everything and done what so many had fantasized about during the industrial era: traveled to the ends of the earth, living freely and independently.

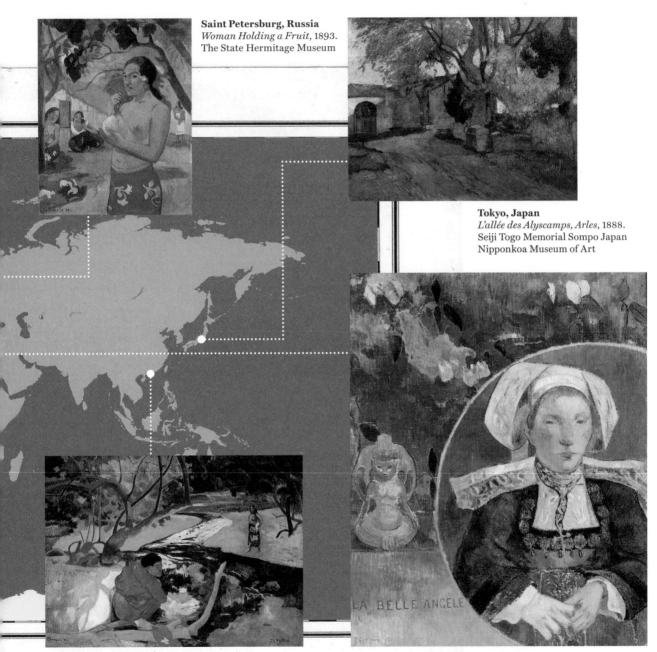

Saint Petersburg, Russia
Woman Holding a Fruit, 1893. The State Hermitage Museum

Tokyo, Japan
L'allée des Alyscamps, Arles, 1888. Seiji Togo Memorial Sompo Japan Nipponkoa Museum of Art

Hong Kong, China
Te poipoi (The Morning), 1892. Private collection

Paris, France
La belle angèle, 1889. Musée d'Orsay

Text: Nienke Denekamp, in collaboration with Sjraar van Heugten and Peter Schuite

Interior design, map and illustration designs: Yolanda Huntelaar, Werkplaats Amsterdam
Cover design: Jeff Wincapaw

Advice and concept: Dik Broekman
Picture editor: Nienke Denekamp
Translator: Laura Watkinson
Copyeditor: Alison Hagge

Printed in Slovakia

Cover image: detail of Paul Gauguin, *Fatata te miti (By the Sea)*, 1892. Courtesy National Gallery of Art, Washington, DC

With thanks to Maite van Dijk and Joost van der Hoeven, Van Gogh Museum, Amsterdam, for their advice about the Martinique chapter.

First published by Rubinstein Publishing as *De grote Gauguin atlas* in 2018.

Copyright © 2018 Rubinstein Publishing BV
Translation copyright © 2019 by Laura Watkinson

Published by Yale University Press, New Haven and London, by arrangement with Rubinstein Publishing BV, Amsterdam, the Netherlands.

Yale University Press, New Haven and London
yalebooks.com/art

Library of Congress Control Number: 2019940764
ISBN 978-0-300-23726-9

10 9 8 7 6 5 4 3 2 1

ABOUT THE AUTHOR

Nienke Denekamp is a freelance writer, editor, and photo editor in Amsterdam. She works for Dutch magazines and has carried out research and editing for TV series about Vincent van Gogh, Pablo Picasso, and Paul Gauguin, which were presented by Dutch actor and director Jeroen Krabbé. In addition, she has written stories for children that were published in the Dutch Little Golden Books series by Rubinstein Publishing, Amsterdam. She is the coauthor of *The Vincent Van Gogh Atlas*, translated by Laura Watkinson (Van Gogh Museum and Yale University Press, 2015).

ABOUT THE DESIGNER

Yolanda Huntelaar, Werkplaats Amsterdam, is a graphic designer. Since studying at the Rietveld Academie, she has been responsible for various projects, ranging from websites and brochures to major book projects such as *The Vincent Van Gogh Atlas* (2015), *Handig Literatuurboek* (2016), and the revision of Van Dale's children's dictionaries (2016). She also initiates projects, such as the photo book *Chin.Ind.Spec.Rest.* (2018), and came up with the design and composition for the typographical maps *Leesbaar Amsterdam* (2015), *Leesbaar Bergen* (2016), and *Leesbaar Groningen* (2018)

ABOUT THE TRANSLATOR

Laura Watkinson lives in a tall, thin house in the center of Amsterdam, with her husband and two cats. She loves literature and learning languages, and she particularly enjoys working with museums and galleries and translating books about art and artists.

ACKNOWLEDGMENTS

The author gratefully received the help of the following people when writing this book: René van Blerk, Suzanne Bogman, Willem Boorsma (passievoorkaartjes.nl), Maite van Dijk, Joost van der Hoeven, Mark Moorman, Cécile van Son, Seppie Groot, and Christian Jamet.

Special thanks to SkyHigh TV Productions, broadcaster AVRO-TROS, presenter Jeroen Krabbé, and director Richard den Dulk for the time and space that I was able to spend on the research/editing of the six-part series *Krabbé zoekt Paul Gauguin*.
avrotros.nl skyhightv.nl

PICTURE CREDITS

Alamy: 27, 38, 124

Archive Den Dulk: 70

Archive Van Blerk: 72

Archive.org: 59, 66, 87

Archives Départementales du
Loiret: 20

bdkr.com: 22, 47

Bibliothèque nationale de France:
23, 54, 56, 66, 68, 123

British Library: 70

Canalmuseum.com: 66, 68

Compagnie generale transatlan-
tique: endpapers

DavidRumsey.com: endpapers, 11,
30

George, Allen and Unwin, London:
132, 134, 149, 153, 155, 159, 160,
165, 167, 168, 169

Getty Digital Collections: 44, 121

Getty Images: 135

Jean-Paul van Cam: 167

Le Monde illustré: 25, 26

L'Illustration: 21, 26, 37, 126, 136

Maison Musée du Pouldu: 122

Muchafoundation.org: 147

National Portrait Gallery, Smithso-
nian Institution: 108, 109

New Zealand Railway Tours: 151

Oldbookillustrations.com: 14

Public domain: endpapers, 25, 31,
48, 56, 62, 69, 78, 106, 105, 113,
131, 145

Rijksmuseum: 100, 101

Salon d'Automne: 174

Sotheby's: 120, 161, 172

Tehoanotenunaa.com: 161

The Illustrated London News: 67

Van Gogh Museum: 123

Venitap.com: 40

All of the postcards are from the
author's archives

All tickets are from the
collection of Willem Boorsma
(passievoorkaartjes.nl)

BIBLIOGRAPHY

- Boyle-Turner, Caroline. *Paul Gauguin & the Marquesas: Paradise Found?* Editions Vagamundo, 2016.
- Bretell, Richard, et al. *The Art of Paul Gauguin.* Exh. cat. National Gallery of Art, Washington, DC, 1988.
- Childs, Elizabeth C. *Vanishing Paradise: Art and Exoticism in Colonial Tahiti.* University of California Press, 2013.
- Danielsson, Bengt. *Gauguin in the South Seas.* East Midland Printing Company, 1965.
- Denekamp, Nienke, and René van Blerk, with Teio Meedendorp. *De grote Van Gogh atlas.* Rubinstein, 2015. Translated by Laura Watkinson as *The Vincent van Gogh Atlas* (Yale University Press, 2015).
- Druick, D. W., ed. *Van Gogh en Gauguin: Het atelier van het zuiden.* Waanders, 2002. Originally published as *Van Gogh and Gauguin: The Studio of the South,* exh. cat. Art Institute of Chicago; Van Gogh Museum (Thames and Hudson, 2001).
- Gauguin, Paul. *Noa Noa.* Translated by O. F. Theis. N. L. Brown, 1919.
- Gauguin, Paul. *Paul Gauguin's Intimate Journals.* Translated by Van Wyck Brooks. Crown Publishers, 1936.
- Gauguin, Pola. *My Father, Paul Gauguin.* Alfred A. Knopf, 1937.
- Groom, Gloria, et al. *Gauguin: Artist as Alchemist.* Exh. cat. Art Institute of Chicago; Réunion des musées nationaux. Yale University Press, 2017.
- Hearn, Lafcadio. *Two Years in the French West Indies.* 1890; Interlink Books, 2001.
- Jamet, Christian. *Gauguin à Orléans.* Editions La Simarre, 2013.
- Jansen, Leo, Hans Luijten, and Nienke Bakker. *Vincent van Gogh: De brieven; De volledige, geïllustreerde en geannoteerde uitgave.* Van Gogh Museum, 2009. Translated as *Vincent van Gogh: The Letters; The Complete Illustrated and Annotated Edition* (Thames and Hudson, 2009).
- Kröger, Jelka, et al. *Meijer de Haan: A Master Revealed.* Hazan Press, 2010.
- Loti, Pierre. *The Marriage of Loti.* Translated by Clara Bell. Frederick A. Stokes, 1925.
- Malingue, Maurice. *Paul Gauguin: Letters to His Wife and Friends.* Saturn Press, 1946.
- Naifeh, Steven, and Gregory White Smith. *Vincent van Gogh: De biografie.* Bert Bakker, 2011. Translated as *Van Gogh: The Life* (Random House, 2011).
- Rechnitzer Pope, Karen. *Gauguin and Martinique.* University of Texas, 1981.
- Shikes, Ralph E., and Paula Harper. *Pissarro: His Life and Work.* Quartet Books, 1980.
- Stipriaan, René van. *Vincent van Gogh: Ooggetuigen van zijn lange weg naar wereldroem.* Singel Uitgeverijen, 2011.
- Sweetman, David. *Paul Gauguin: A Complete Life.* Hodder and Stoughton, 1995.
- Thomson, Belinda. *Gauguin: Maker of Myth.* Exh. cat. Tate Modern, London; National Gallery of Art, Washington, DC. Princeton University Press/Tate, 2010.

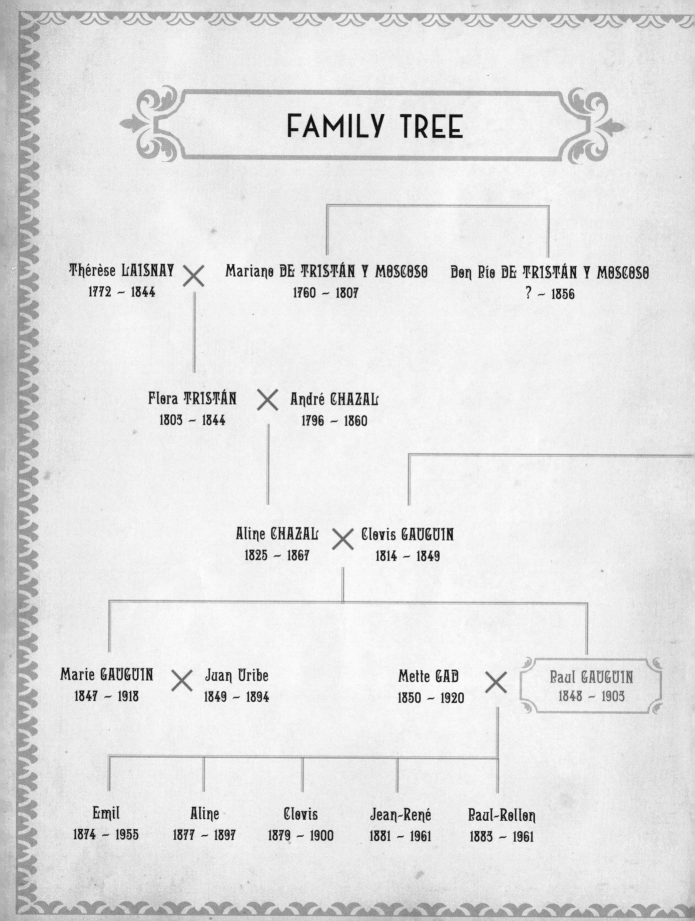

FAMILY TREE

Thérèse LAISNAY
1772 – 1844

Mariano DE TRISTÁN Y MOSCOSO
1760 – 1807

Don Pío DE TRISTÁN Y MOSCOSO
? – 1856

Flora TRISTÁN
1803 – 1844

André CHAZAL
1796 – 1860

Aline CHAZAL
1825 – 1867

Clovis GAUGUIN
1814 – 1849

Marie GAUGUIN
1847 – 1918

Juan Uribe
1849 – 1894

Mette GAD
1850 – 1920

Paul GAUGUIN
1848 – 1903

Emil
1874 – 1955

Aline
1877 – 1897

Clovis
1879 – 1900

Jean-René
1881 – 1961

Paul-Rollon
1883 – 1961

Paul GAUGUIN

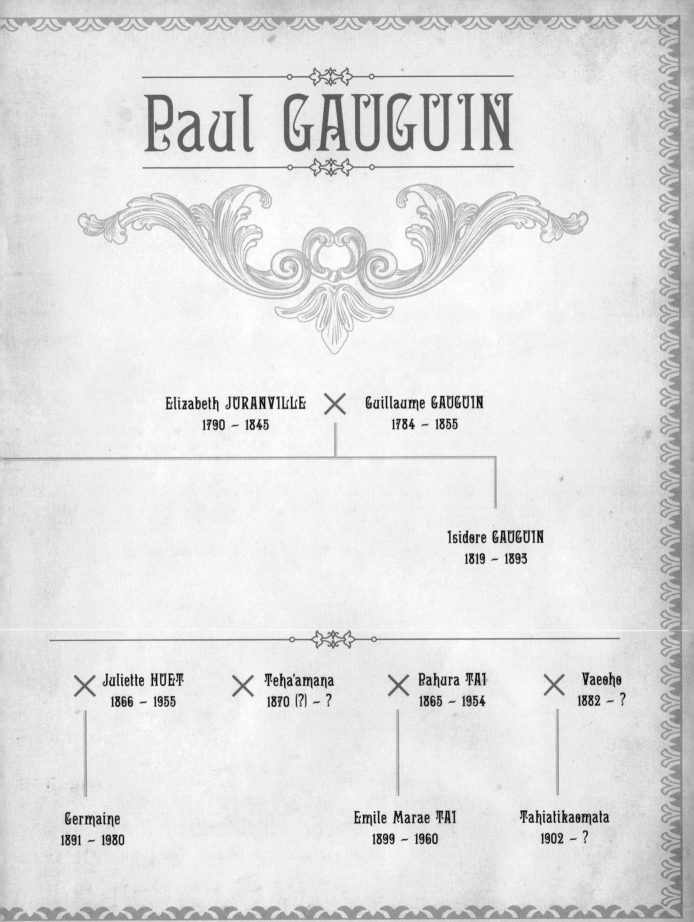

Elizabeth JURANVILLE
1790 – 1845
✕
Guillaume GAUGUIN
1784 – 1855

Isidore GAUGUIN
1819 – 1893

✕ Juliette HUET
1866 – 1955

✕ Teha'amana
1870 (?) – ?

✕ Pahura TAI
1865 – 1954

✕ Vaeoho
1882 – ?

Germaine
1891 – 1980

Emile Marae TAI
1899 – 1960

Tahiatikaomata
1902 – ?

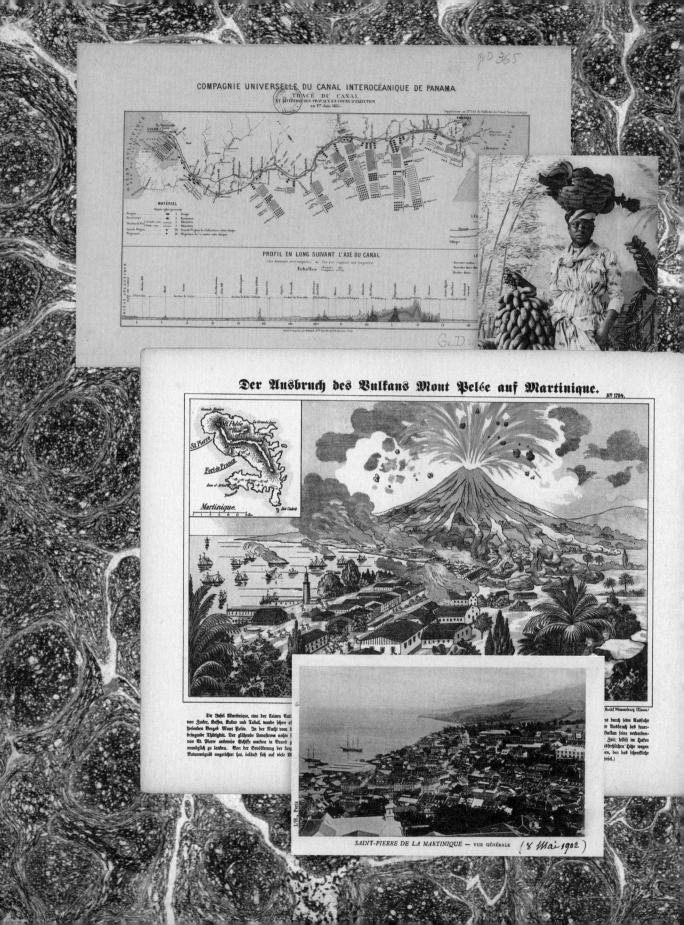